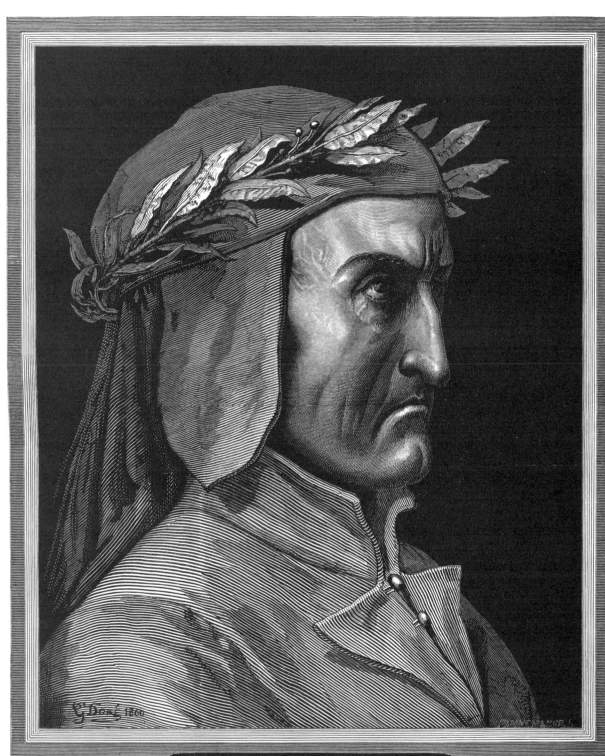

DANTE ALIGHIERI

The DORÉ ILLUSTRATIONS for DANTE'S DIVINE COMEDY

136 Plates by
GUSTAVE DORÉ

Dover Publications, Inc., New York

The Doré Illustrations for Dante's Divine Comedy is a new work,
first published by Dover Publications, Inc., in 1976.
136 illustrations are reproduced from *Dante Aligieri's Göttliche
Komödie . . . Illustrirt von Gustav Doré*, published by W. Moeser,
Berlin, n.d., in two volumes. The quotations that accompany
the plates in the present volume have been taken from *The
Divine Comedy of Dante Alighieri Translated by Henry Wadsworth
Longfellow* as published in three volumes by Ticknor and Fields,
Boston, in 1867. A new Publisher's Note has been written
especially for this Dover edition.

DOVER *Pictorial Archive* SERIES

International Standard Book Number: 0-486-23231-X
Library of Congress Catalog Card Number: 75-17176

Manufactured in the United States of America
Dover Publications, Inc.
31 East 2nd Street
Mineola, N.Y. 11501

Publisher's Note

Gustave Doré was perhaps the most successful illustrator of the nineteenth century. Born in Strasbourg on January 6, 1832, he revealed his artistic bent early in childhood. His father's desire that he enter a respectable profession was ignored by his mother, who encouraged his development as an artist not only in the early years, but throughout his entire adult life. At the age of fifteen, while on a trip to Paris, he sold some work to Charles Philipon's *Journal pour rire,* and soon after was a regular contributor of lithographic caricatures drawn in the manner of Gavarni and Honoré Daumier. His work was successful and his rise swift. In 1854 he executed wonderfully bizarre illustrations for an edition of Rabelais, and then, according to a systematic plan, went on to illustrate many of the classics, including Balzac's *Contes drôlatiques* (1856), *Perrault's Fairy Tales* (1861), Cervantes' *Don Quixote* (1863), the Bible (1865–66), Milton's *Paradise Lost* (1866), Tennyson's *Idylls of the King* (1867-68), and Coleridge's *The Rime of the Ancient Mariner* (1876). These books appeared in many editions in many nations; a work such as the Doré Bible was a treasured possession of countless middle-class families. His religious and historical paintings and sculptures, to which he devoted great effort, were less successful. He died in Paris on January 23, 1883, leaving unfinished a memorial to Dumas *père* and illustrations for an edition of Shakespeare.

Doré first seriously entertained the idea of illustrating Dante's *Divine Comedy* in a large folio edition in 1855. Although he could read no Italian, and probably relied on the French prose translation of Pier Angelo Fiorentino which later appeared with his illustrations along with the original Italian text, his study of the masterpiece was thorough. Work on the first section, the *Inferno,* began in 1857. When he was finished, he found that no publisher was willing to undertake the work; it was generally held that so large a volume would have to be sold at a prohibitively high price. Undaunted, Doré published the plates and text at his own expense in 1861. The work immediately won extravagant praise. Doré, many contended, had supplanted Botticelli as the greatest illustrator of Dante. These illustrations remained Doré's personal favorites; he frequently went back to them as sources for paintings. In 1868 work on the *Purgatorio* and *Paradiso* was finished, and the complete *Divine Comedy* was published by L. Hachette et Cie., Paris.

Doré worked with astonishing speed, usually drawing his designs directly onto the woodblocks. Early in his career he had been upset by the low quality of engraving, and he assembled a shop of about 40 engravers he thought competent to work on his illustrations—Pisan, Pannemaker and Jonnard foremost among them. Much of the credit for the success of Doré's illustrations, especially those contained in this volume where the thick, rich blacks of the *Inferno* melt into the grays and whites of the *Paradiso,* belongs to these skilled artisans.

These illustrations mark a sharp contrast with Doré's earlier ones. In place of the grotesque and satirical, Doré, moving onto a grander plane, creates a weird, rather theatrical otherworldliness. Théophile Gautier commented on this atmosphere: "What strikes us at first glance in Gustave Doré's illustrations for Dante are the surroundings in which the scenes that he draws take place and which have no relation to the appearance of the mundane world." (*Moniteur* Universel, July 30, 1861.)

The illustrations for the present edition have been taken from *Dante Alighieri's Göttliche Komödie, Uebersetzt von Wilhelm Krigar. Illustrirt von Gustav Doré. Mit einem Vorwort von Dr. Karl Witte. Verlag von W. Moeser in Berlin,* n.d., two volumes, because of the superior quality of the plates. The translation used in the captions is that of Henry Wadsworth Longfellow as published by Ticknor and Fields, Boston, 1867, three volumes.

List of Plates

Frontispiece. Dante Alighieri

THE *INFERNO*

1. The Forest
2. The Panther
3. The Lion
4. The She-Wolf
5, 6. Virgil and Dante
7. Beatrice and Virgil
8. The Gate of Hell
9. Charon and the River Acheron
10. The Embarkation of the Souls
11. Limbo—the Innocent Souls
12. Limbo—Poets and Heroes
13. Minos
14. The Lustful
15–18. Paolo and Francesca
19. Cerberus
20. The Gluttons—Ciacco
21. Pluto and Virgil
22. The Avaricious and Prodigal
23. The Styx—the Irascible
24. The Styx—Phlegyas
25. The Styx—Philippo Argenti
26. The Portals of Dis
27. The Erinnys
28. The Angel
29. Burning Graves—the Heresiarchs
30. Farinata
31. The Tomb of Anastatius
32. The Minotaur
33. The Centaurs—Nessus
34. Chiron
35. The Harpies' Wood
36, 37. The Suicides
38. The Blasphemers—Capaneus
39. Brunetto Latini
40. Geryon—Symbol of Deceit
41. The Descent on the Monster
42. Devils and Seducers
43. Paramours and Flatterers
44. Thaïs
45. The Simonists
46. Devils and Barrators
47. Devils and Virgil
48. Barrators—Giampolo
49. Alichino and Calcabrina
50. Tumult and Escape
51. The Hypocrites
52. The Hypocrites—Crucified Pharisee
53. Thieves
54. Transformation into Snakes
55. Evil Councellors
56. Schismatics—Mahomet
57. Sower of Discord
58. Bertram de Born
59. Geri del Bello
60–62. Forgers
63. Myrrha
64. The Giants—Nimrod
65. Ephialtes
66. Antaeus—Descent to the Last Circle
67. Cocytus—Traitors
68. Traitors—Bocca degli Abbati
69. Ugolino and Archbishop Ruggieri
70. Ugolino
71. Ugolino and Gaddo
72. Ugolino
73. The Judecca—Lucifer
74. The Way to the Upper World
75. The Poets Emerge from Hell

THE *PURGATORIO*

76. Venus
77. Cato of Utica
78. The Vessel
79. The Celestial Pilot
80. The Mountain's Foot
81. The Ascent
82, 83. The Late Repenters
84. Buonconte da Montefeltro
85. Pia
86. Sordello and Virgil
87. The Dell
88. The Serpent
89. Twilight
90. The Eagle
91. The Portals of Purgatory
92. The Sculptures

vii

THE *PARADISO*

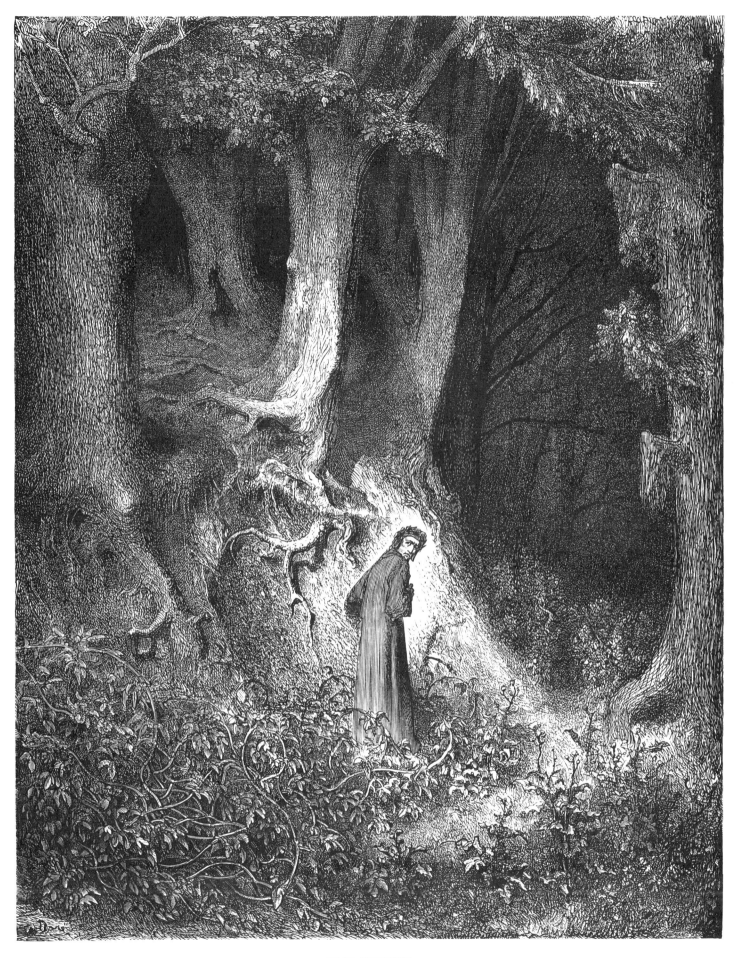

THE FOREST
Midway upon the journey of our life / I found myself within a forest dark, / For
the straightforward pathway had been lost (*Inf.* I, 1–3).

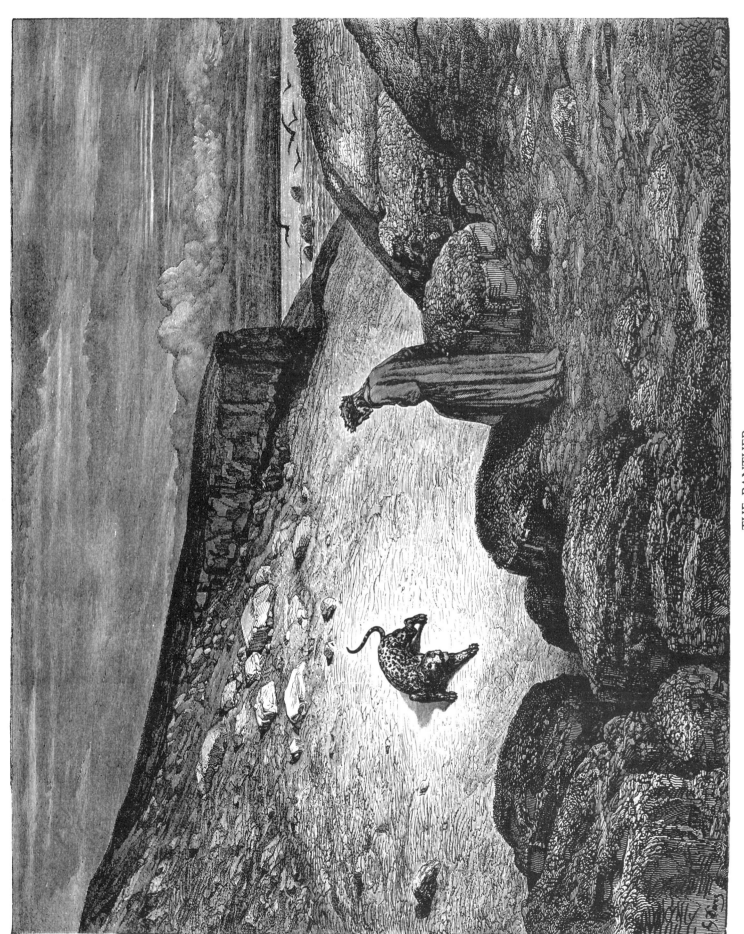

THE PANTHER

And lo! almost where the ascent began, / A panther light and swift exceedingly, /
Which with a spotted skin was covered o'er! (*Inf.* I, 31–33).

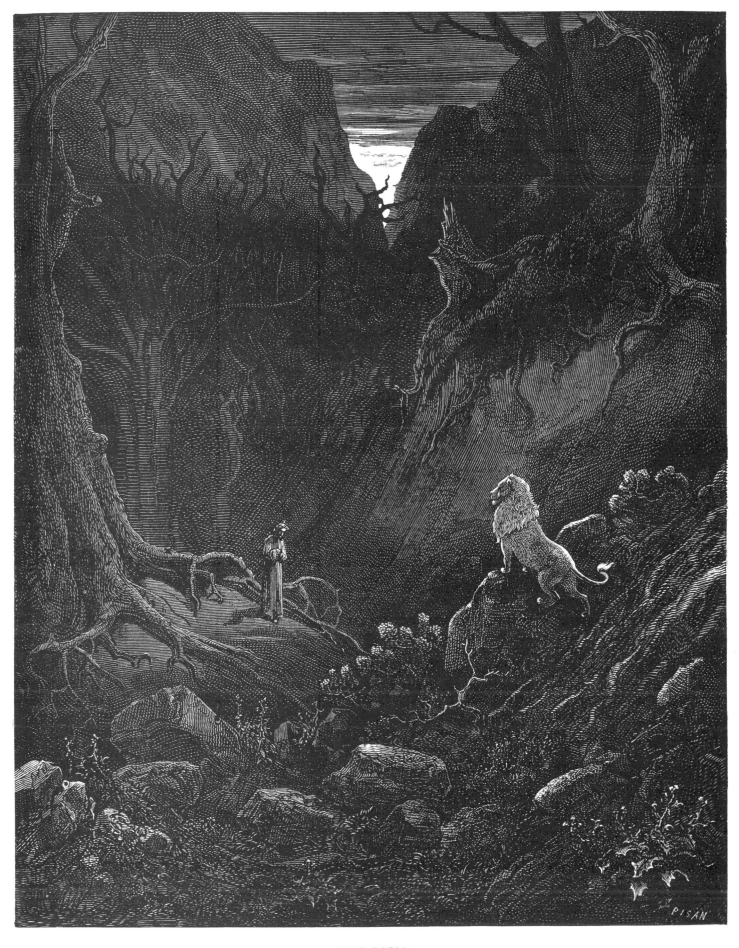

THE LION
He seemed as if against me he were coming / With head uplifted, and with ravenous
hunger (*Inf.* I, 46, 47).

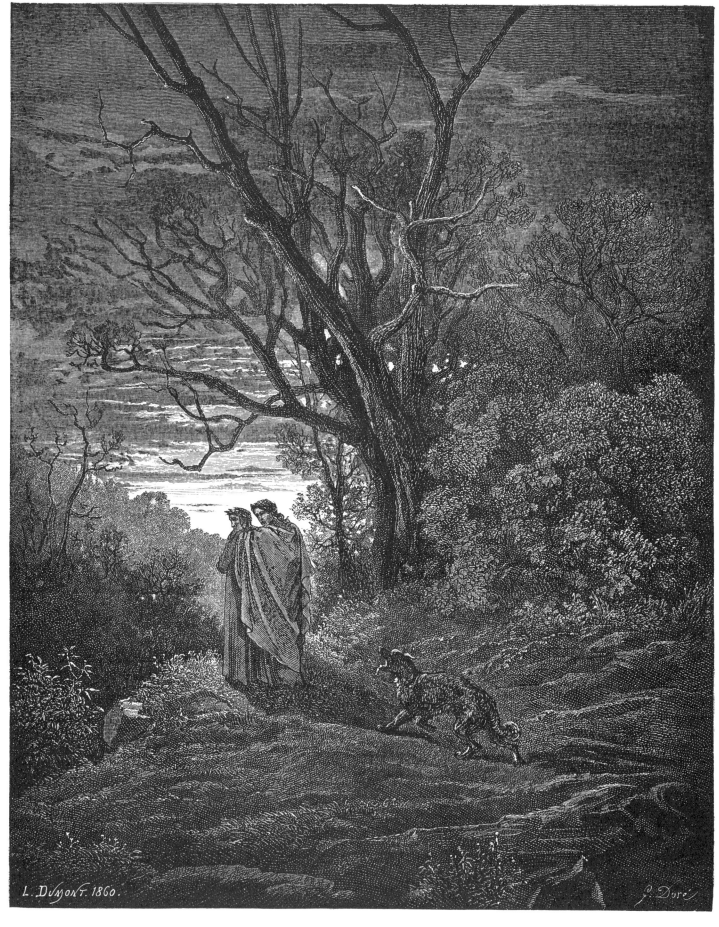

THE SHE-WOLF
"Behold the beast, for which I have turned back; / Do thou protect me from her, famous Sage" (*Inf.* I, 88, 89).

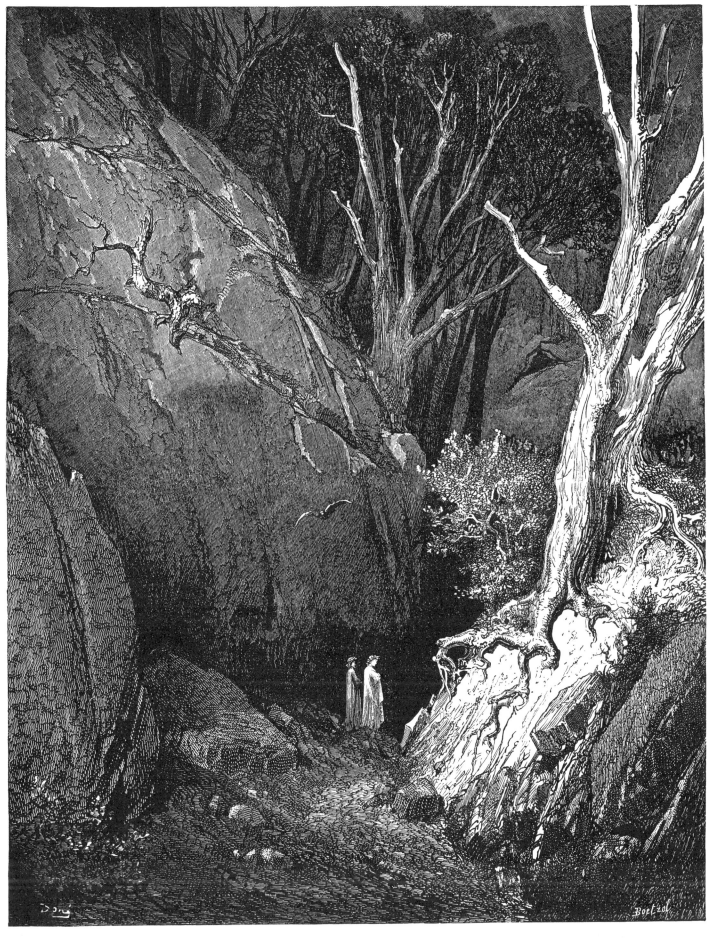

VIRGIL AND DANTE
Then he moved on, and I behind him followed (*Inf.* I, 136).

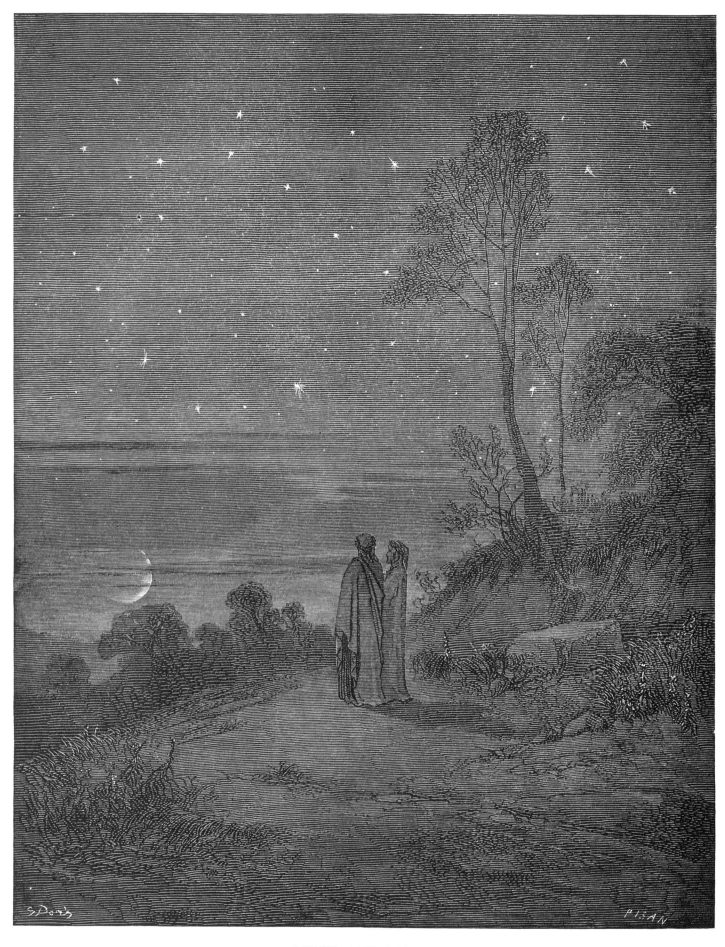

VIRGIL AND DANTE
Day was departing (*Inf.* II, 1).

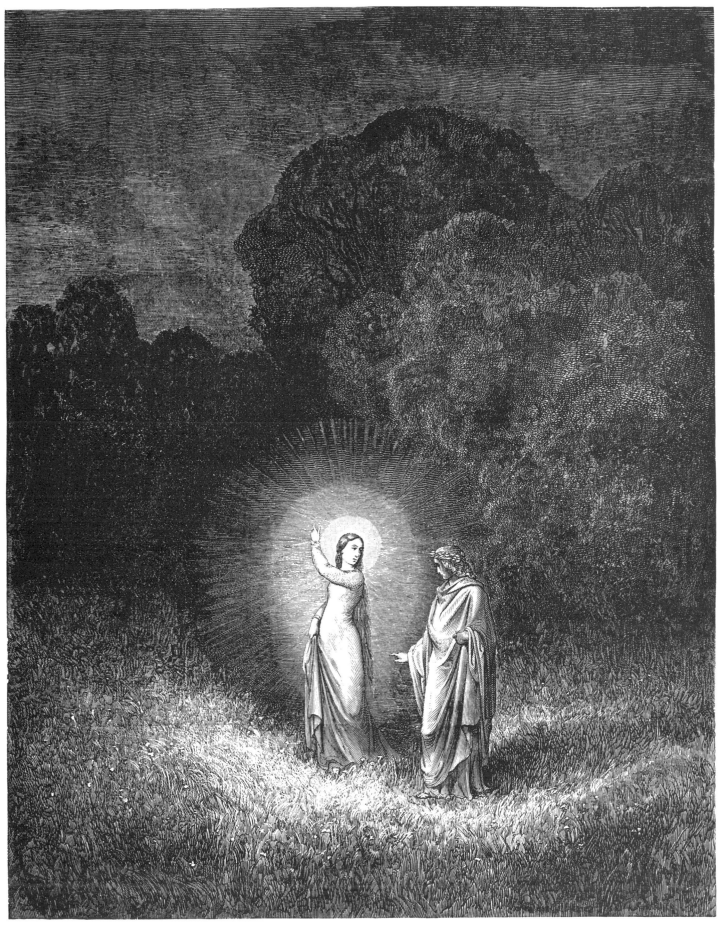

BEATRICE AND VIRGIL
"Beatrice am I, who do bid thee go" (*Inf.* II, 70).

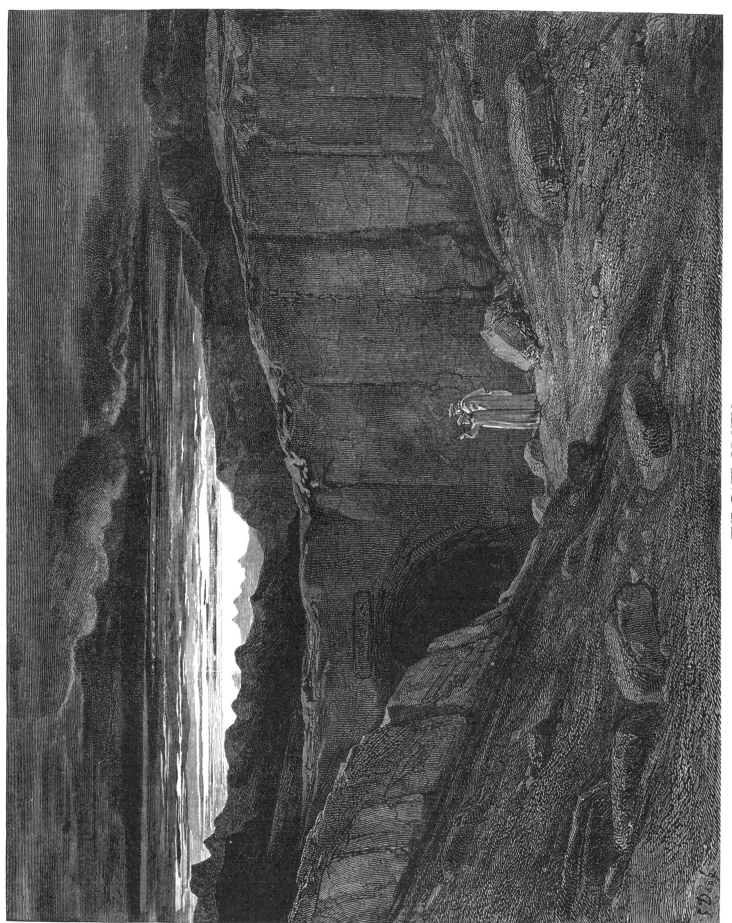

THE GATE OF HELL

"All hope abandon, ye who enter in!" (*Inf.* III, 9).

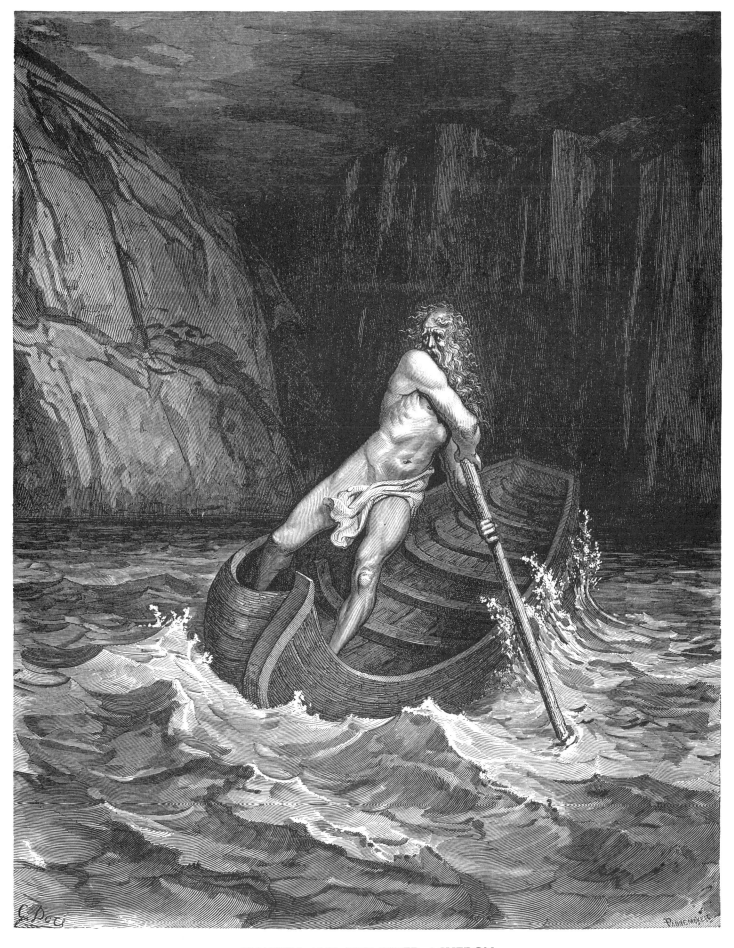

CHARON AND THE RIVER ACHERON
And lo! towards us coming in a boat / An old man, hoary with the hair of eld, /
Crying: "Woe unto you, ye souls depraved!" (*Inf.* III, 82–84).

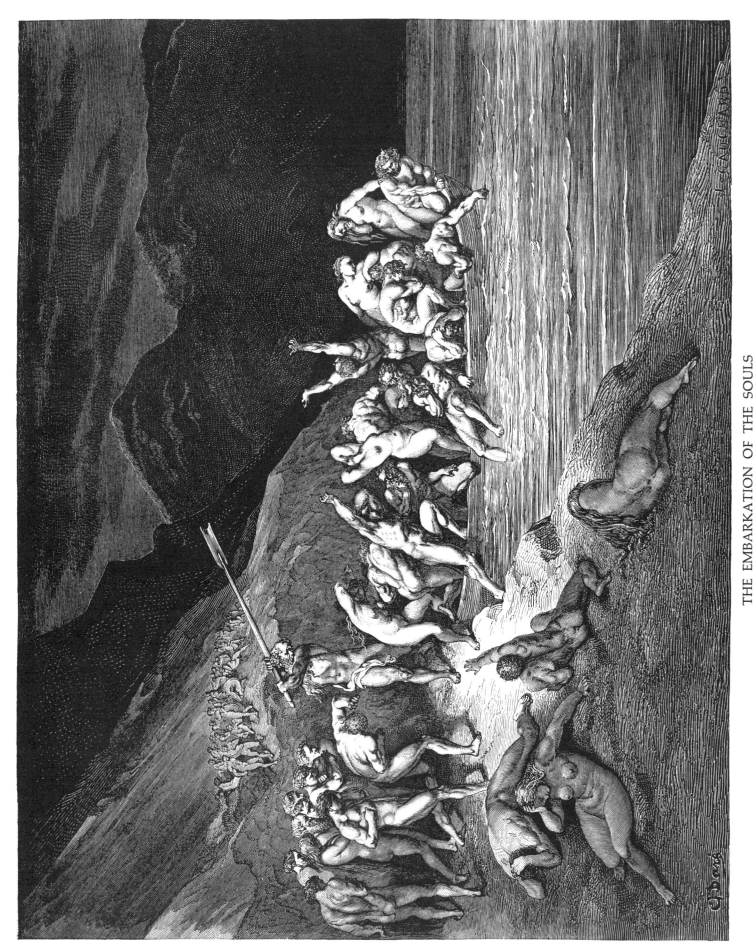

THE EMBARKATION OF THE SOULS

Charon the demon, with the eyes of glede, / Beckoning to them, collects them all together, / Beats with his oar whoever lags behind (*Inf*. III, 109–111).

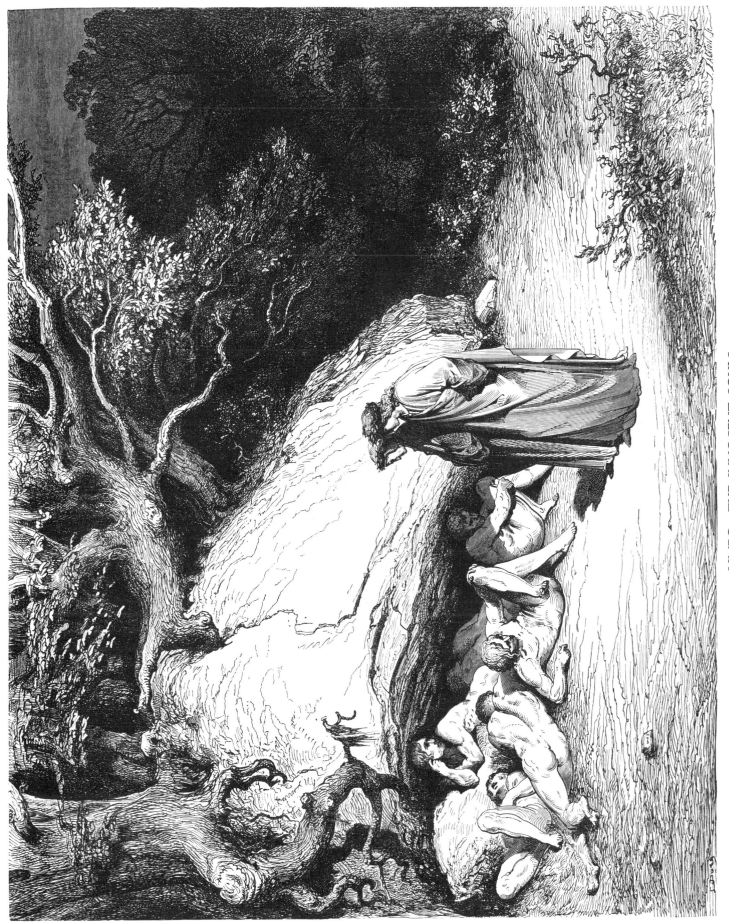

LIMBO—THE INNOCENT SOULS

"Lost are we, and are only so far punished, / That without hope we live on in desire"
(Inf. IV, 41, 42).

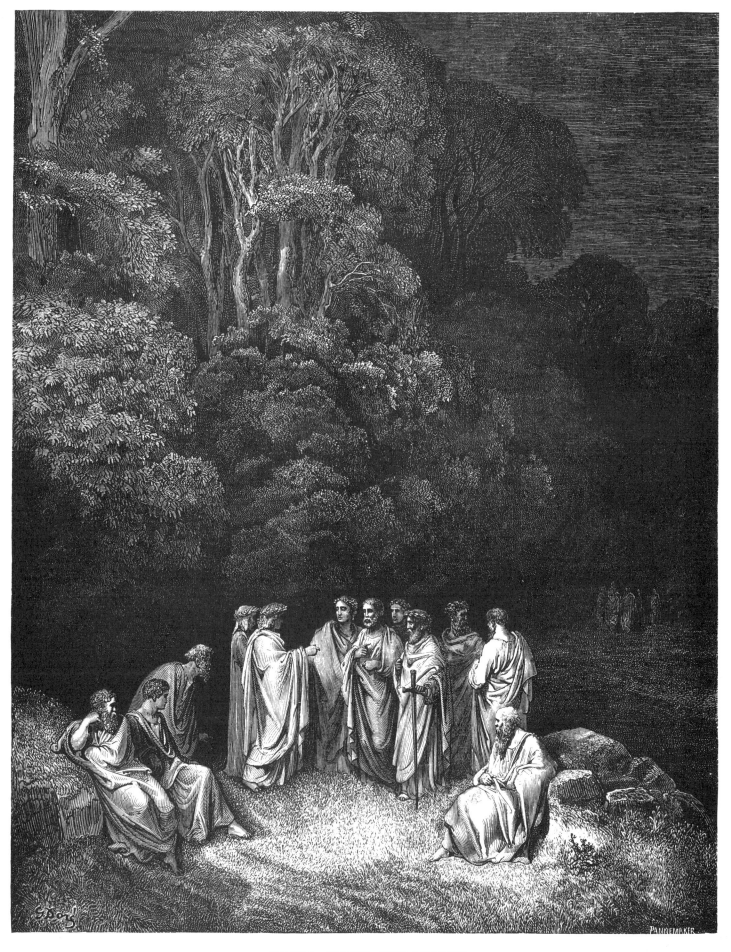

LIMBO—POETS AND HEROES
Thus I beheld assemble the fair school / Of that lord of the song pre-eminent, /
Who o'er the others like an eagle soars (*Inf.* IV, 94–96).

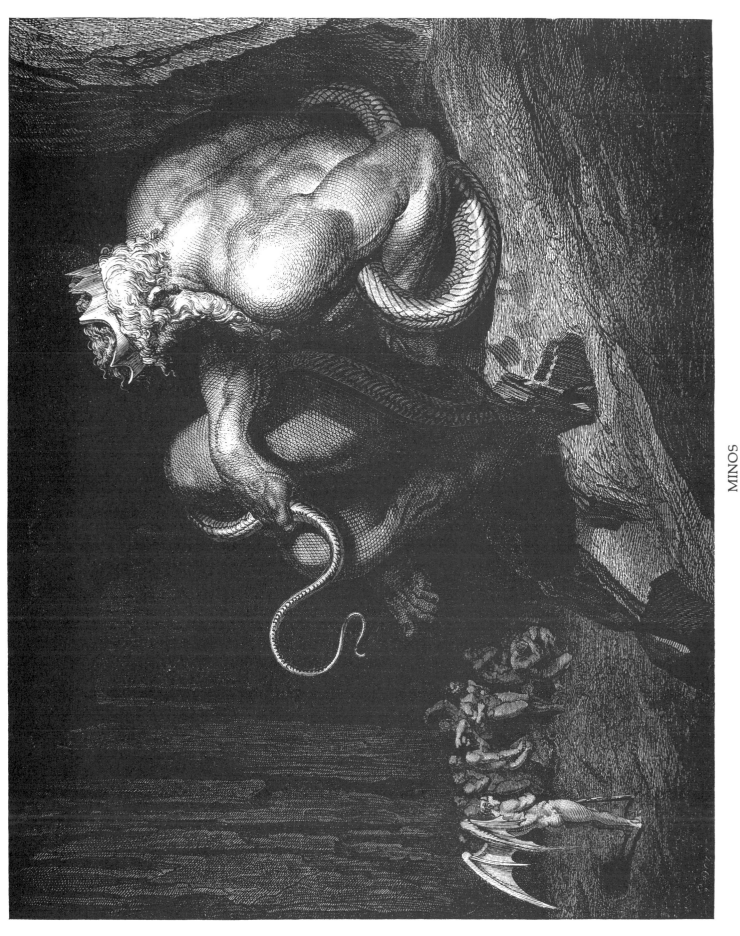

MINOS

There standeth Minos horribly, and snarls; / Examines the transgressions at the entrance; / Judges, and sends according as he girds him (*Inf.* V, 4–6).

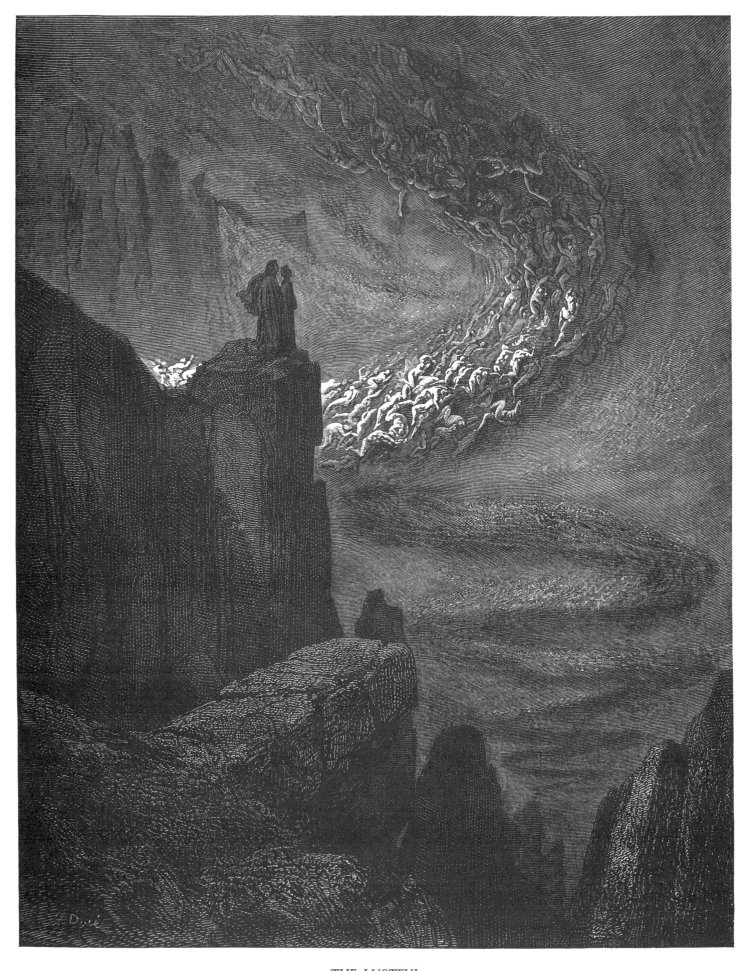

THE LUSTFUL
The infernal hurricane that never rests / Hurtles the spirits onward in its rapine
(*Inf.* V, 31, 32).

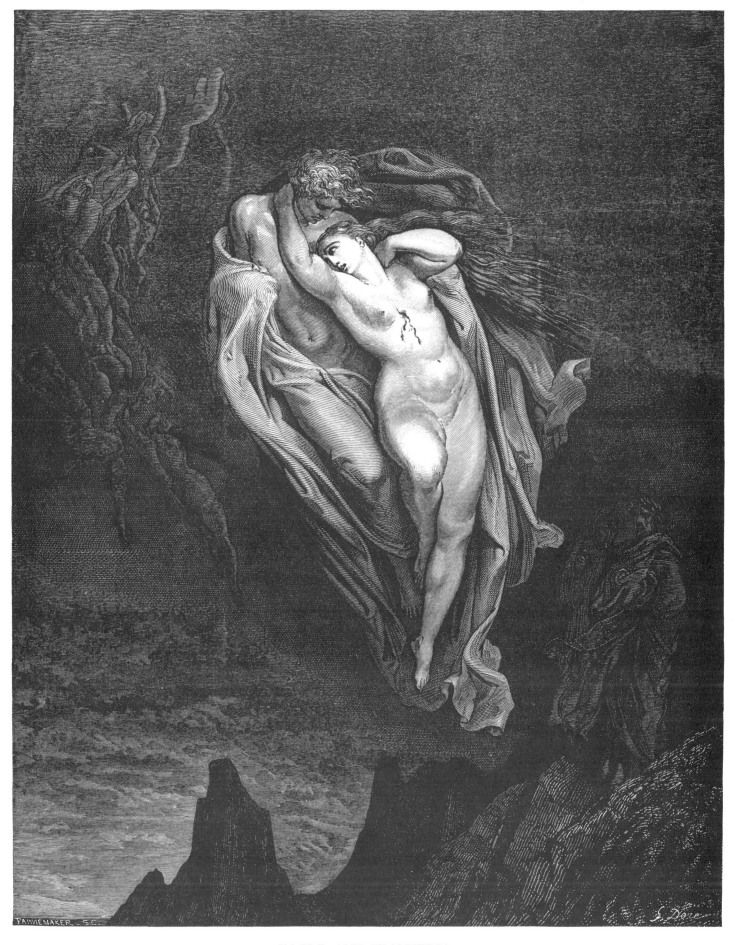

PAOLO AND FRANCESCA
"O Poet, willingly / Speak would I to those two, who go together, / And seem upon
the wind to be so light" (*Inf.* V, 73–75).

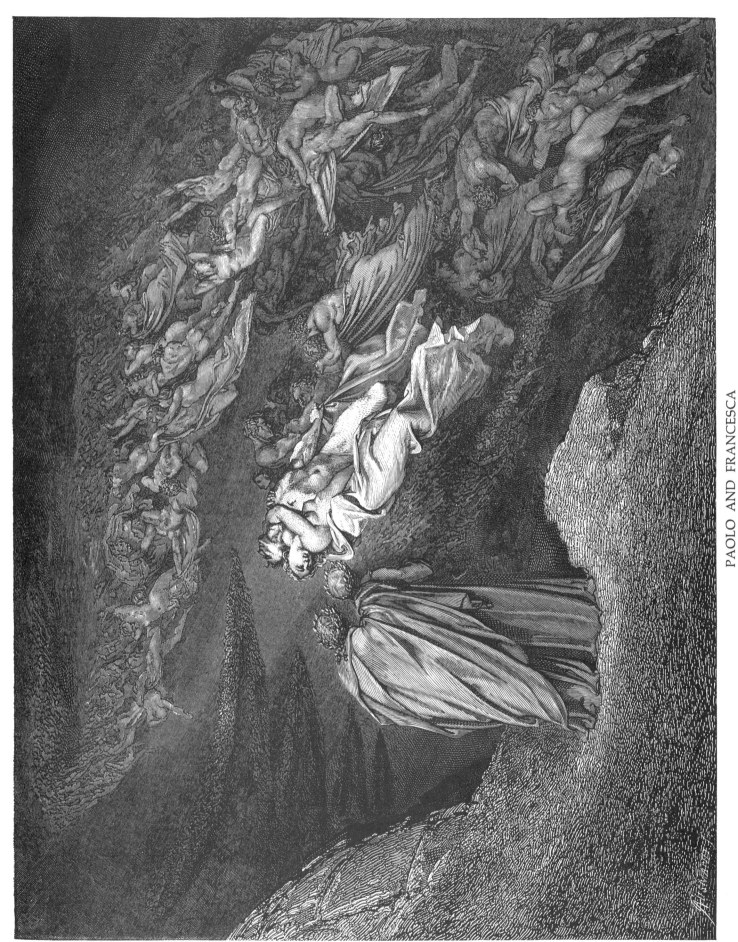

PAOLO AND FRANCESCA

"Love has conducted us unto one death; / Caïna waiteth him who quenched our life!" (*Inf.* V, 106, 107).

PAOLO AND FRANCESCA
"That day no farther did we read therein" (*Inf.* V, 138).

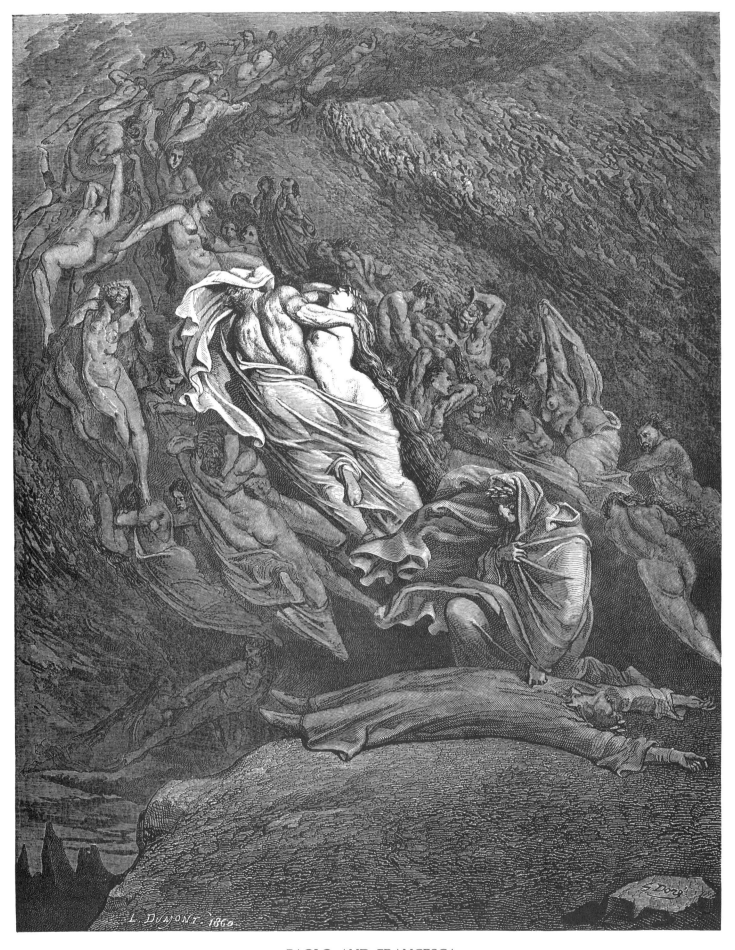

PAOLO AND FRANCESCA
I swooned away as if I had been dying, / And fell, even as a dead body falls (*Inf.*
V, 141, 142).

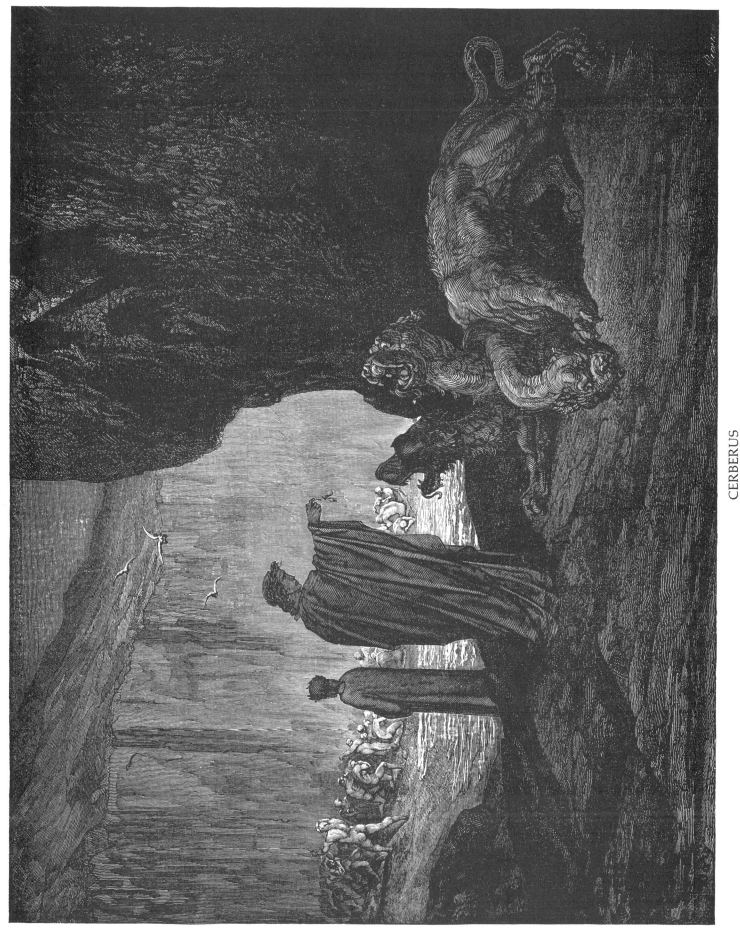

CERBERUS

And my Conductor, with his spans extended, / Took of the earth, and with his fists
well filled, / He threw it into those rapacious gullets (*Inf.* VI, 25–27).

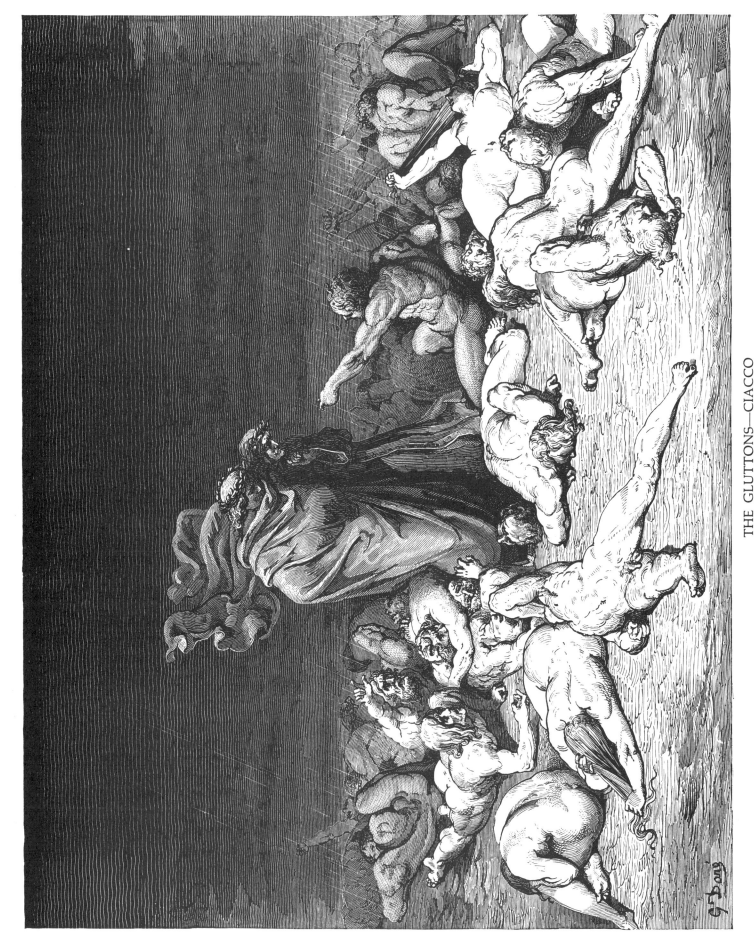

THE GLUTTONS—CIACCO

"For the pernicious sin of gluttony / I, as thou seest, am battered by this rain" (*Inf.* VI, 53, 54).

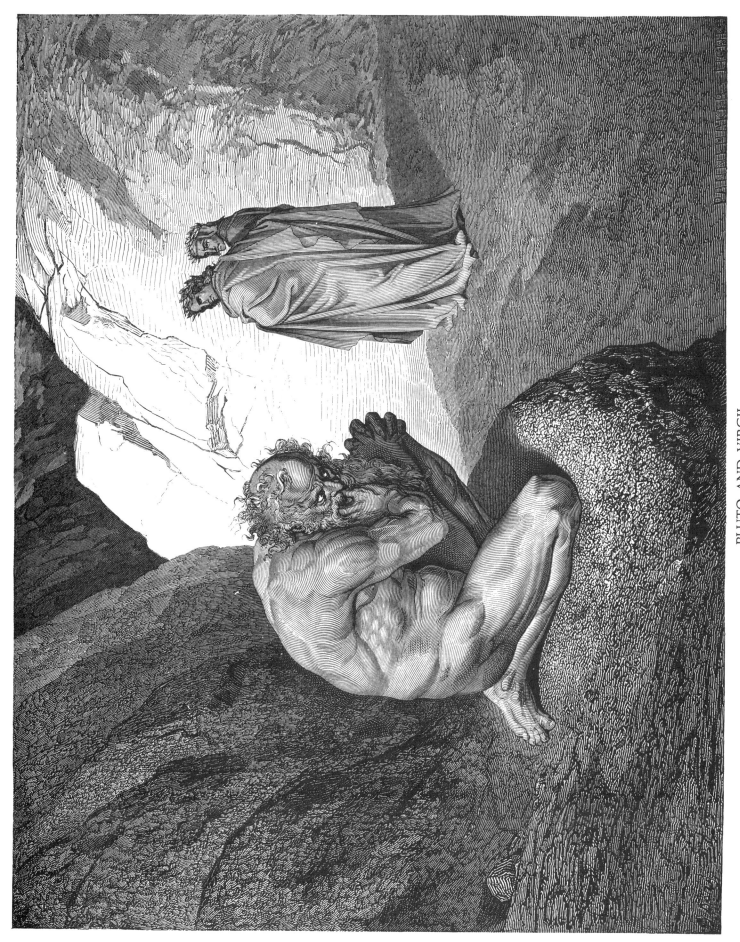

PLUTO AND VIRGIL

"Be silent thou accursed wolf; / Consume within thyself with thine own rage"
(Inf. VII, 8, 9).

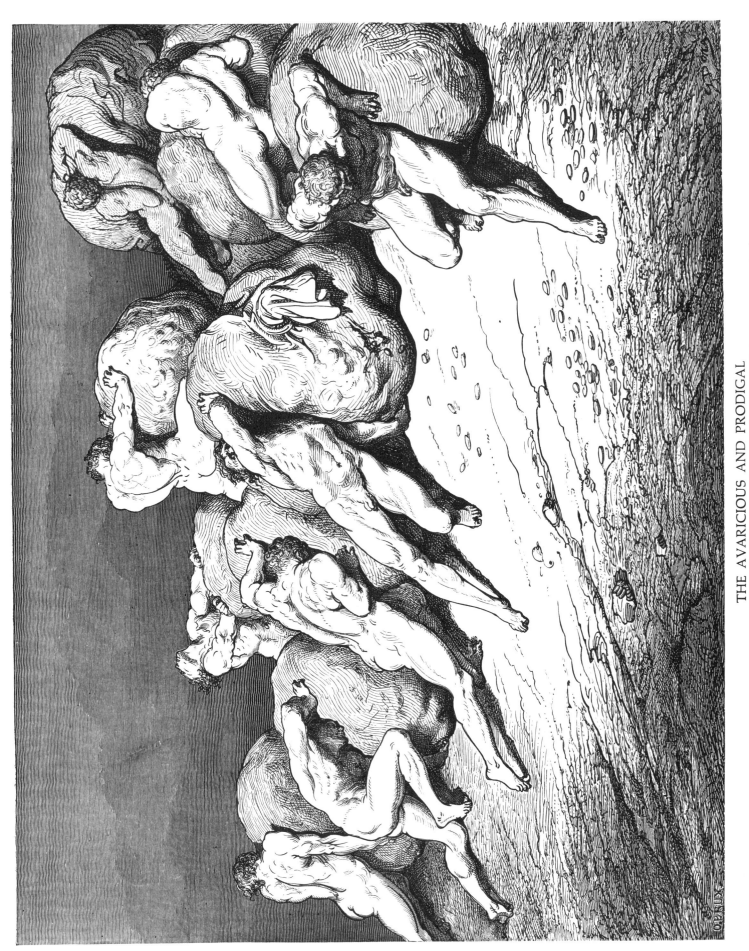

THE AVARICIOUS AND PRODIGAL

"For all the gold that is beneath the moon, / Or ever has been, of these weary souls / Could never make a single one repose" (Inf. VII, 64–66).

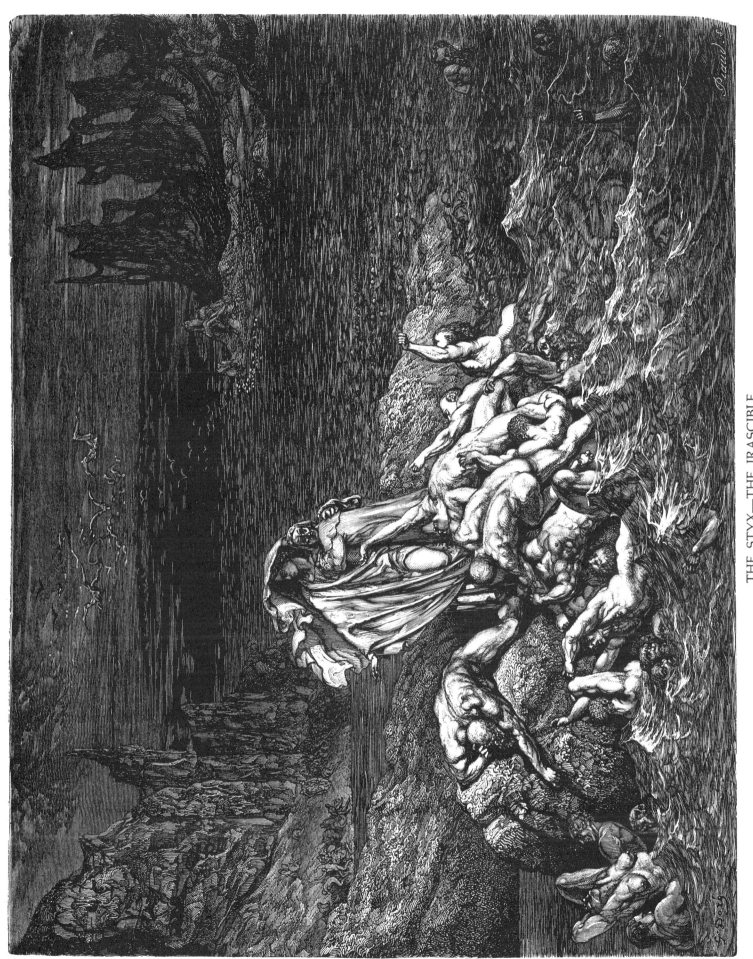

THE STYX—THE IRASCIBLE

"Son, thou now beholdest / The souls of those whom anger overcame" (*Inf.* VII, 115, 116).

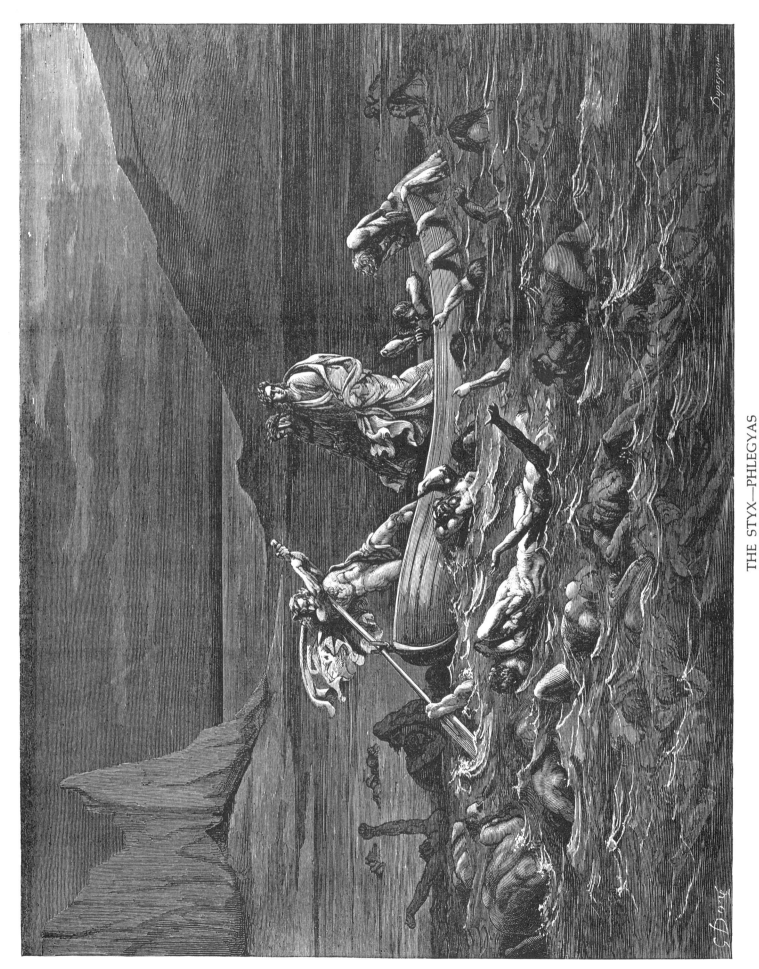

THE STYX—PHLEGYAS

The antique prow goes on its way, dividing / More of the water than 't is wont with
others (*Inf.* VIII, 29, 30).

24

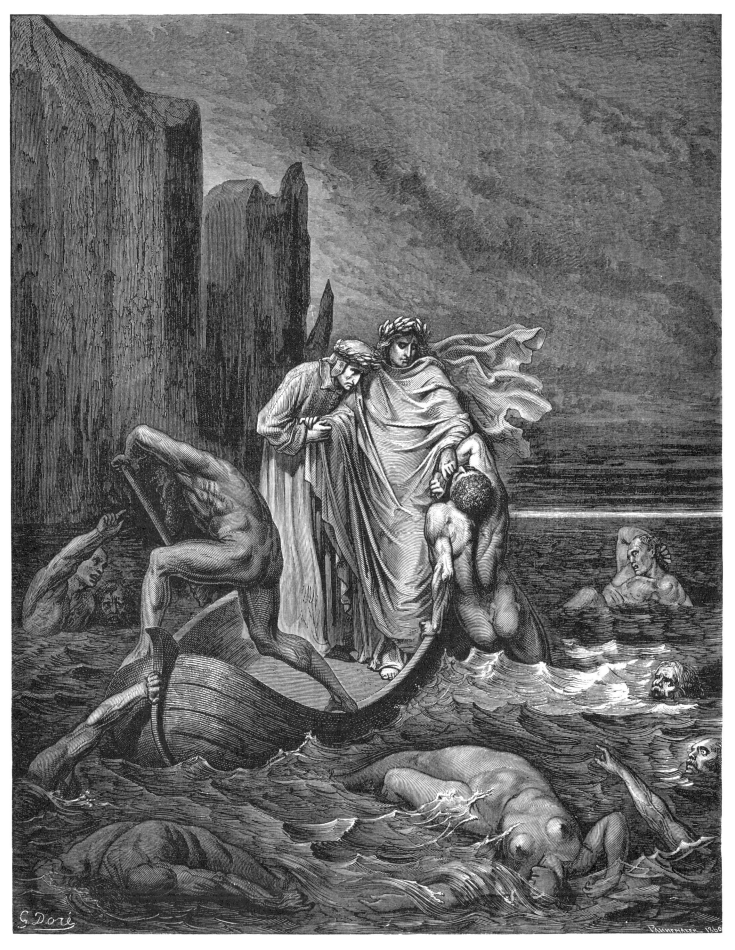

THE STYX—PHILIPPO ARGENTI

Then stretched he both his hands unto the boat; / Whereat my wary Master thrust
him back (*Inf.* VIII, 40, 41).

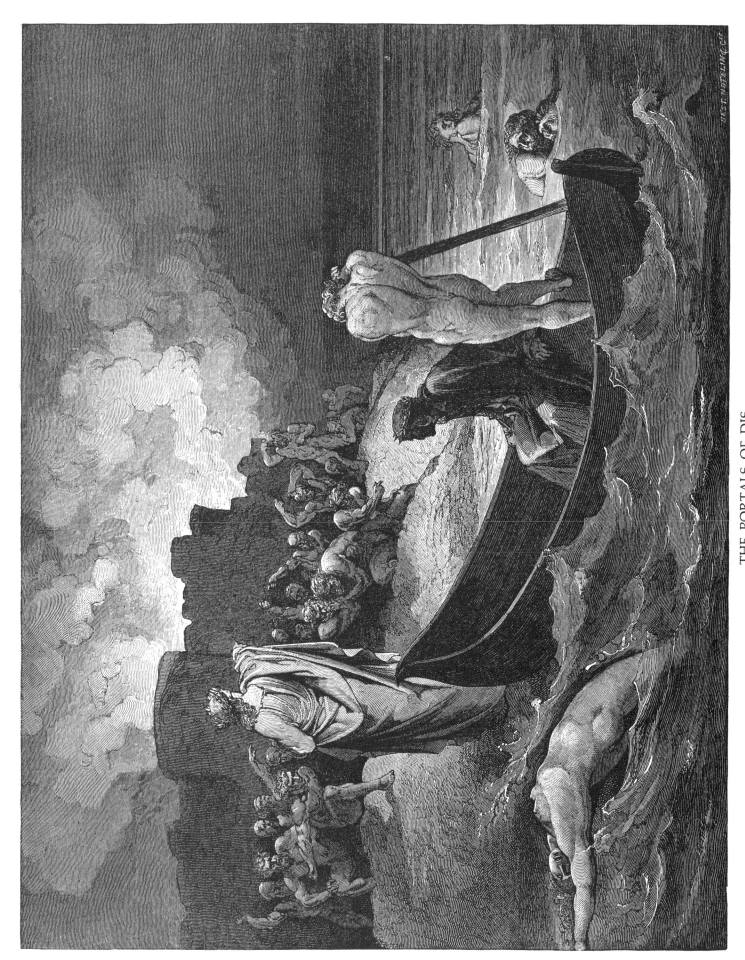

THE PORTALS OF DIS

I could not hear what he proposed to them; / But with them there he did not linger long, / Ere each within in rivalry ran back (*Inf.* VIII, 112–114).

26

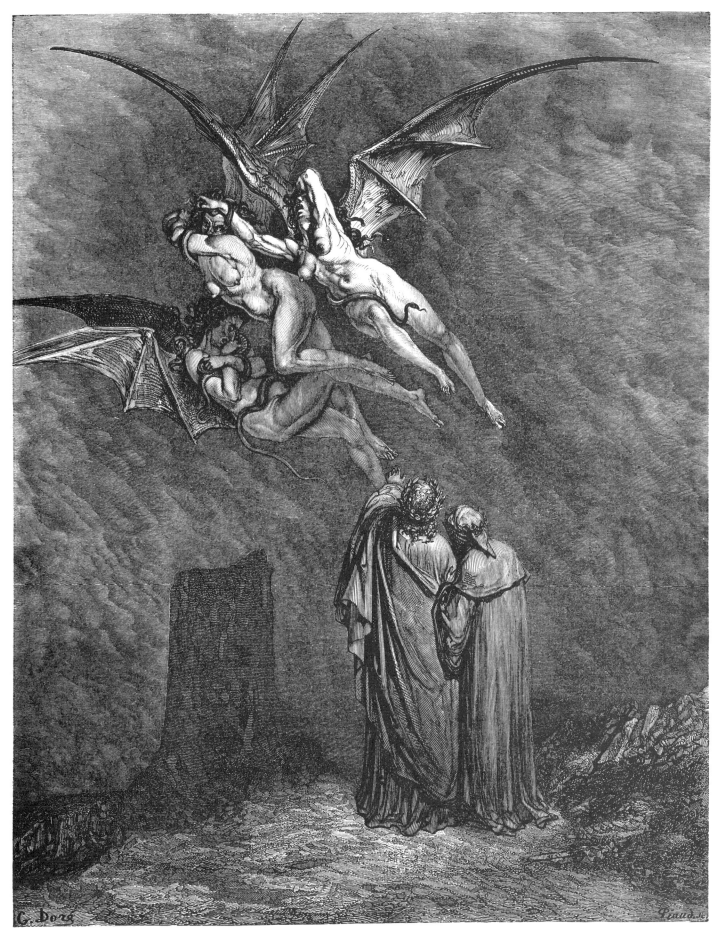

THE ERINNYS

"This is Megaera, on the left-hand side; / She who is weeping on the right, Alecto; /
Tisiphone is between" (*Inf.* IX, 46–48).

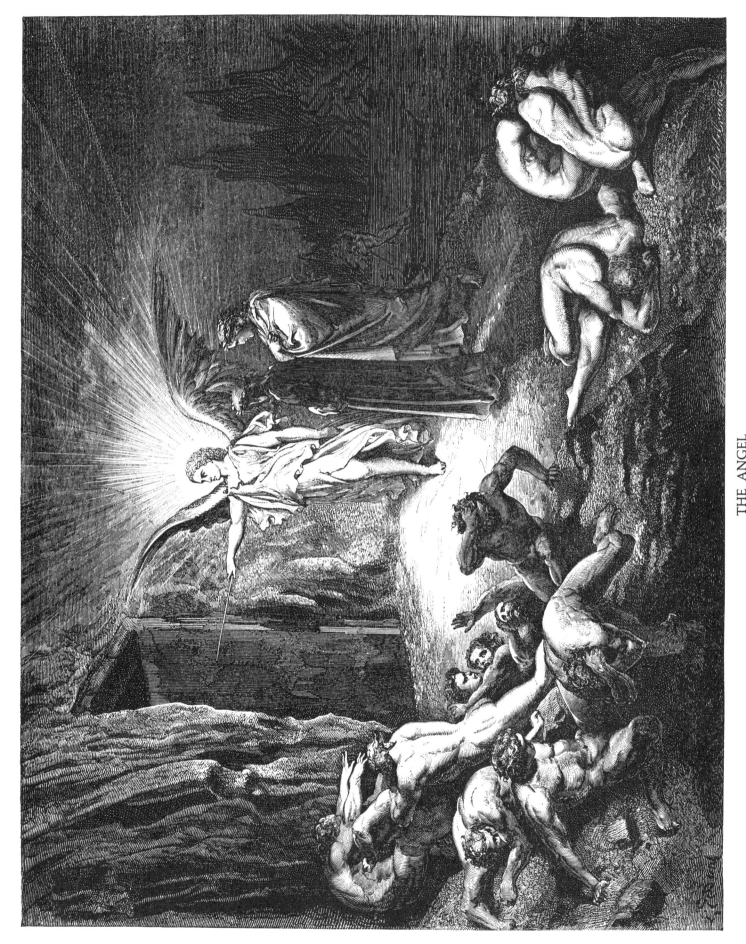

THE ANGEL

He reached the gate, and with a little rod / He opened it, for there was no resistance
(*Inf.* IX, 89, 90).

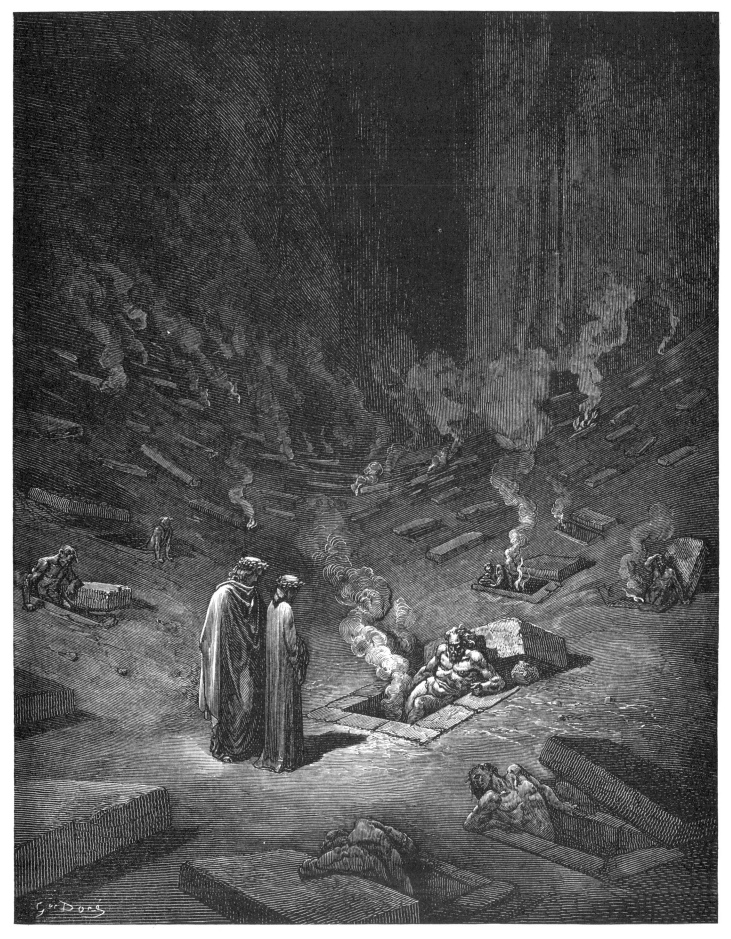

BURNING GRAVES—THE HERESIARCHS

"My Master, what are all those people / Who, having sepulture within those tombs, /
Make themselves audible by doleful sighs?" (*Inf.* IX, 124–126).

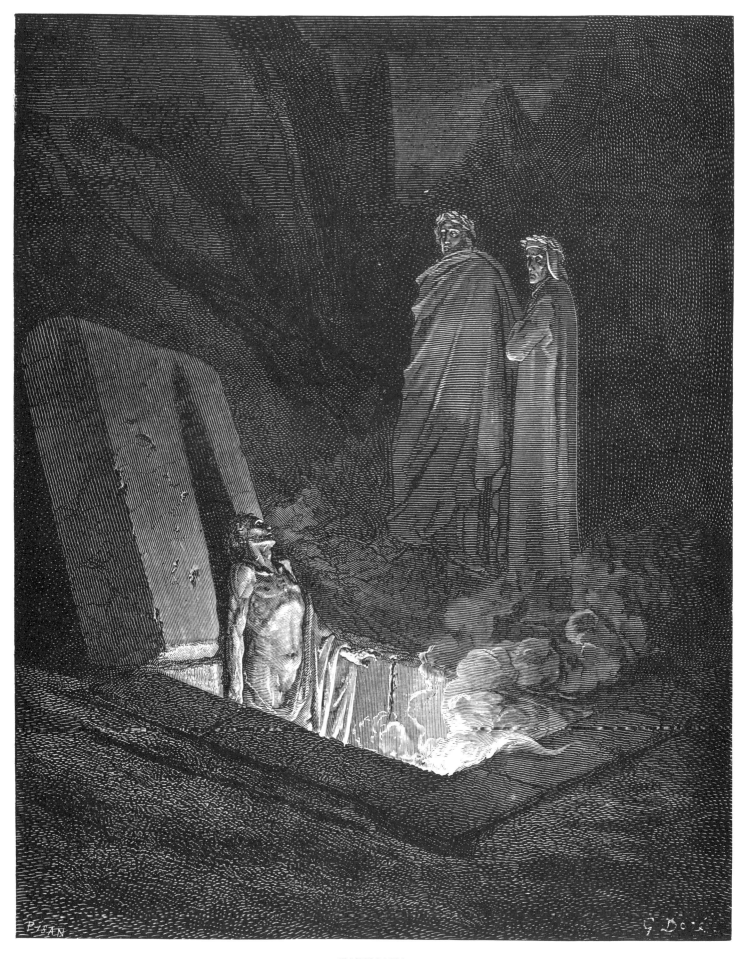

FARINATA

As soon as I was at the foot of his tomb, / Somewhat he eyed me, and, as if disdain-
ful, / Then asked of me, "Who were thine ancestors?" (*Inf.* X, 40–42).

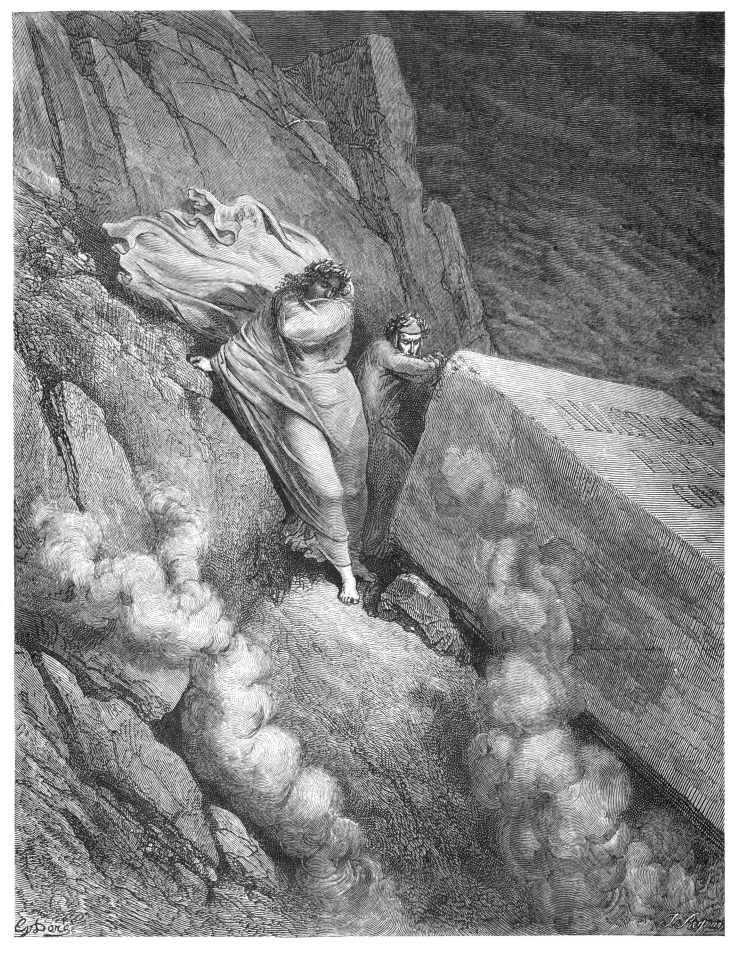

THE TOMB OF ANASTASIUS

We drew ourselves aside behind the cover / Of a great tomb, whereon I saw a
writing, / Which said: "Pope Anastasius I hold" (*Inf.* XI, 6–8).

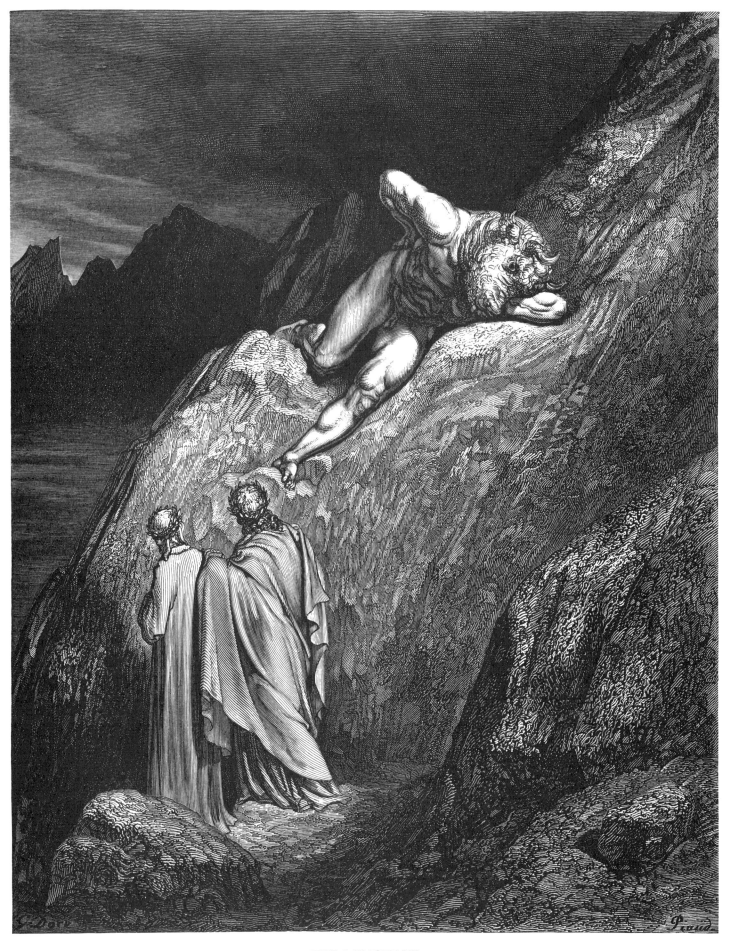

THE MINOTAUR

And on the border of the broken chasm / The infamy of Crete was stretched along, /
Who was conceived in the fictitious cow (*Inf.* XII, 11–13).

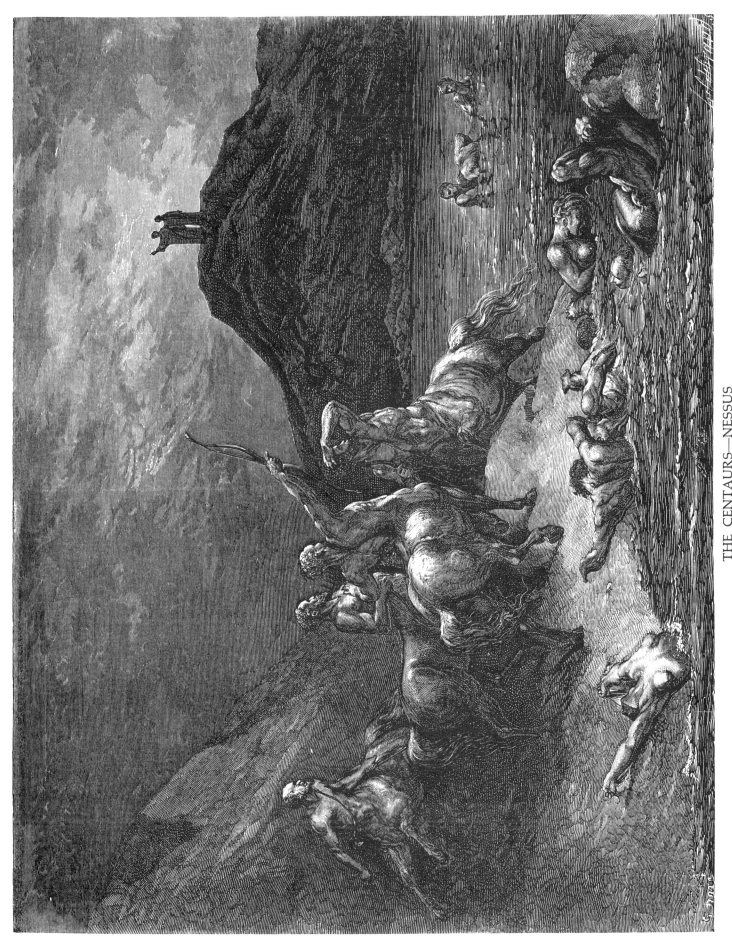

THE CENTAURS—NESSUS

Beholding us descend, each one stood still, / And from the squadron three detached
themselves, / With bows and arrows in advance selected (*Inf.* XII, 58–60).

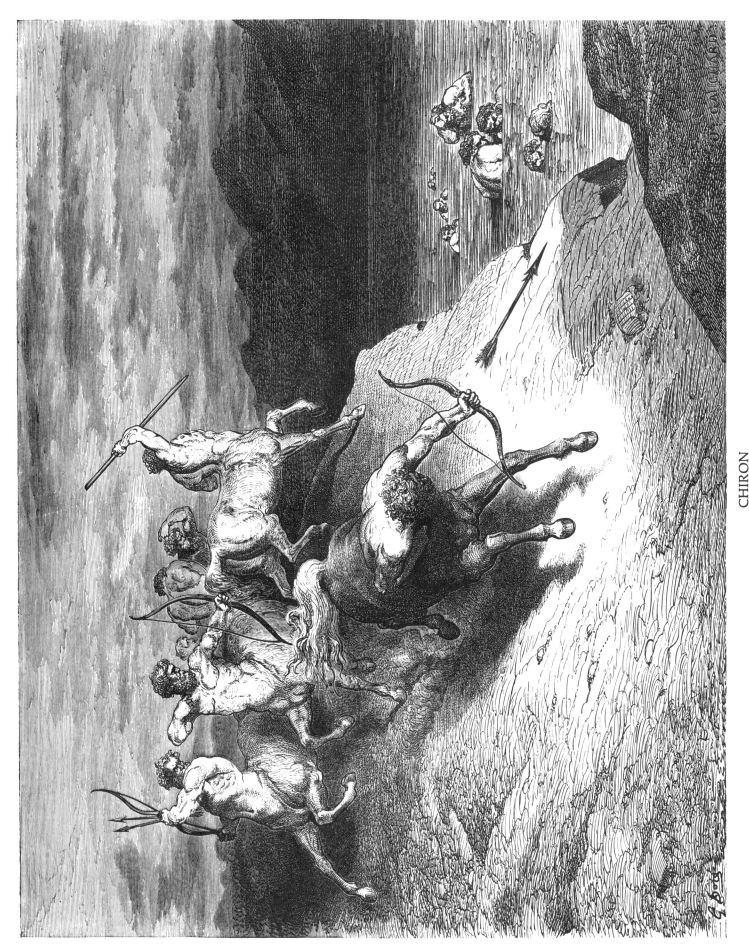

CHIRON

Chiron an arrow took, and with the notch / Backward upon his jaws he put his beard
(*Inf.* XII, 77, 78).

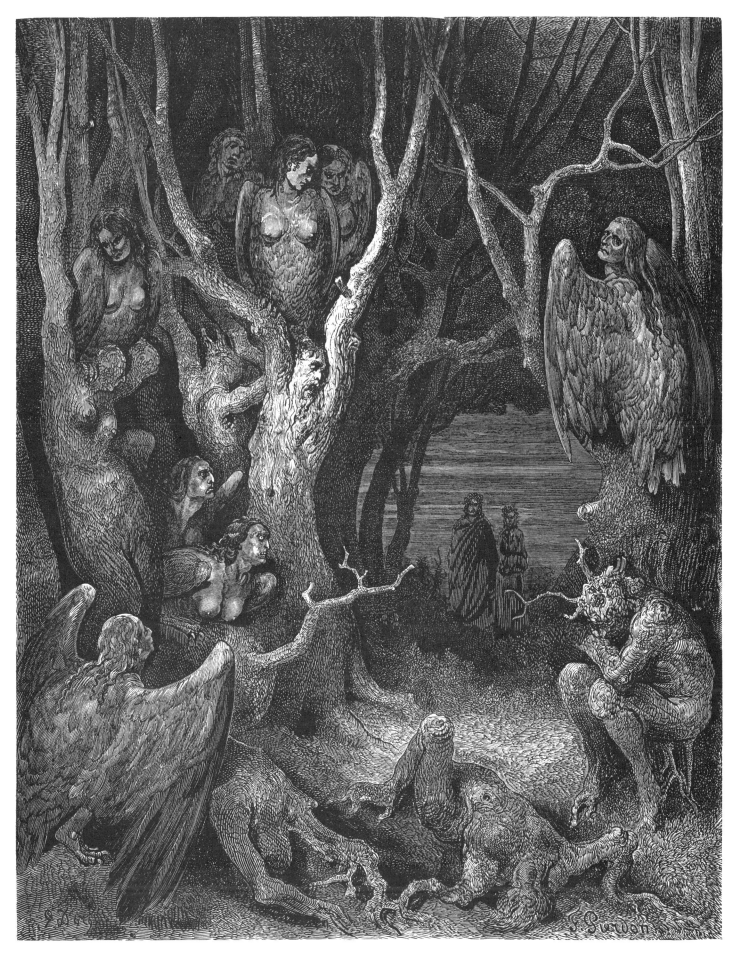

THE HARPIES' WOOD
They make laments upon the wondrous trees (*Inf.* XIII, 15).

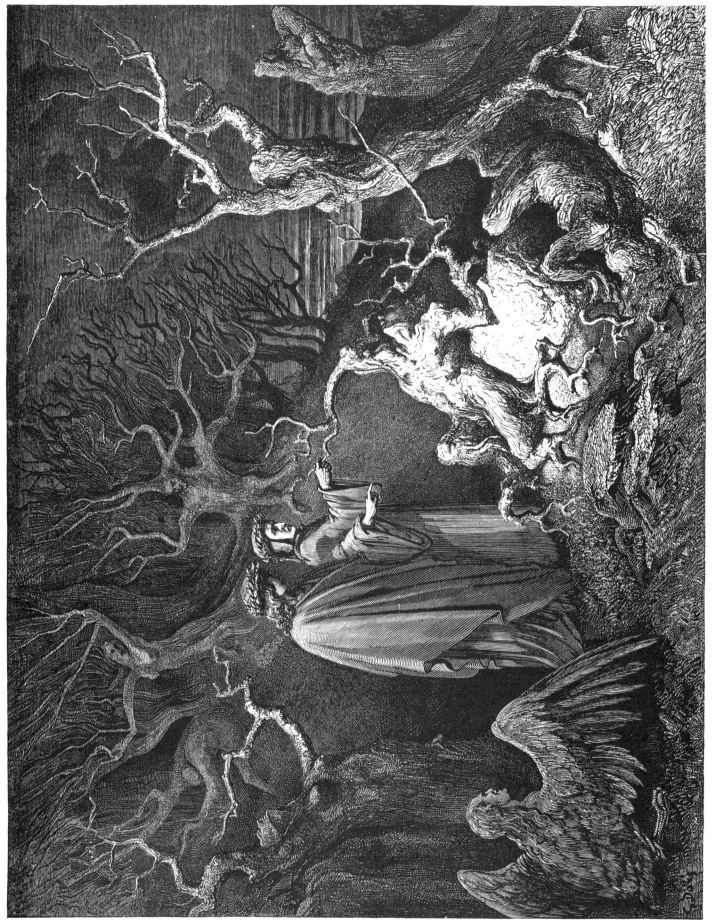

THE SUICIDES

Then stretched I forth my hand a little forward, / And plucked a branchlet off from a great thorn; / And the trunk cried, "Why dost thou mangle me?" (*Inf.* XIII, 31–33).

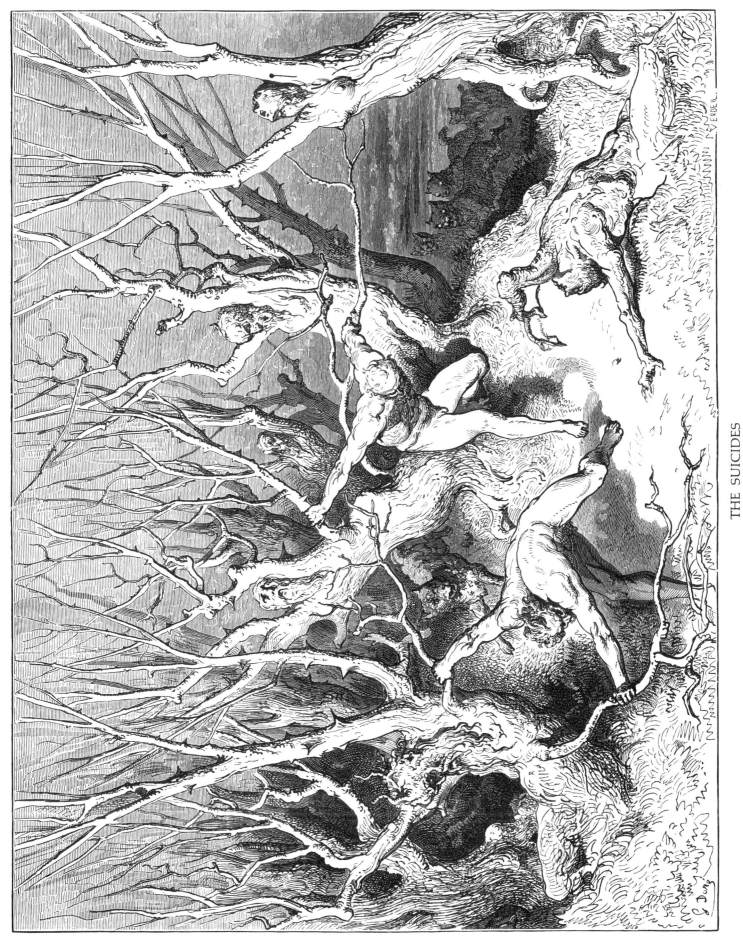

THE SUICIDES

And two behold! upon our left-hand side, / Naked and scratched, fleeing so furiously, / That of the forest every fan they broke (*Inf.* XIII, 115–117).

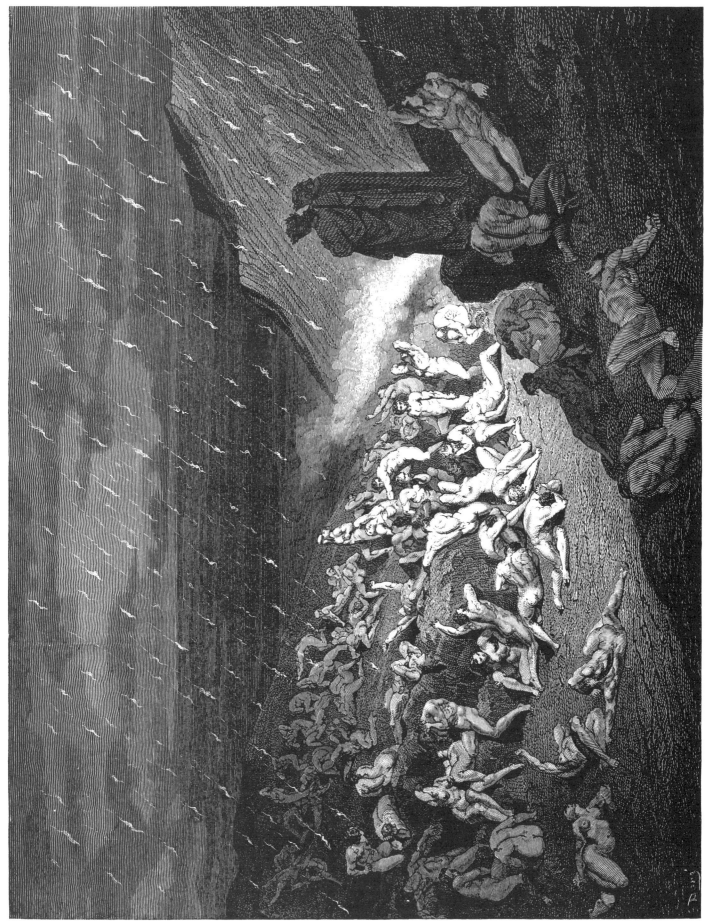

THE BLASPHEMERS—CAPANEUS

O'er all the sand-waste, with a gradual fall, / Were raining down dilated flakes of fire (*Inf.* XIV, 28, 29).

BRUNETTO LATINI

"Are you here, Ser Brunetto?" (*Inf.* XV, 30).

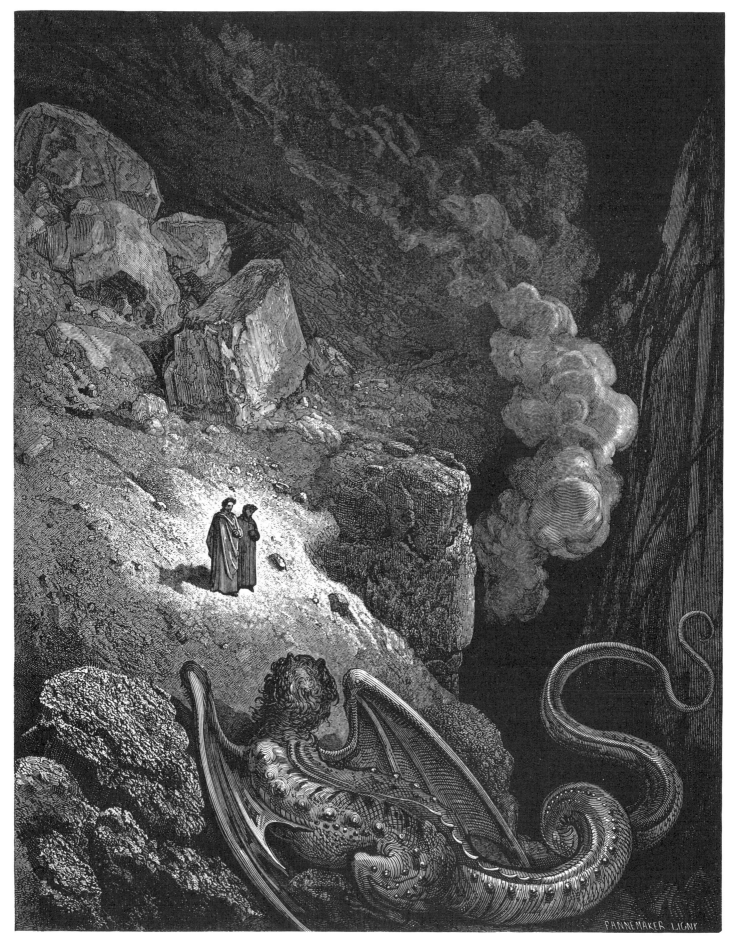

GERYON—SYMBOL OF DECEIT
And that uncleanly image of deceit / Came up and thrust ashore its head and bust
(*Inf.* XVII, 7, 8).

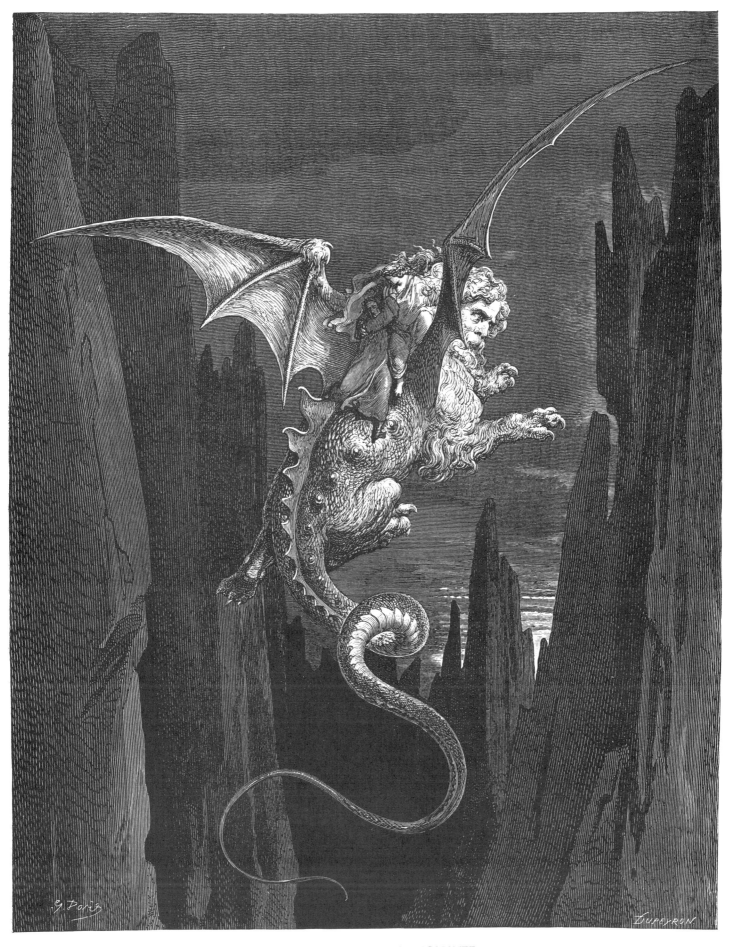

THE DESCENT ON THE MONSTER
Onward he goeth, swimming slowly, slowly; / Wheels and descends (*Inf.* XVII, 115, 116).

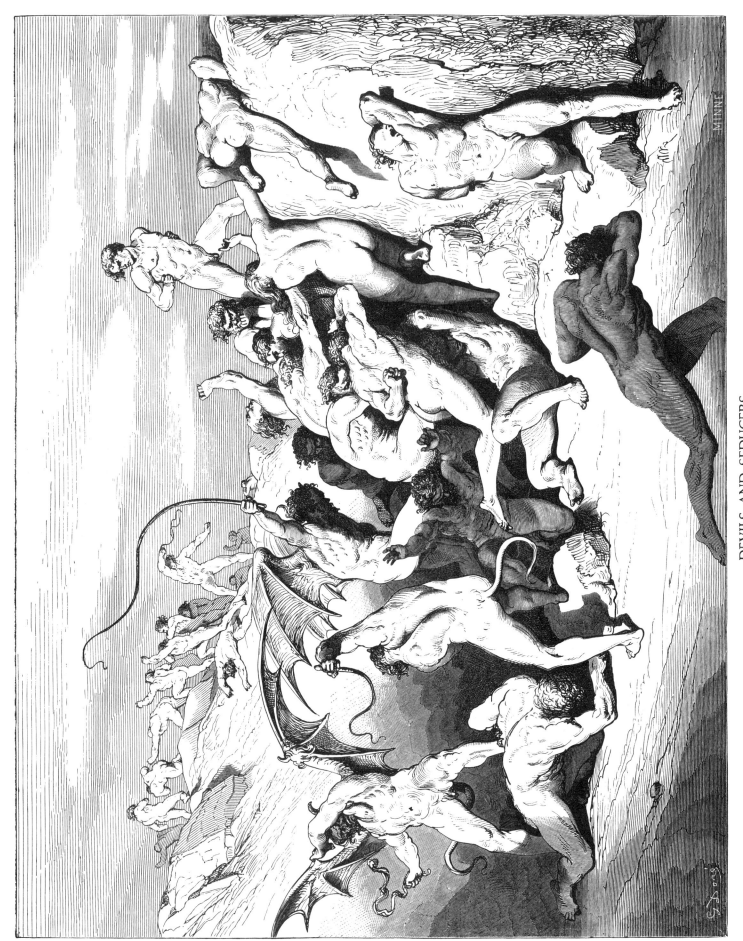

DEVILS AND SEDUCERS

Ah me! how they did make them lift their legs / At the first blows! (*Inf.* XVIII, 37, 38).

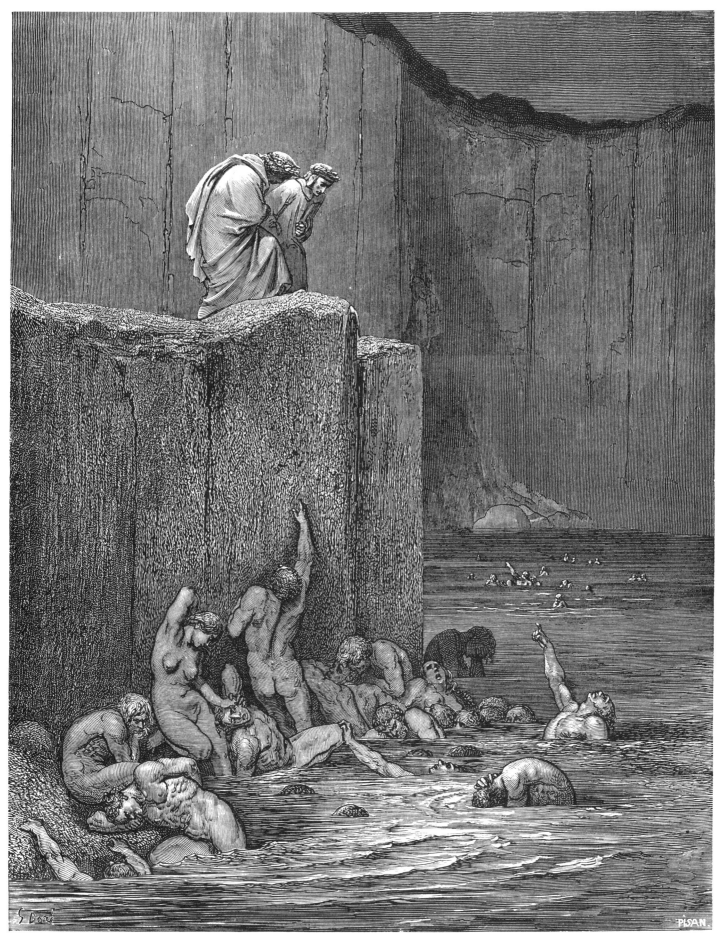

PARAMOURS AND FLATTERERS
I saw a people smothered in a filth / That out of human privies seemed to flow
(*Inf.* XVIII, 113, 114).

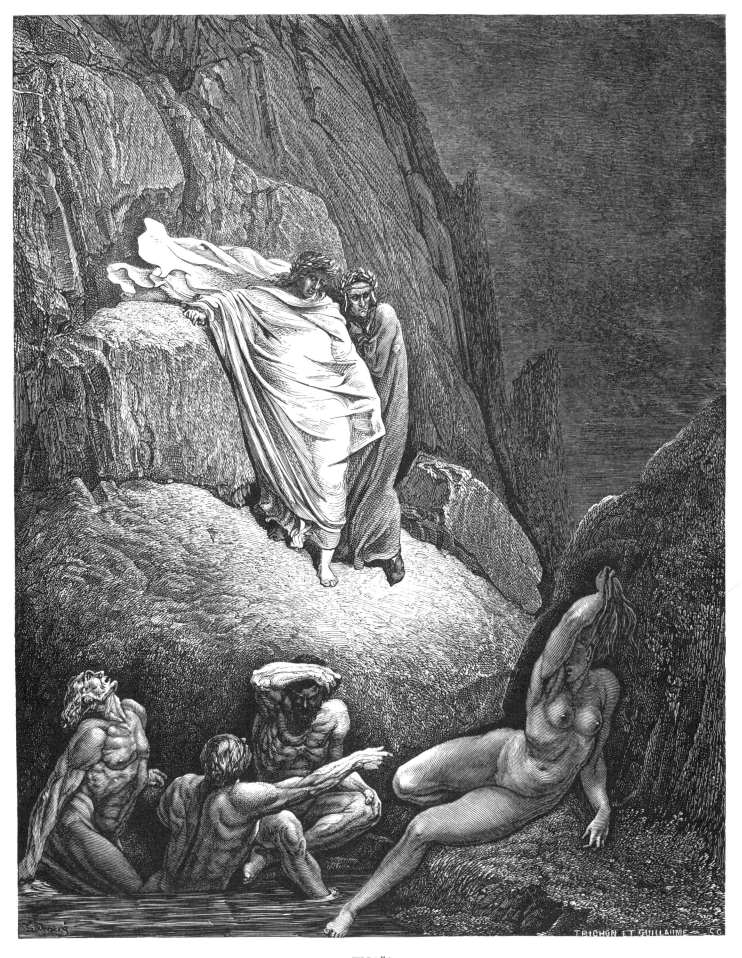

THAÏS
"Thaïs the harlot is it, who replied / Unto her paramour, when he said, 'Have I /
Great gratitude from thee?' — 'Nay, marvellous' " (*Inf.* XVIII, 133–135).

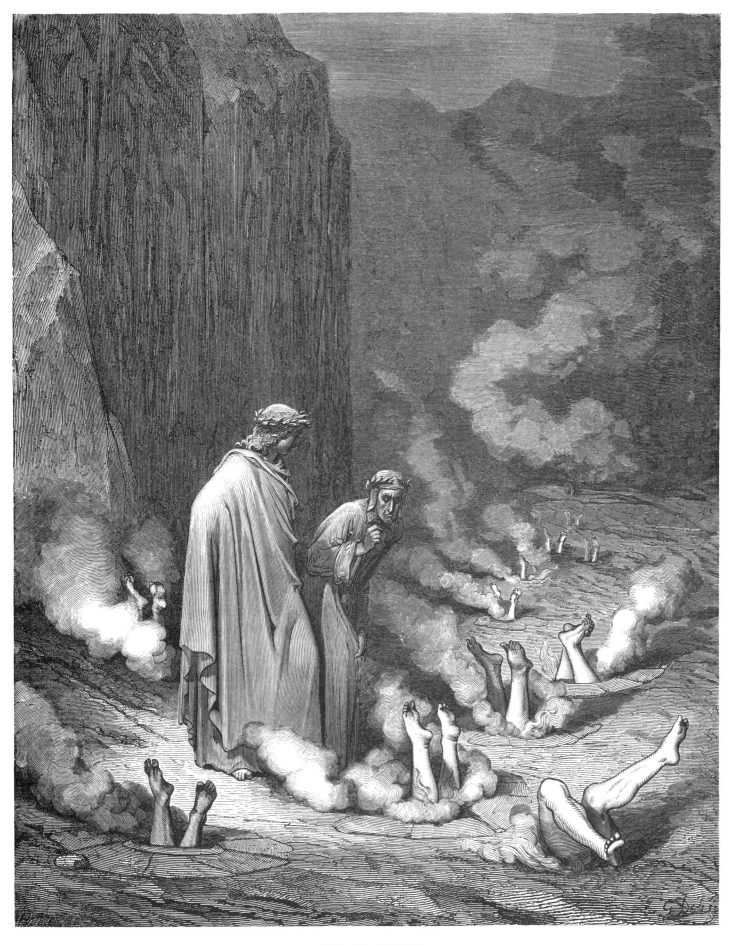

THE SIMONISTS

"O doleful soul, implanted like a stake," / To say began I, "if thou canst, speak out"

(*Inf.* XIX, 47, 48).

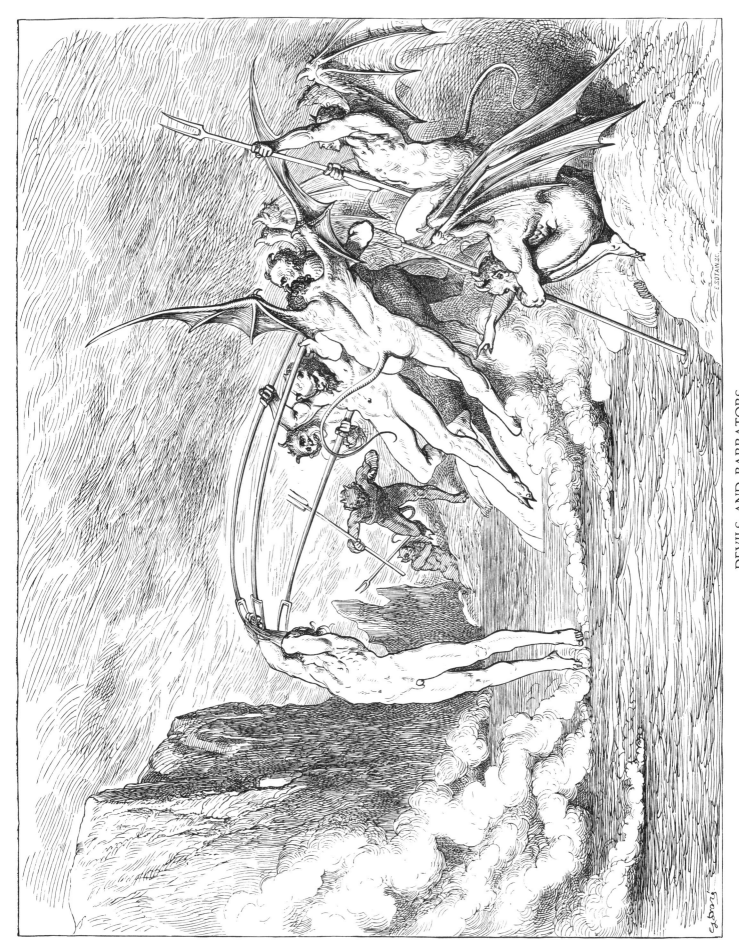

DEVILS AND BARRATORS
They seized him then with more than a hundred rakes (*Inf.* XXI, 52).

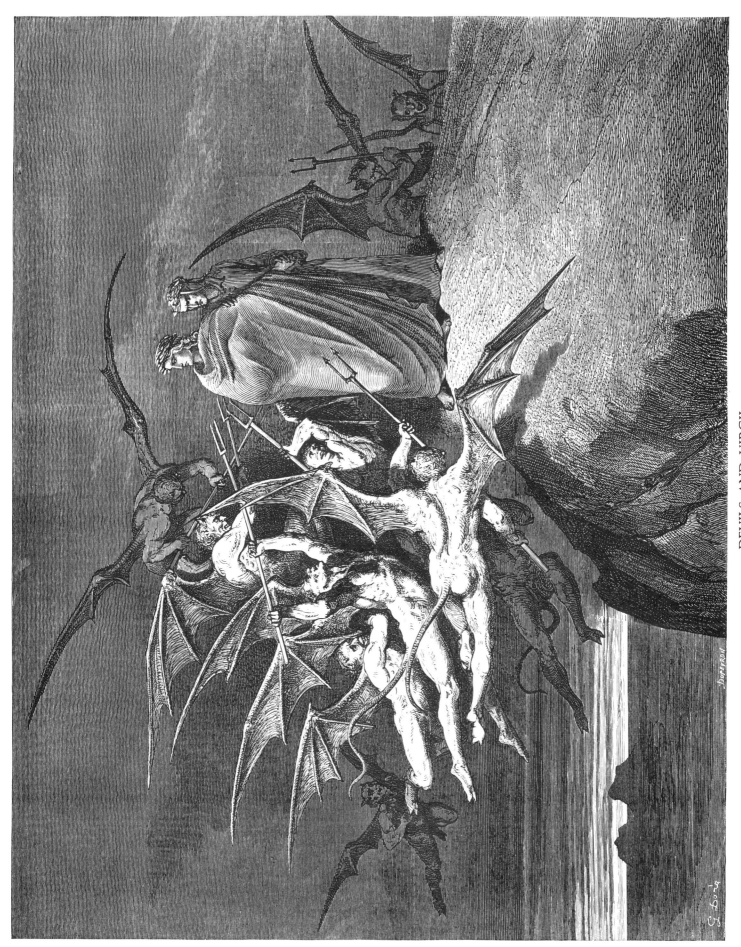

DEVILS AND VIRGIL

But he cried out: "Be none of you malignant!" (*Inf.* XXI, 72).

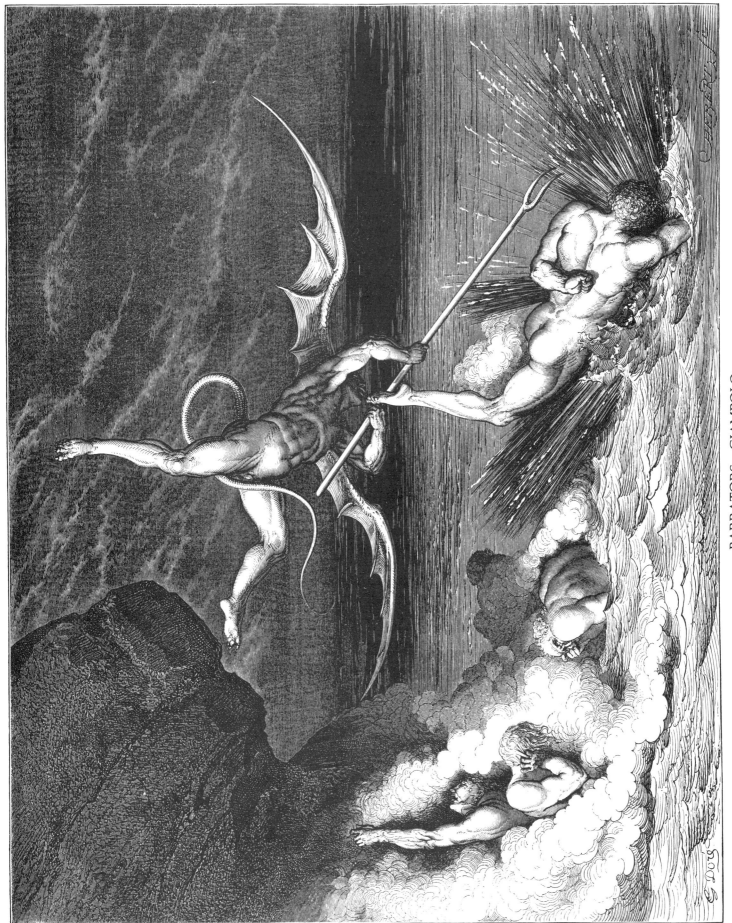

BARRATORS—GIAMPOLO
Therefore he moved, and cried: "Thou art o'ertaken" (*Inf.* XXII, 126).

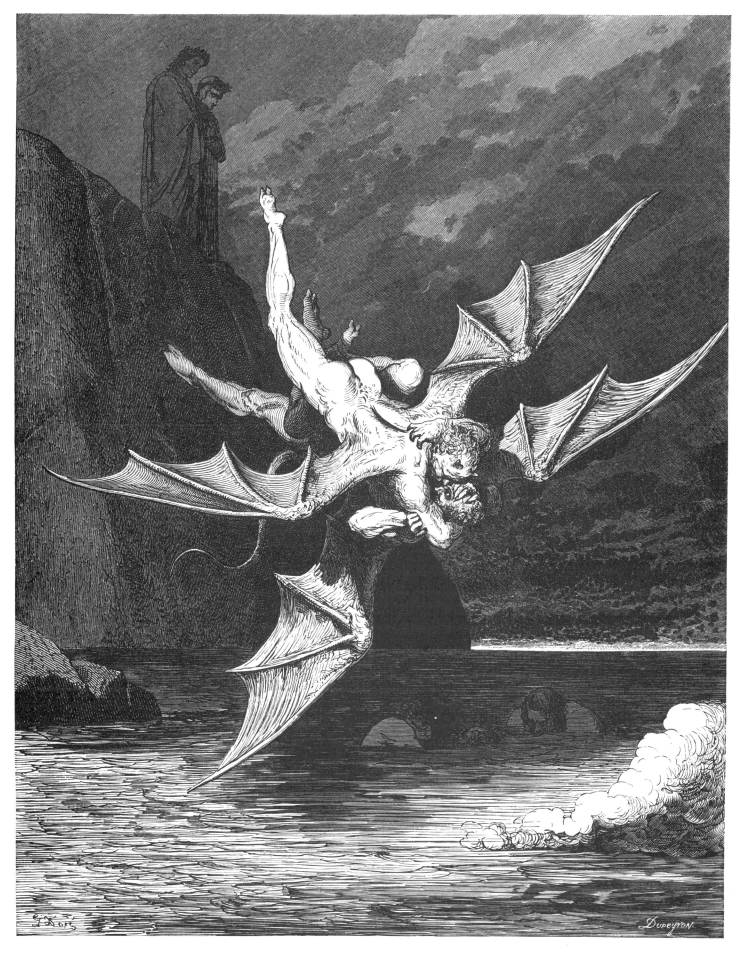

ALICHINO AND CALCABRINA

But sooth the other was a doughty sparhawk / To clapperclaw him well; and both
of them / Fell in the middle of the boiling pond (*Inf.* XXII, 139–141).

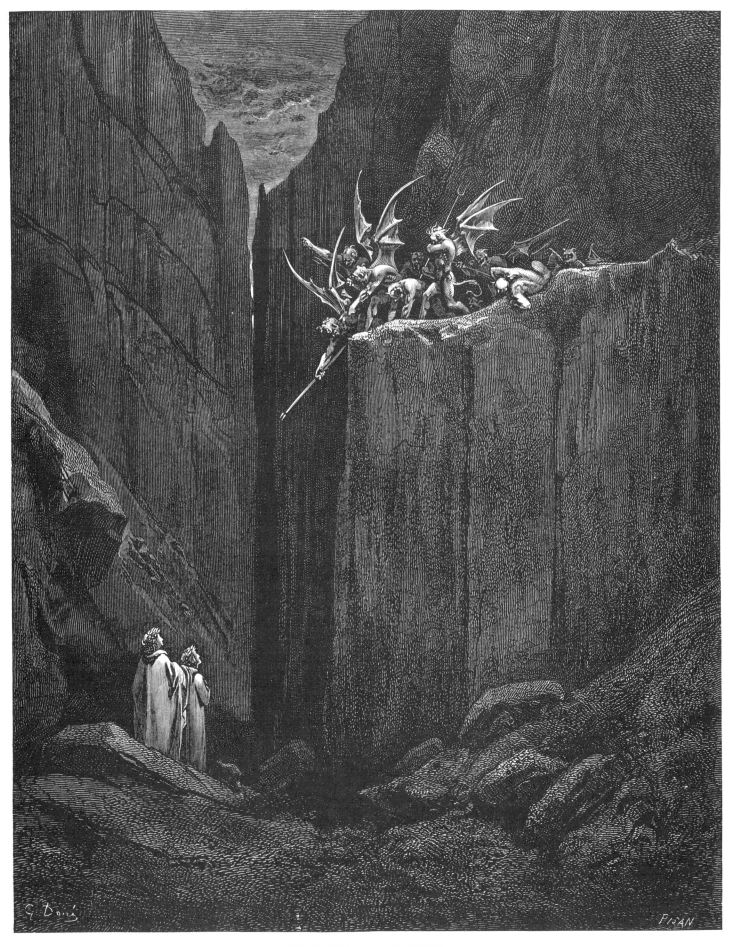

TUMULT AND ESCAPE
Hardly the bed of the ravine below / His feet had reached, ere they had reached the
hill / Right over us (*Inf.* XXIII, 52–54).

THE HYPOCRITES

They had on mantles with the hoods low down / Before their eyes (*Inf.* XXIII, 61, 62).

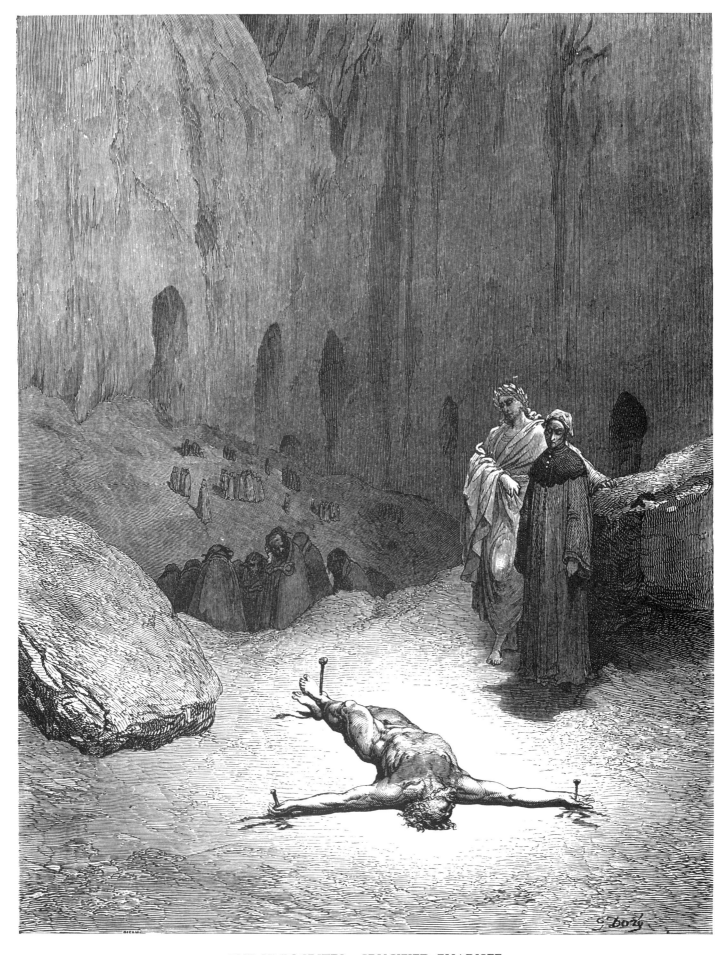

THE HYPOCRITES—CRUCIFIED PHARISEE
"This transfixed one, whom thou seest, / Counselled the Pharisees that it was meet /
To put one man to torture for the people (*Inf.* XXIII, 115–117).

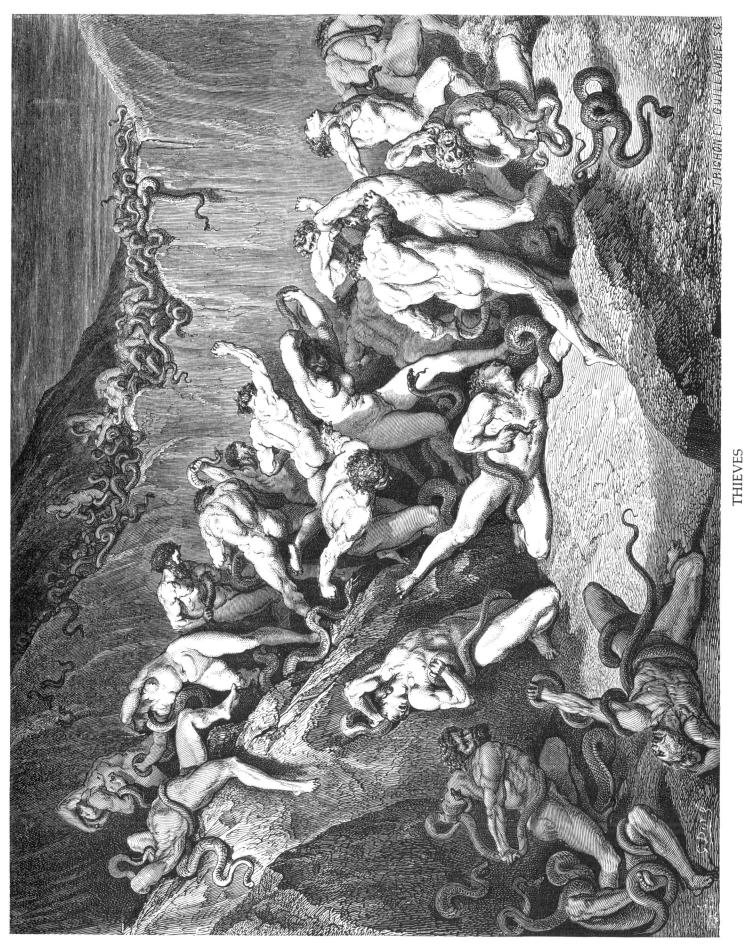

THIEVES

Among this cruel and most dismal throng / People were running naked and affrighted

(*Inf.* XXIV, 91, 92).

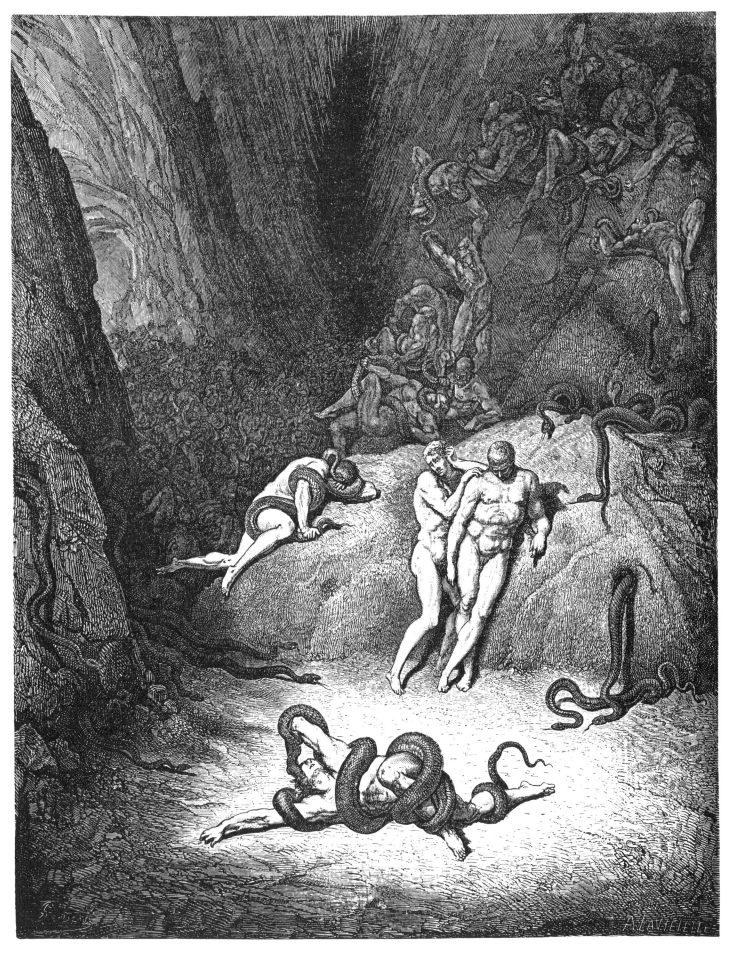

TRANSFORMATION INTO SNAKES
"O me, Agnello, how thou changest! / Behold, thou now art neither two nor one"
(*Inf.* XXV, 68, 69).

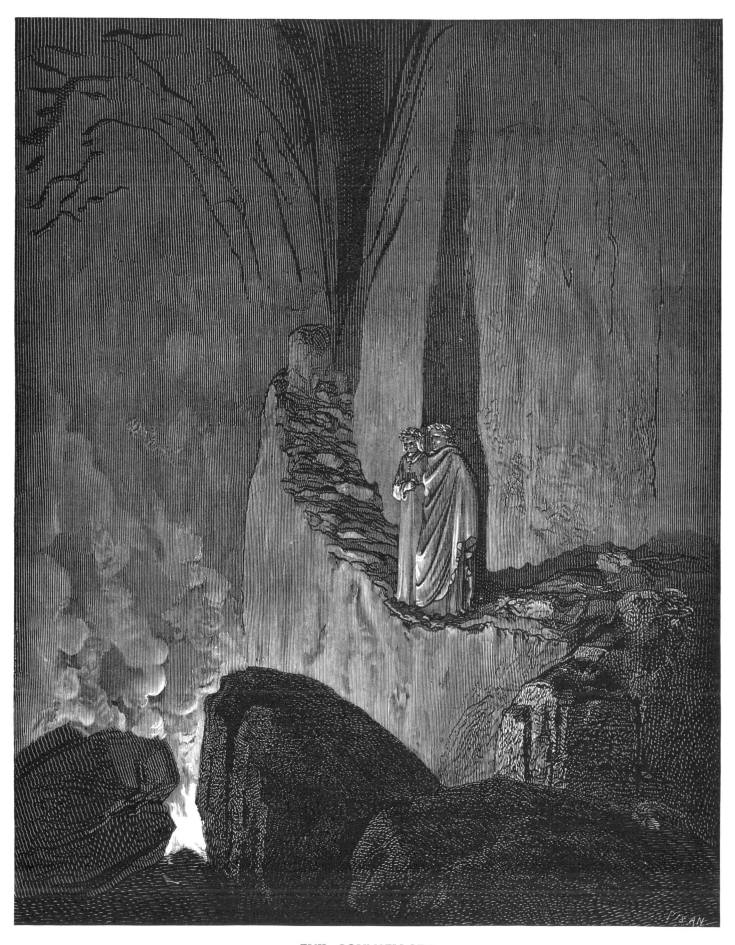

EVIL COUNSELLORS
"Within the fires the spirits are; / Each swathes himself with that wherewith he burns" (*Inf.* XXVI, 47, 48).

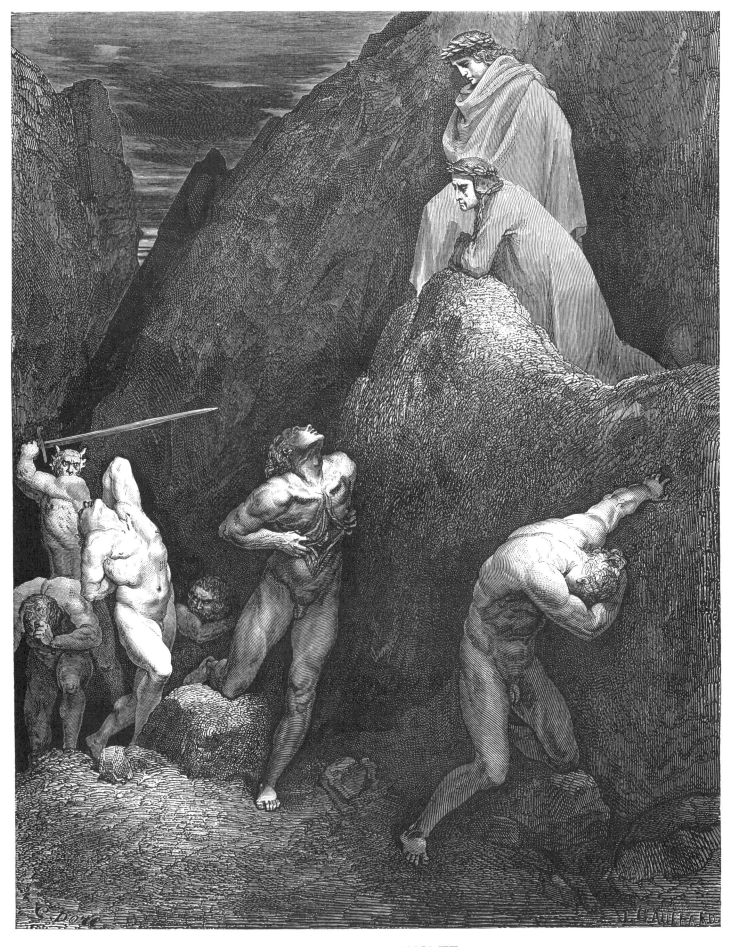

SCHISMATICS—MAHOMET
He looked at me, and opened with his hands / His bosom, saying: "See now how I
rend me" (*Inf.* XXVIII, 29, 30).

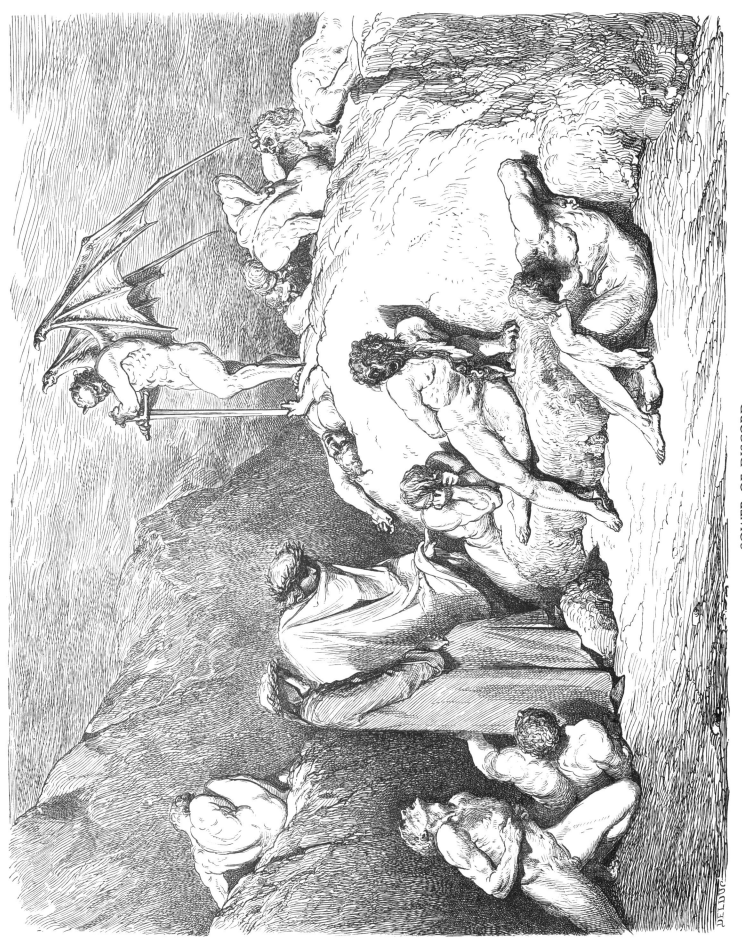

SOWER OF DISCORD

"Call to remembrance Pier da Medicina" (*Inf.* XXVIII, 73).

57

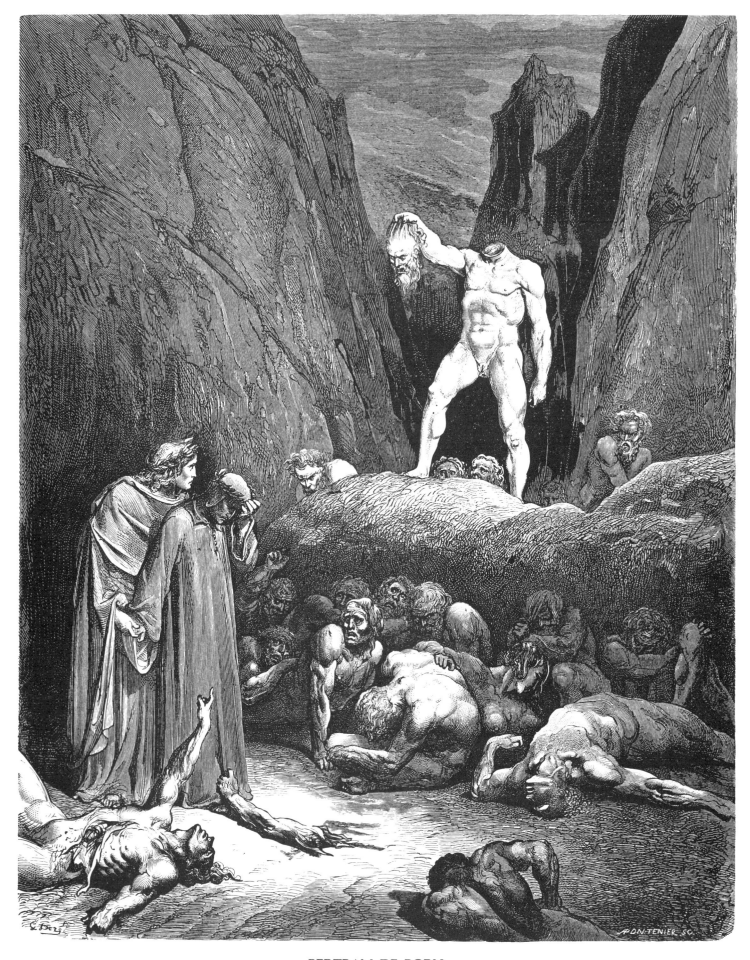

BERTRAM DE BORN
By the hair it held the head dissevered, / Hung from the hand in fashion of a lantern,
/ And that upon us gazed and said: "O me!" (*Inf.* XXVIII, 121–123).

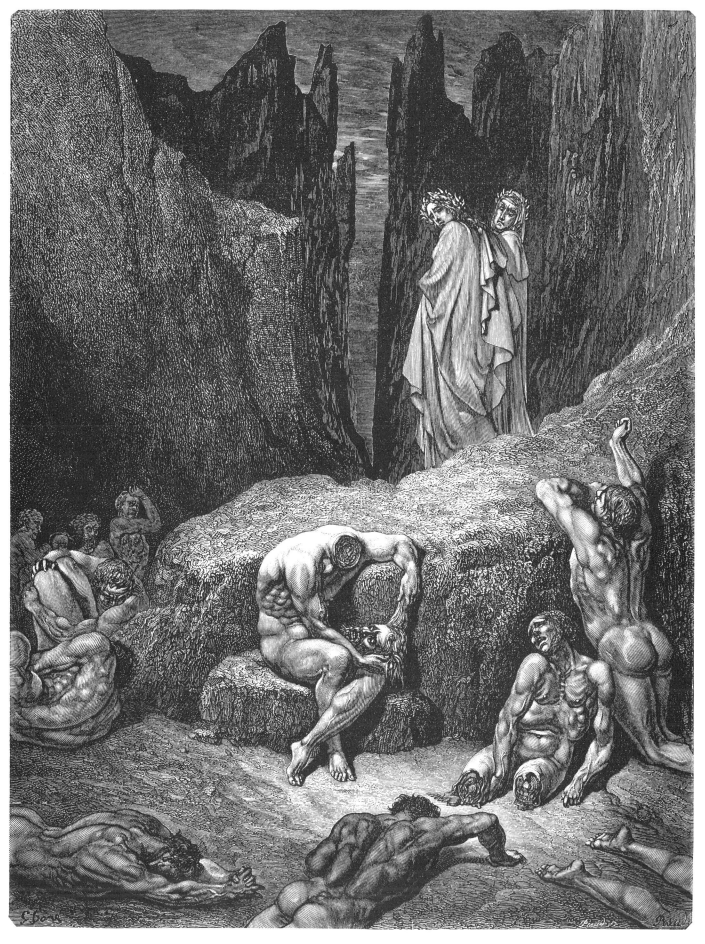

GERI DEL BELLO

But said Virgilius: "What dost thou still gaze at? / Why is thy sight still riveted
down there / Among the mournful, mutilated shades?" (*Inf.* XXIX, 4–6).

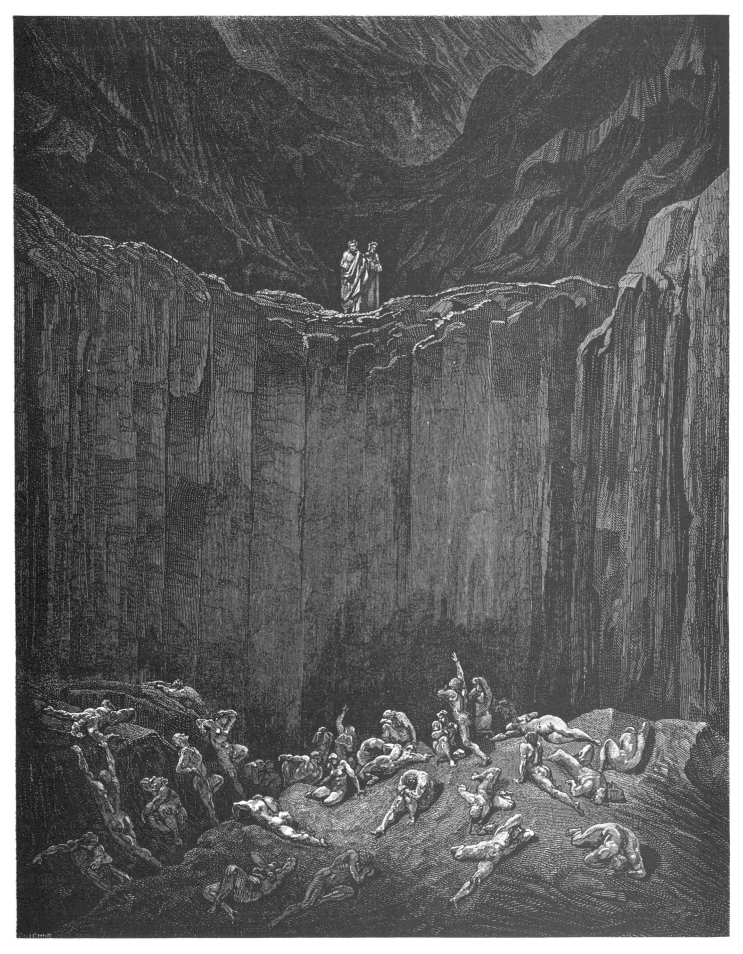

FORGERS

Such a stench came from it / As from putrescent limbs is wont to issue (*Inf.* XXIX, 50, 51).

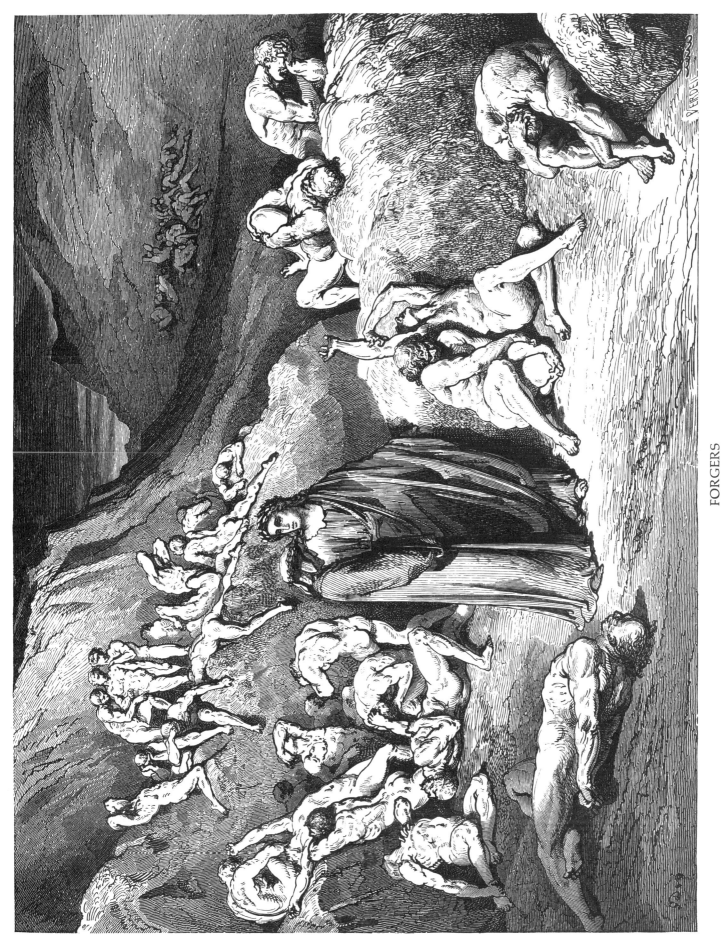

FORGERS

Every one was plying fast the bite / Of nails upon himself, for the great rage / Of itching which no other succor had (*Inf.* XXIX, 79–81).

FORGERS

"That mad sprite is Gianni Schicchi, / And raving goes thus harrying other people"
(Inf. XXX, 32, 33).

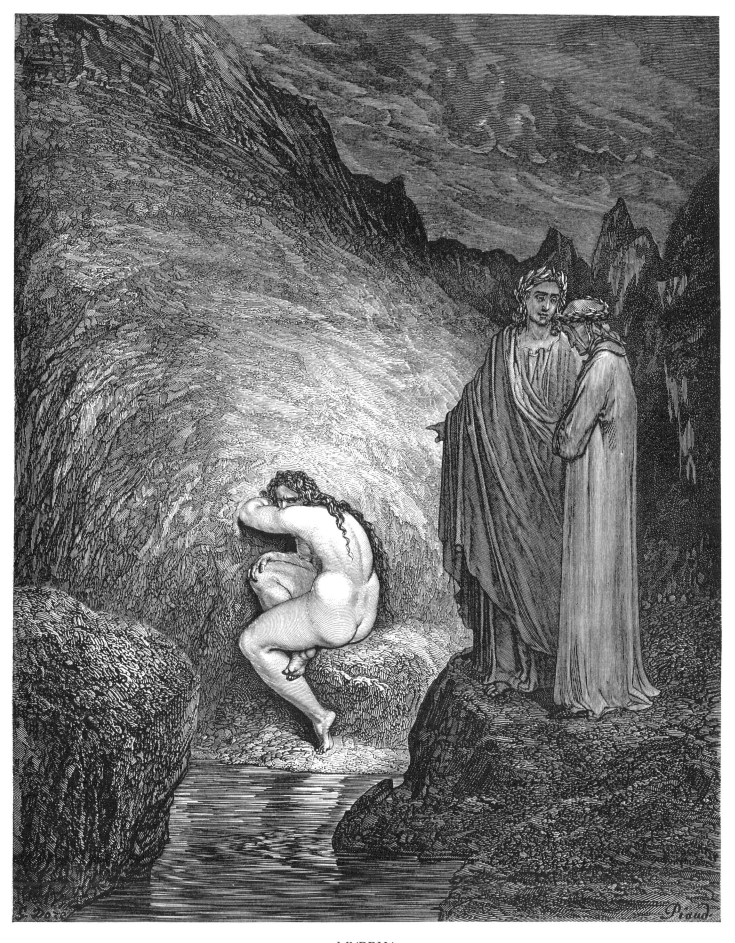

MYRRHA
"That is the ancient ghost / Of the nefarious Myrrha, who became / Beyond all
rightful love her father's lover" (*Inf.* XXX, 37–39).

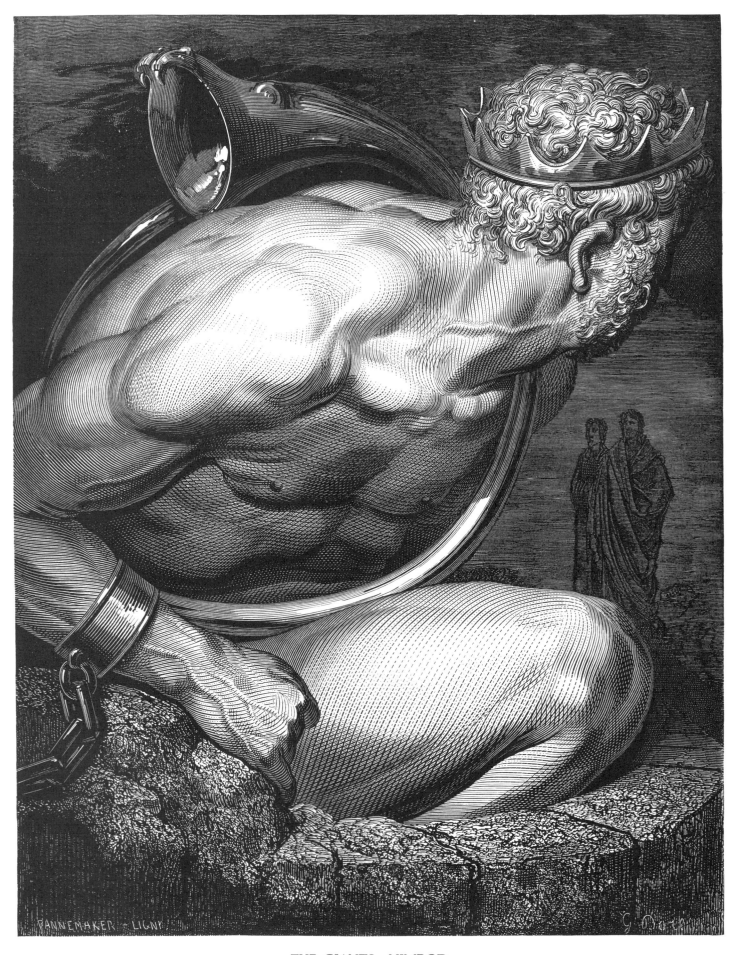

THE GIANTS—NIMROD
"Soul idiotic, / Keep to thy horn, and vent thyself with that, / When wrath or other passion touches thee" (*Inf.* XXXI, 70–72).

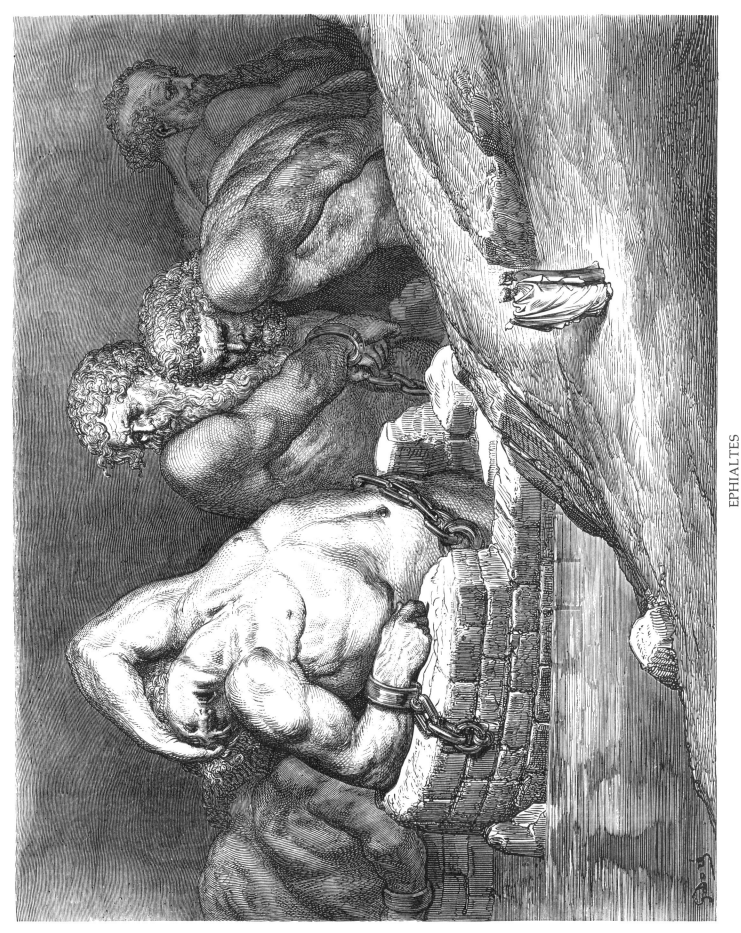

EPHIALTES

"This proud one wished to make experiment / Of his own power against the
Supreme Jove" (*Inf.* XXXI, 91, 92).

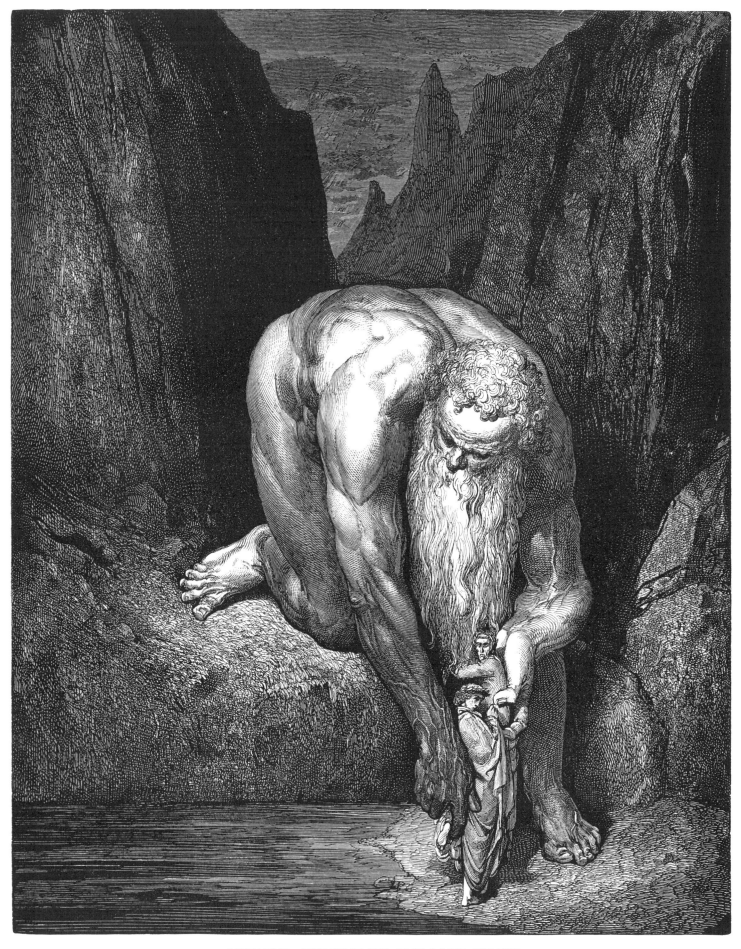

ANTAEUS—DESCENT TO THE LAST CIRCLE
But lightly in the abyss, which swallows up / Judas with Lucifer, he put us down
(*Inf.* XXXI, 142, 143).

COCYTUS—TRAITORS

"Look how thou steppest! / Take heed thou do not trample with thy feet / The heads
of the tired, miserable brothers!" (*Inf.* XXXII, 19–21).

TRAITORS—BOCCA DEGLI ABATI

Then by the scalp behind I seized upon him, / And said: "It must needs be thou
name thyself, / Or not a hair remain upon thee here" (*Inf*. XXXII, 97–99).

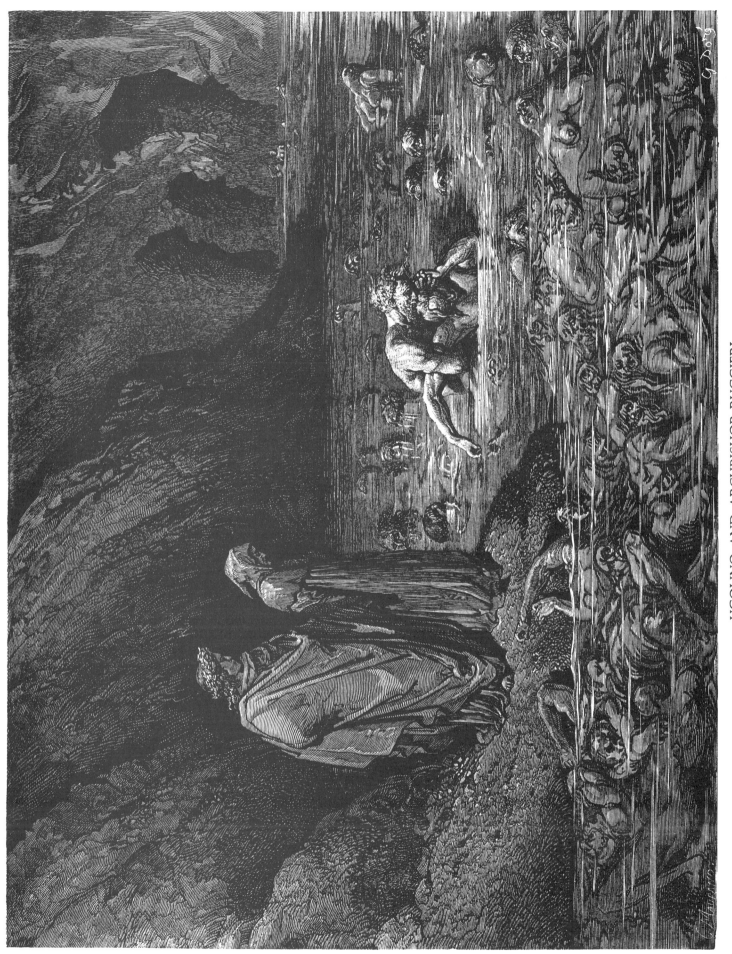

UGOLINO AND ARCHBISHOP RUGGIERI

The uppermost on the other set his teeth, / There where the brain is to the nape
united (*Inf.* XXXII, 128, 129).

UGOLINO

"I calmed me then, not to make them more sad" (*Inf.* XXXIII, 64).

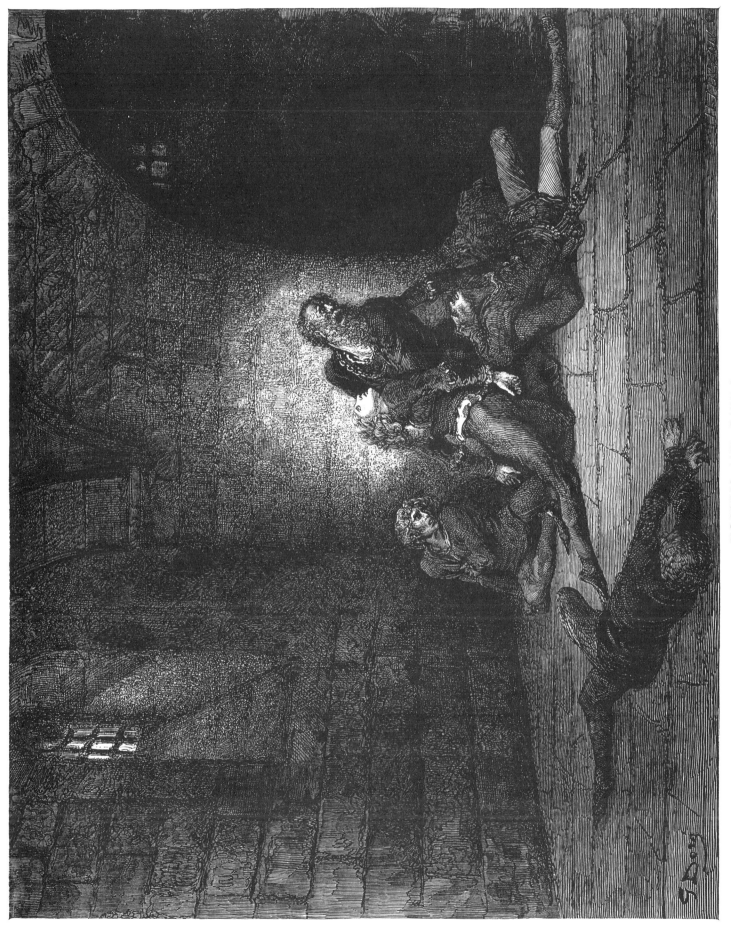

UGOLINO AND GADDO

"Gaddo / Threw himself down outstretched before my feet, / Saying, 'My father, why dost thou not help me?'" (*Inf.* XXXIII, 67–69).

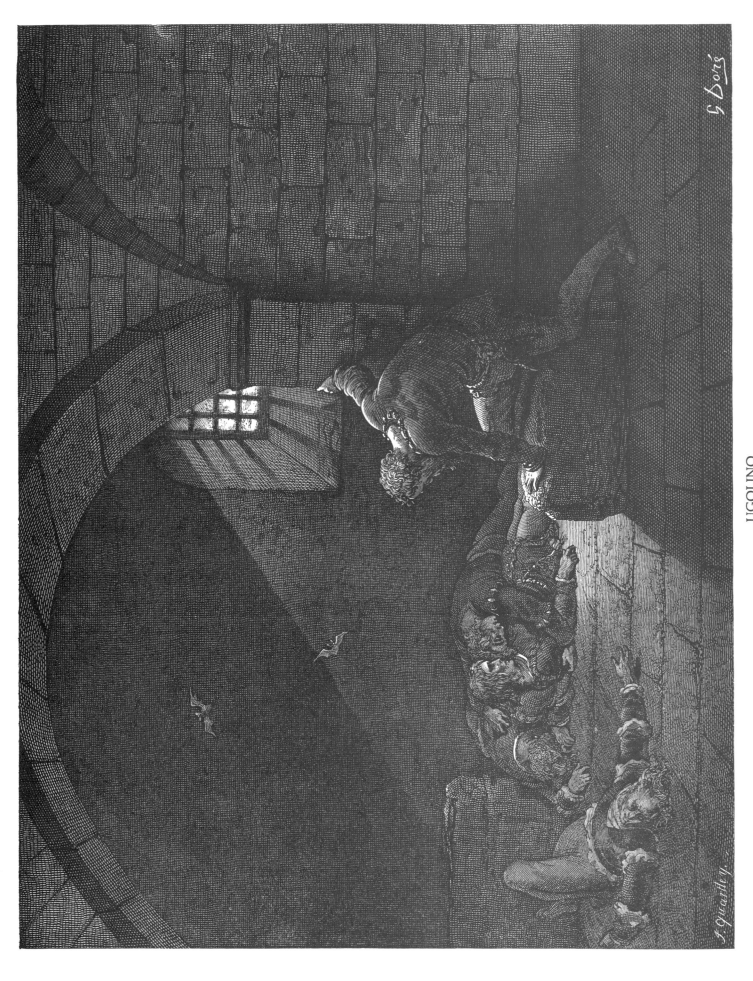

UGOLINO

"Then hunger did what sorrow could not do" (*Inf.* XXIII, 75).

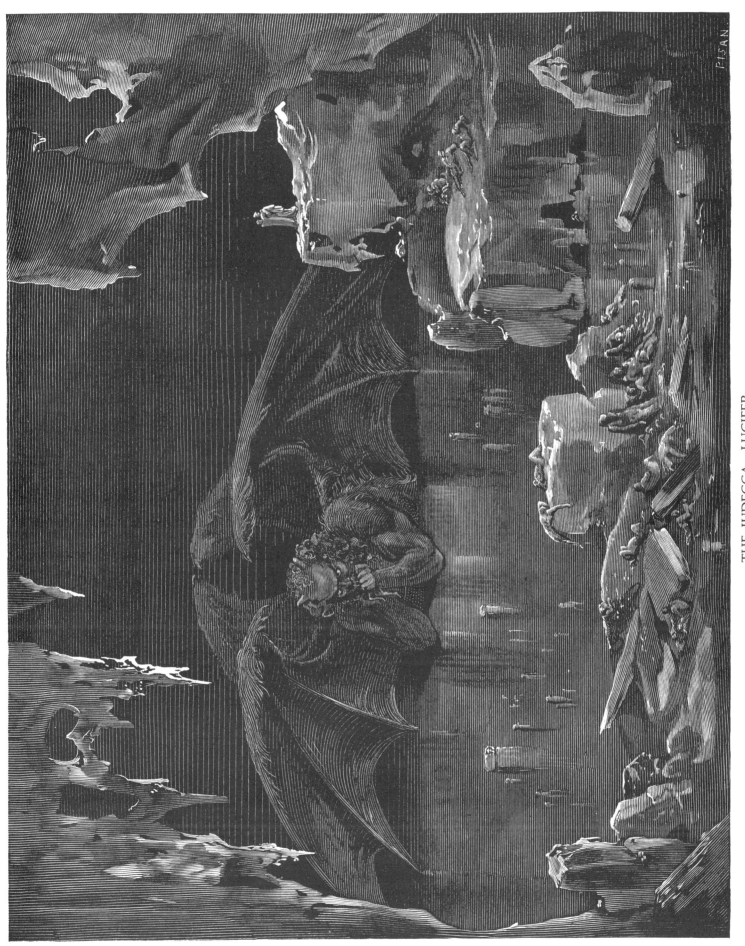

THE JUDECCA—LUCIFER

"Behold Dis, and behold the place / Where thou with fortitude must arm thyself"
(*Inf.* XXXIV, 20, 21).

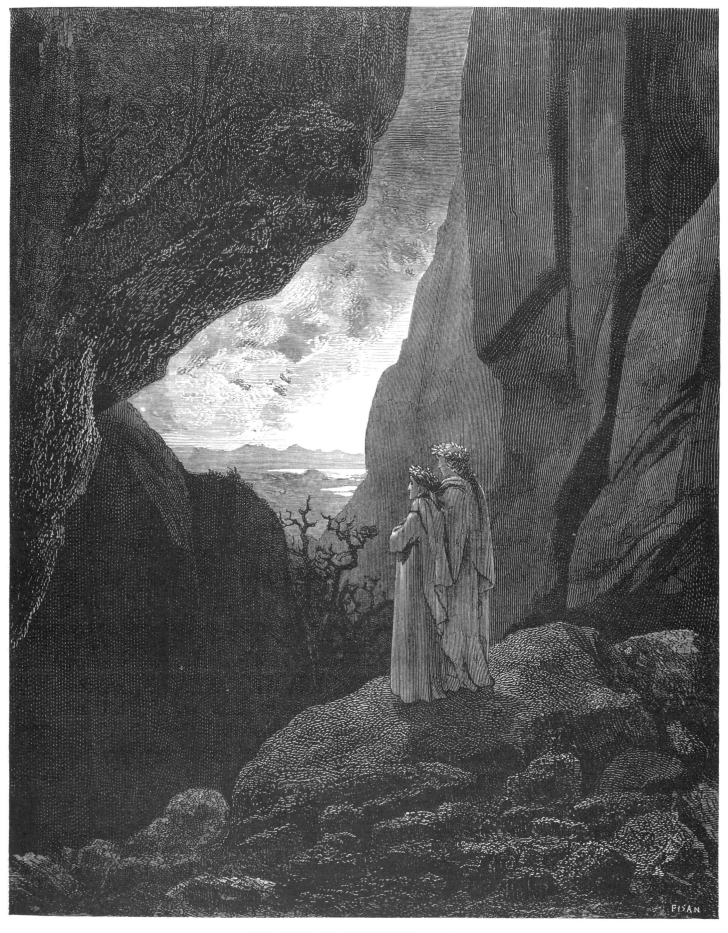

THE WAY TO THE UPPER WORLD
The Guide and I into that hidden road / Now entered, to return to the bright world
(*Inf.* XXXIV, 133, 134).

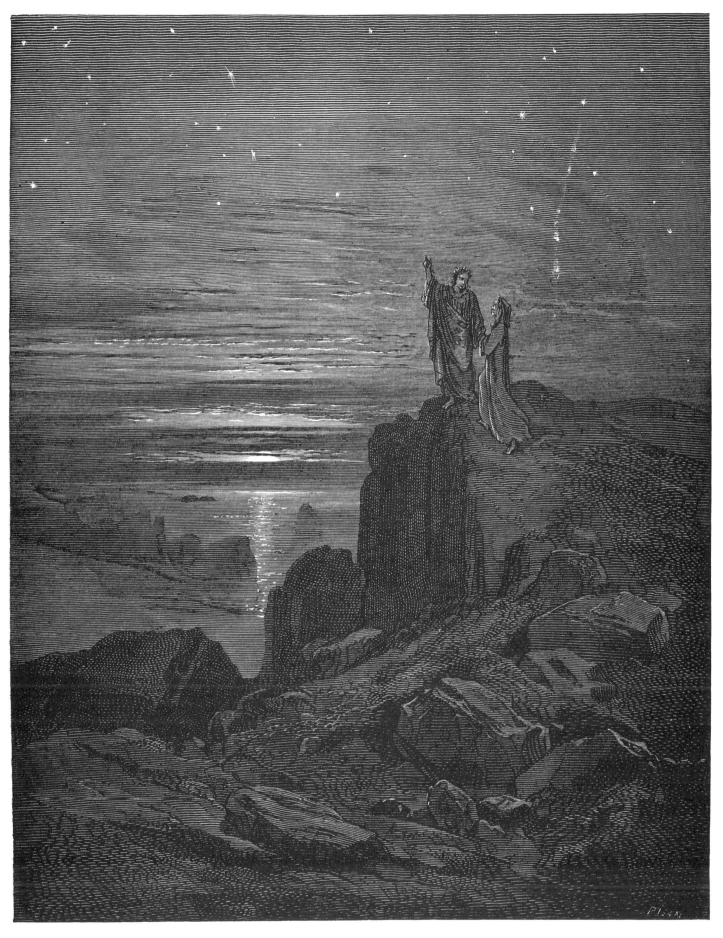

THE POETS EMERGE FROM HELL
Thence we came forth to rebehold the stars (*Inf.* XXXIV, 139).

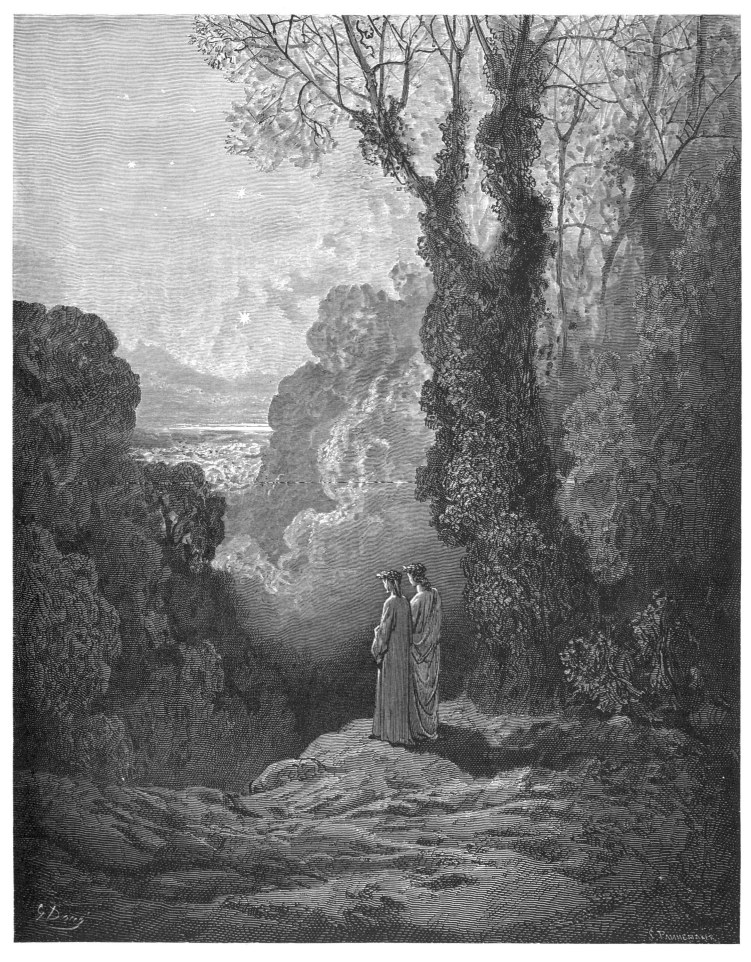

VENUS

The beauteous planet, that to love incites, / Was making all the orient to laugh,
/ Veiling the Fishes that were in her escort (*Purg.* I, 19–21).

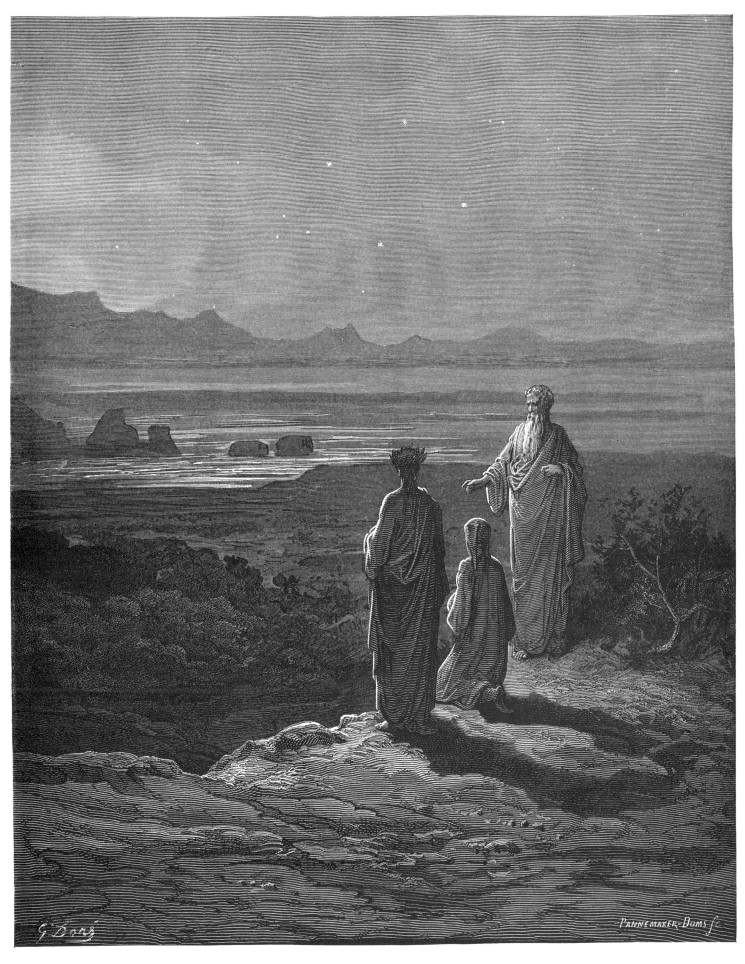

CATO OF UTICA

I saw beside me an old man alone, / Worthy of so much reverence in his look, / That more owes not to father any son (*Purg.* I, 31–33).

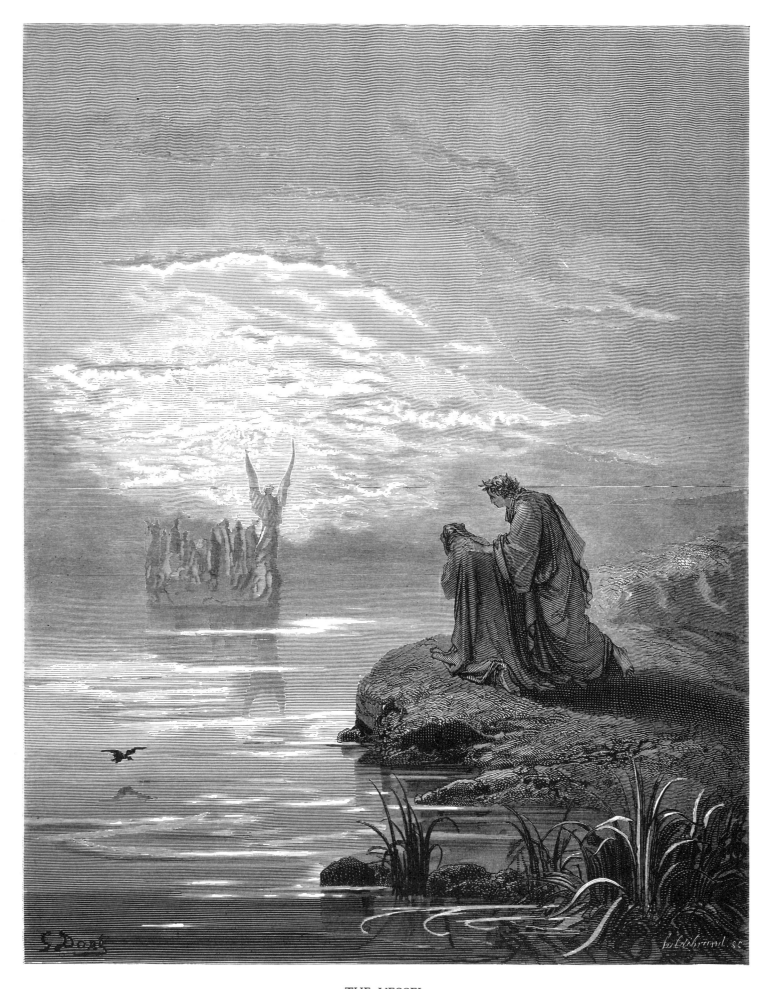

THE VESSEL
But when he clearly recognized the pilot, / He cried: "Make haste, make haste to
bow the knee! / Behold the angel of God!" (*Purg.* II, 27–29).

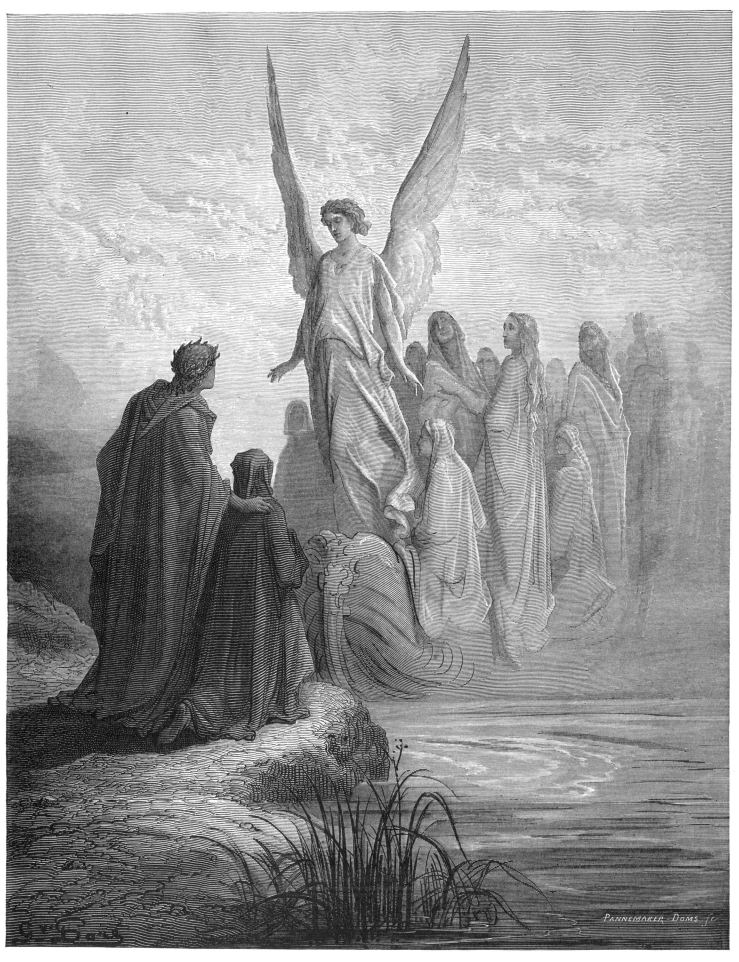

THE CELESTIAL PILOT
Beatitude seemed written in his face (*Purg.* II, 44).

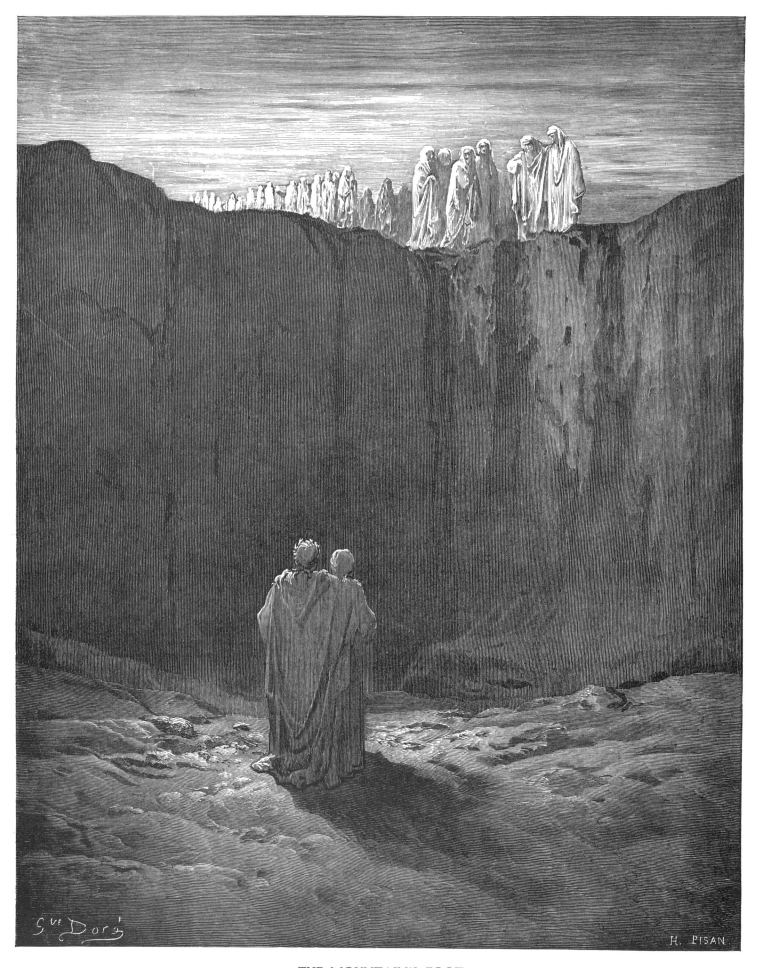

THE MOUNTAIN'S FOOT

On the left hand appeared to me a throng / Of souls, that moved their feet in our
direction, / And did not seem to move (*Purg.* III, 58–60).

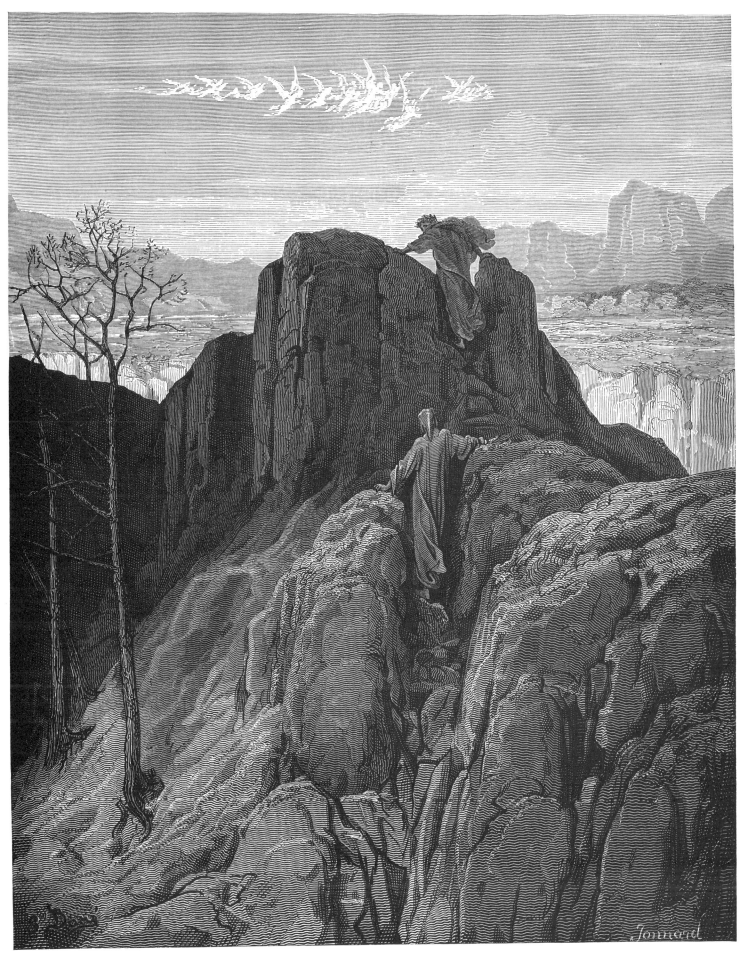

THE ASCENT
We mounted upward through the rifted rock, / And on each side the border pressed
upon us (*Purg.* IV, 31, 32).

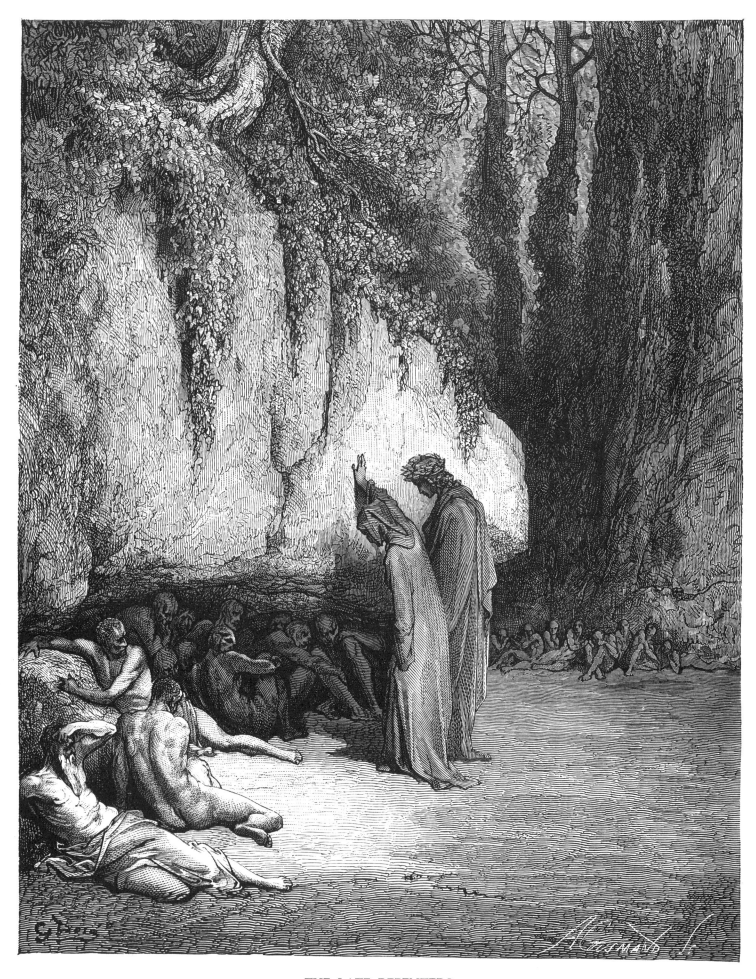

THE LATE REPENTERS
There were persons there / Who in the shadow stood behind the rock, / As one
through indolence is wont to stand (*Purg.* IV, 103–105).

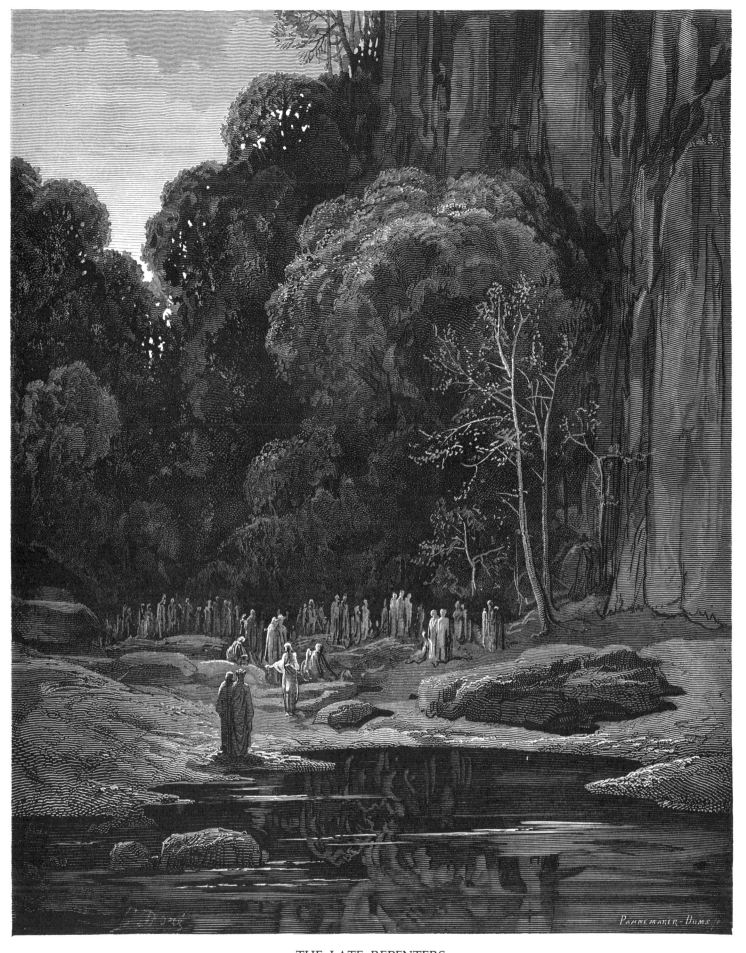

THE LATE REPENTERS

Meanwhile along the mountain-side across / Came people in advance of us a little,
/ Singing the Miserere verse by verse (*Purg.* V, 22–24).

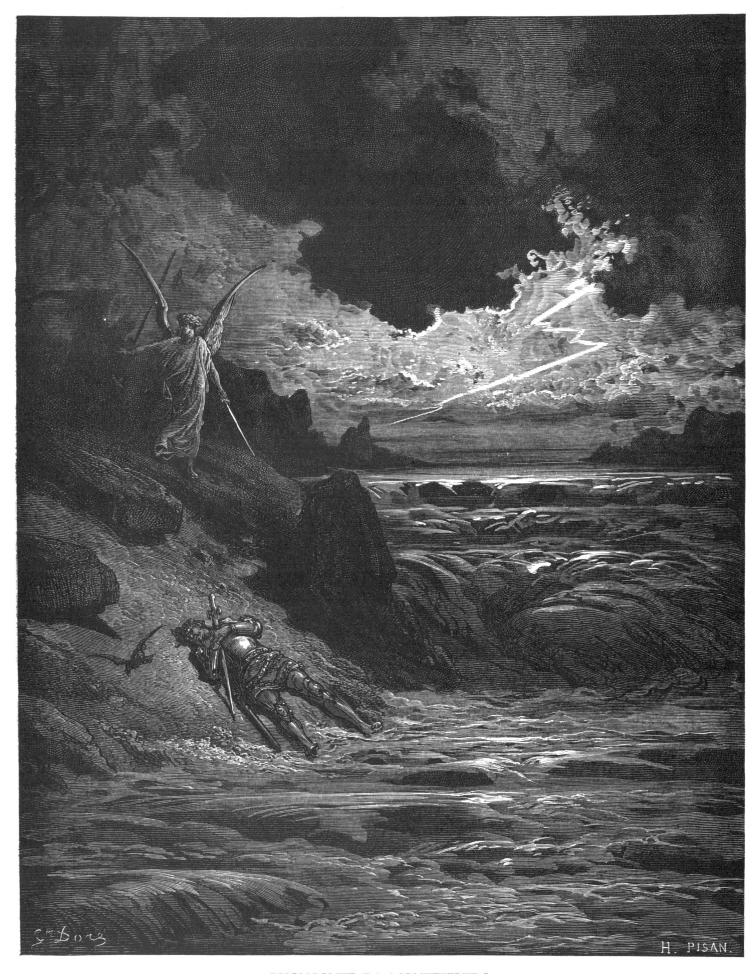

BUONCONTE DA MONTEFELTRO

"God's Angel took me up, and he of hell / Shouted: 'O thou from heaven, why dost
thou rob me?'" (*Purg.* V, 104, 105).

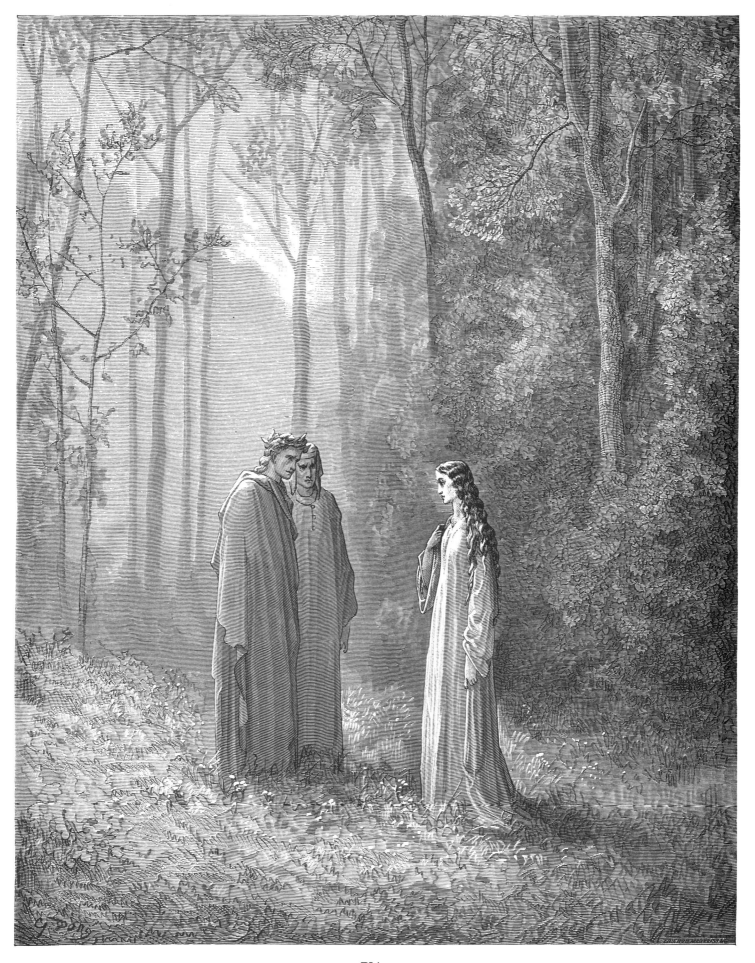

PIA
"Do thou remember me who am the Pia; / Siena made me, unmade me Maremma"
(*Purg.* V, 133, 134).

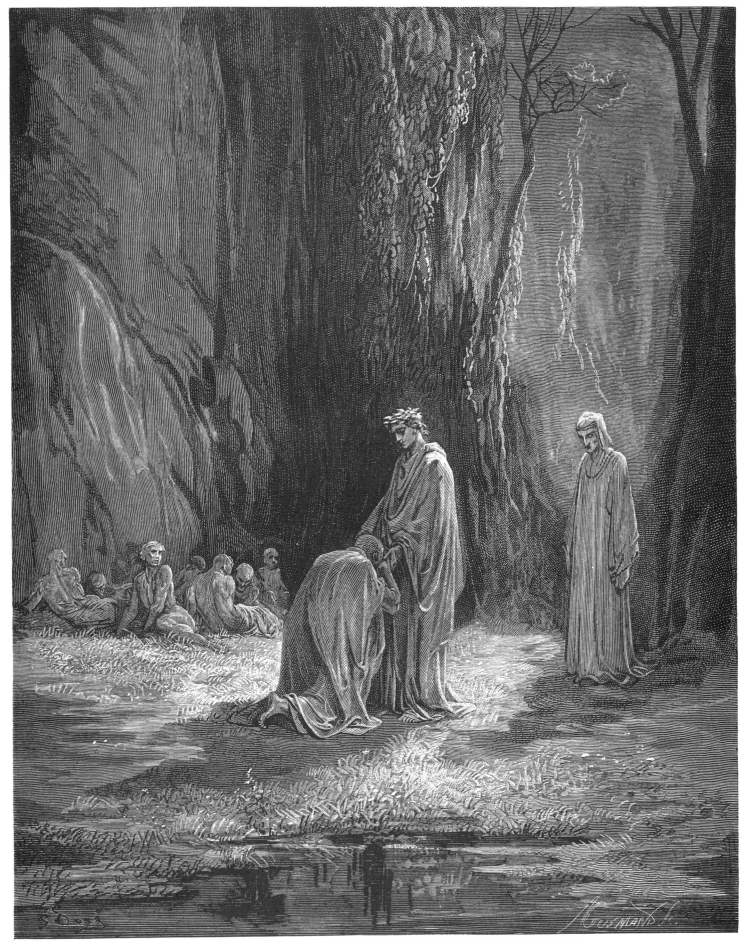

SORDELLO AND VIRGIL
So he appeared; and then bowed down his brow, / And with humility returned
towards him, / And, where inferiors embrace, embraced him (*Purg.* VII, 13–15).

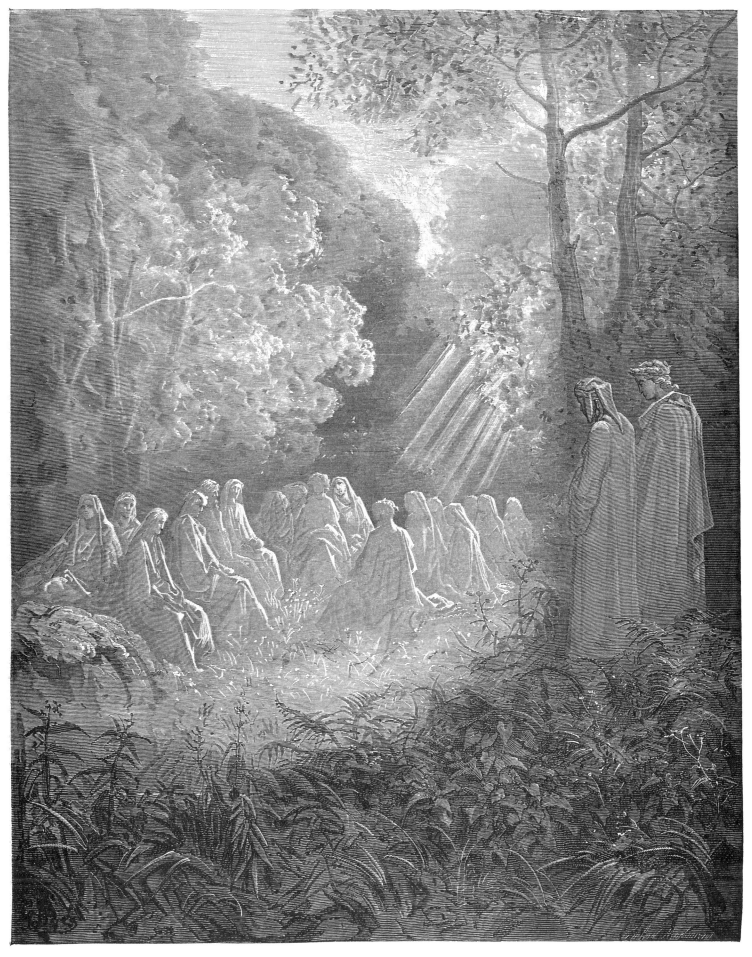

THE DELL

"Salve Regina," on the green and flowers / There seated, singing, spirits I beheld
(*Purg.* VII, 82, 83).

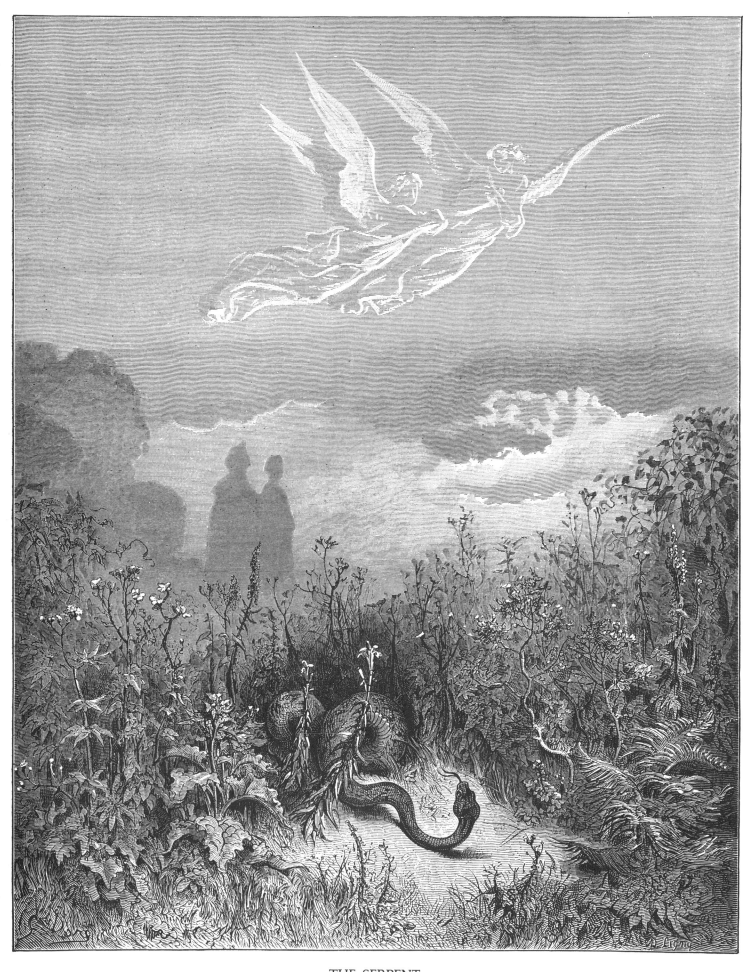

THE SERPENT
Hearing the air cleft by their verdant wings, / The serpent fled, and round the
Angels wheeled (*Purg.* VIII, 106, 107).

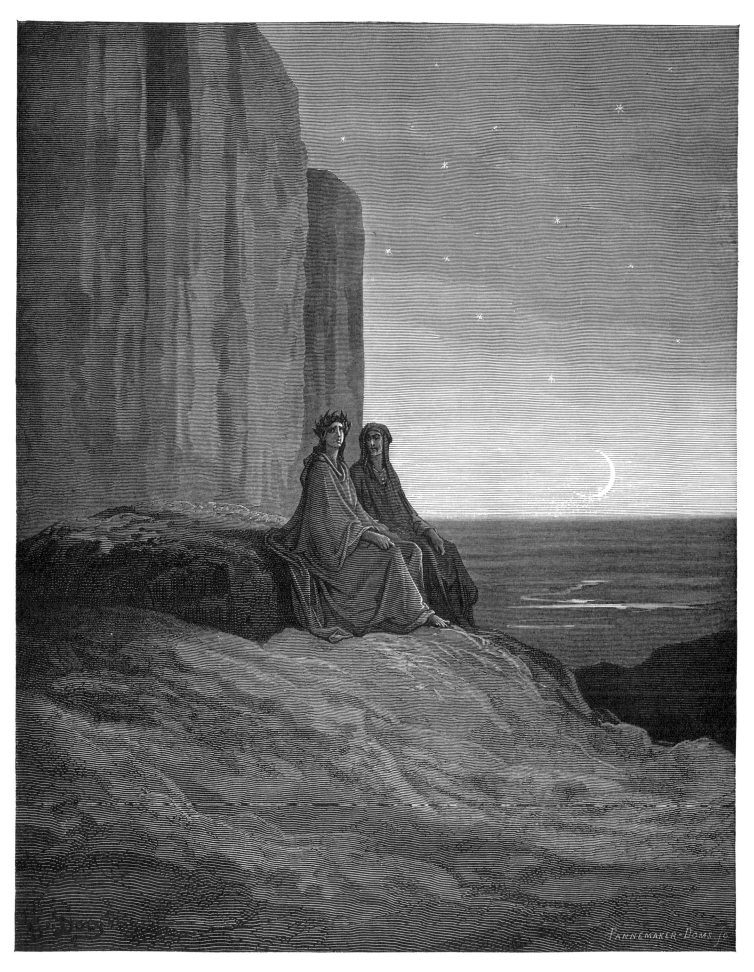

TWILIGHT
The concubine of old Tithonus now / Gleamed white upon the eastern balcony
(*Purg.* IX, 1, 2).

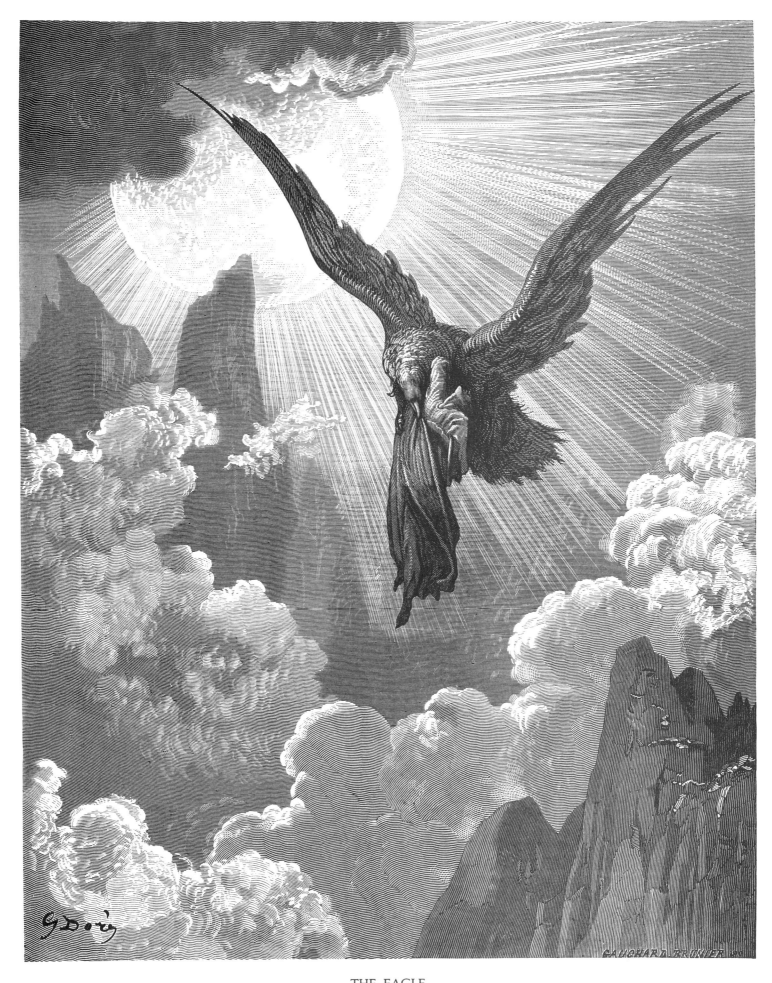

THE EAGLE
Terrible as the lightning he descended, / And snatched me upward even to the fire
(*Purg.* IX, 29, 30).

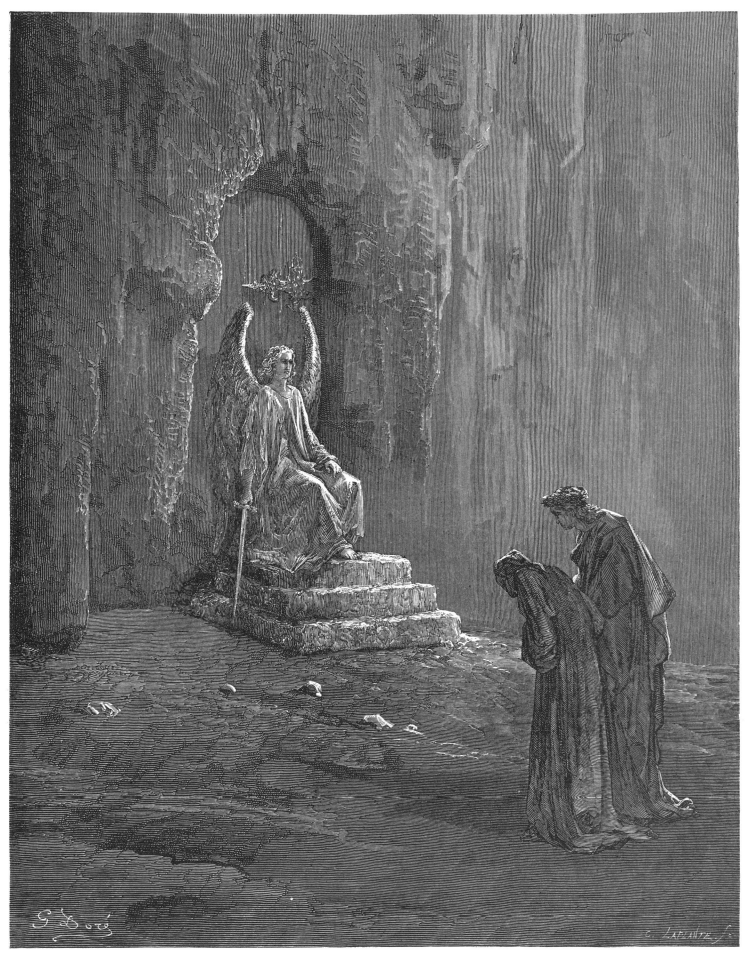

THE PORTALS OF PURGATORY
I saw him seated on the highest stair, / Such in the face that I endured it not. /
And in his hand he held a naked sword (*Purg.* IX, 80–82).

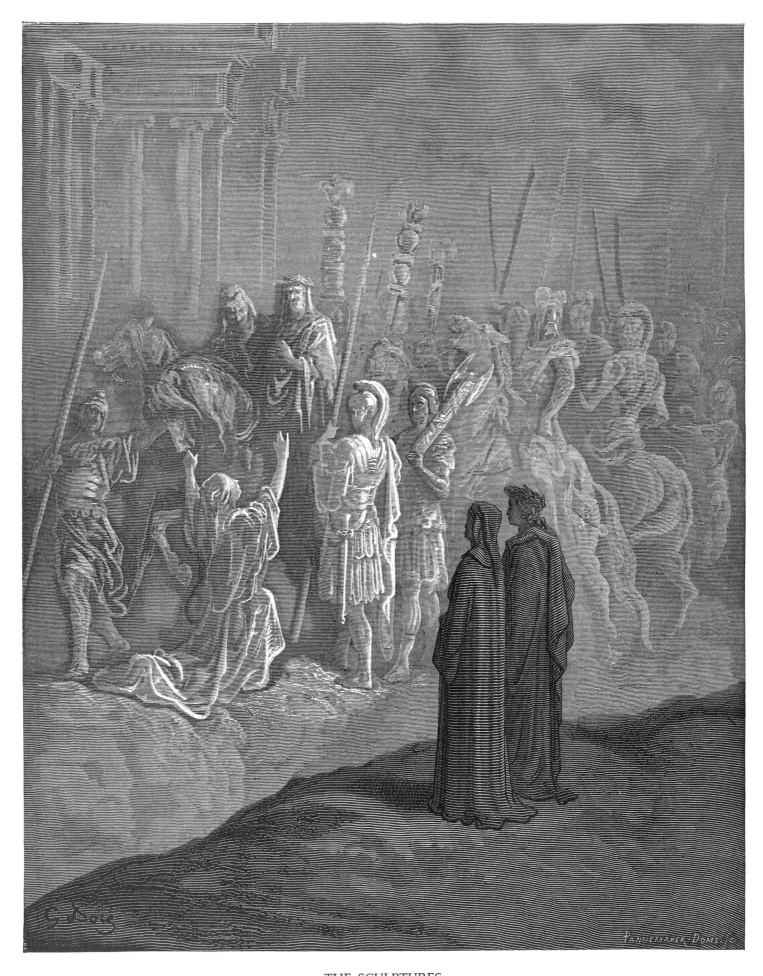

THE SCULPTURES
The wretched woman in the midst of these / Seemed to be saying: "Give me
vengeance, Lord, / For my dead son" (*Purg.* X, 82–84).

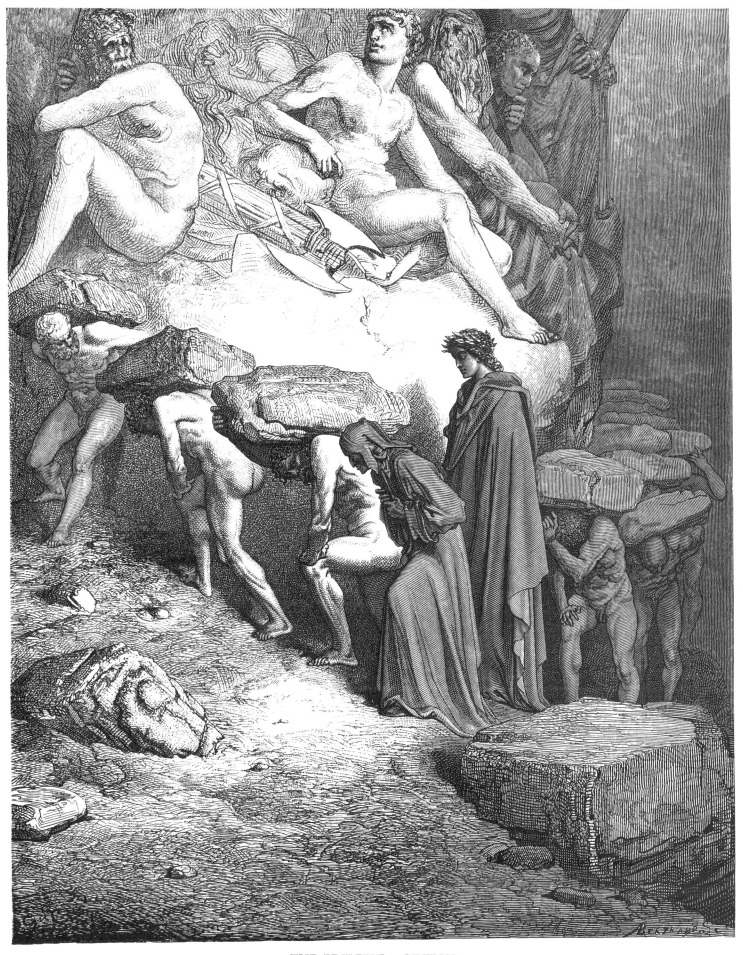

THE PRIDEFUL—ODERISI

Abreast, like oxen going in a yoke, / I with that heavy-laden soul went on (*Purg*.
XII, 1, 2).

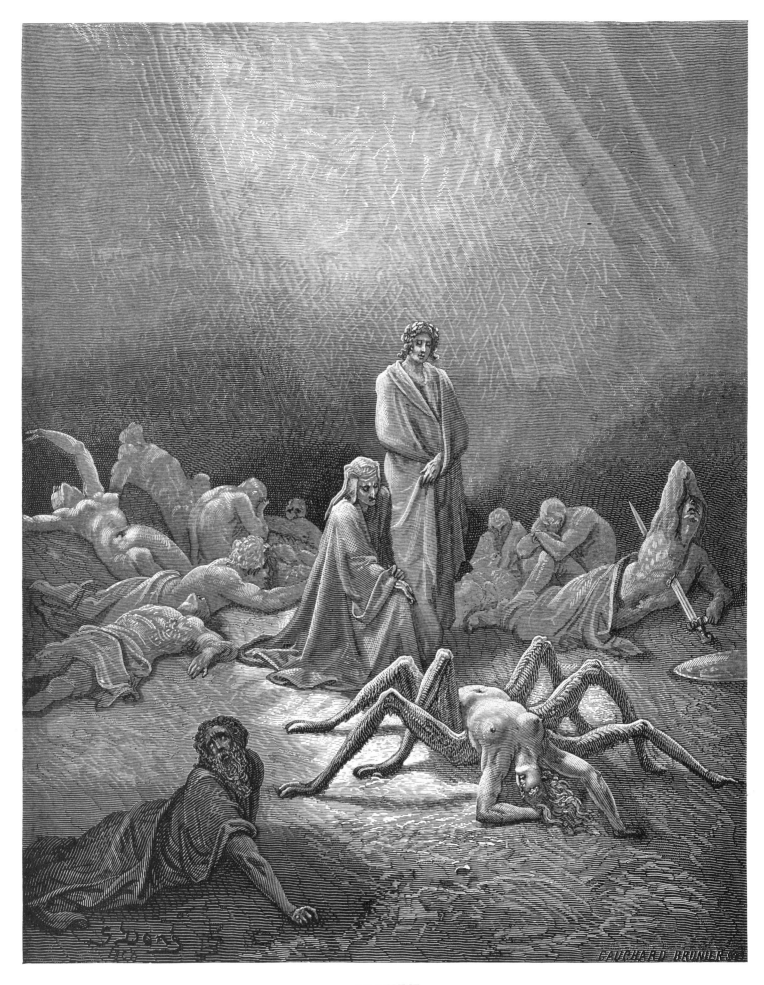

ARACHNE
O mad Arachne! so I thee beheld / E'en then half spider (*Purg*. XII, 43, 44).

94

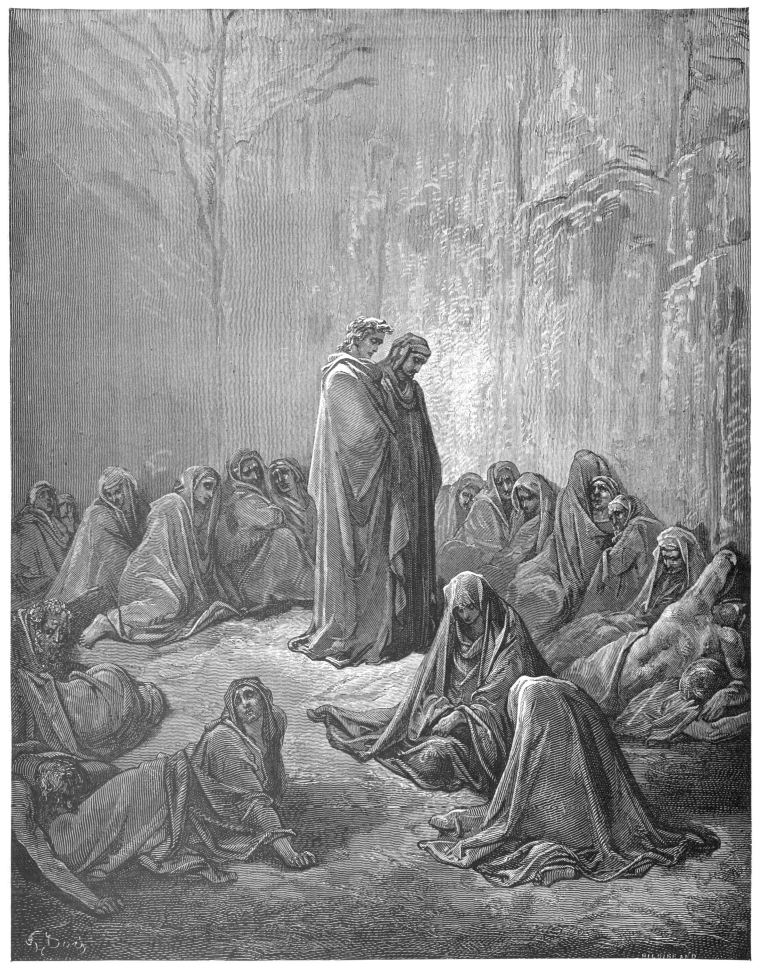

THE ENVIOUS

Covered with sackcloth vile they seemed to me, / And one sustained the other with
his shoulder, / And all of them were by the bank sustained (*Purg.* XIII, 58–60).

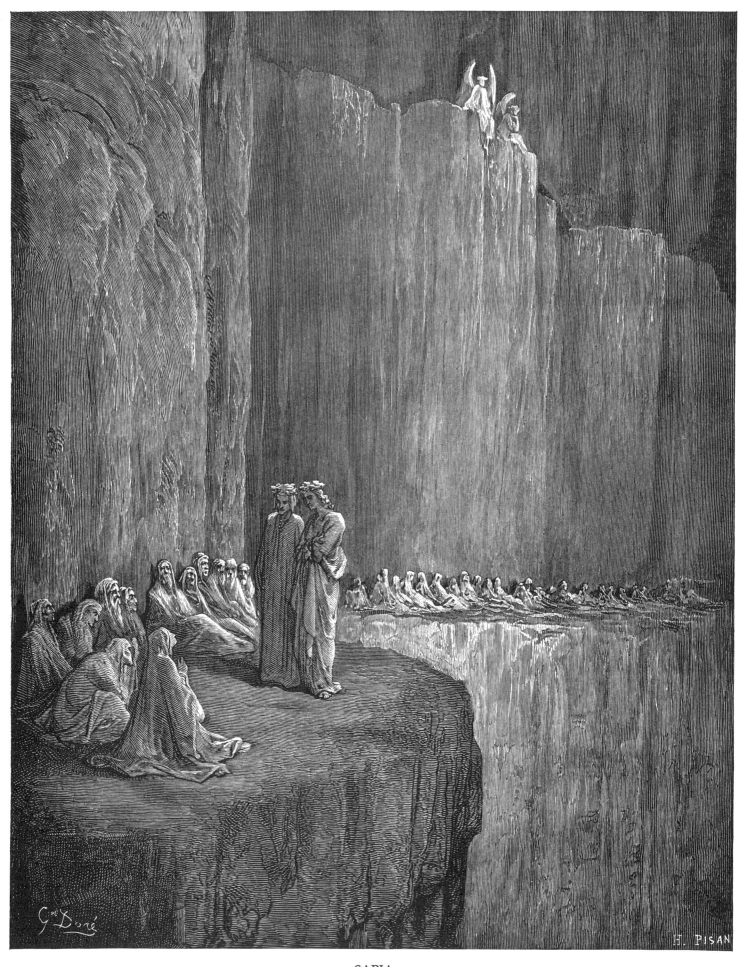

SAPIA
"Sienese was I," it replied, "and with / The others here recleanse my guilty life"
(*Purg.* XIII, 106, 107).

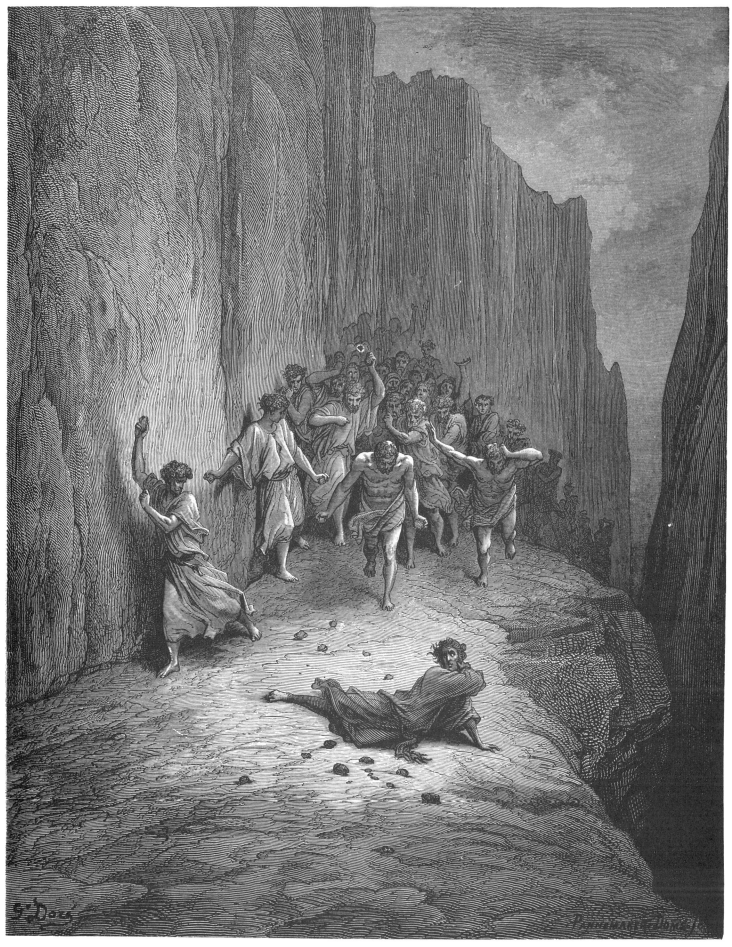

THE STONING OF STEPHEN

Then saw I people hot in fire of wrath, / With stones a young man slaying, clamor-
ously / Still crying to each other, "Kill him! kill him!" (*Purg.* XV, 106–108).

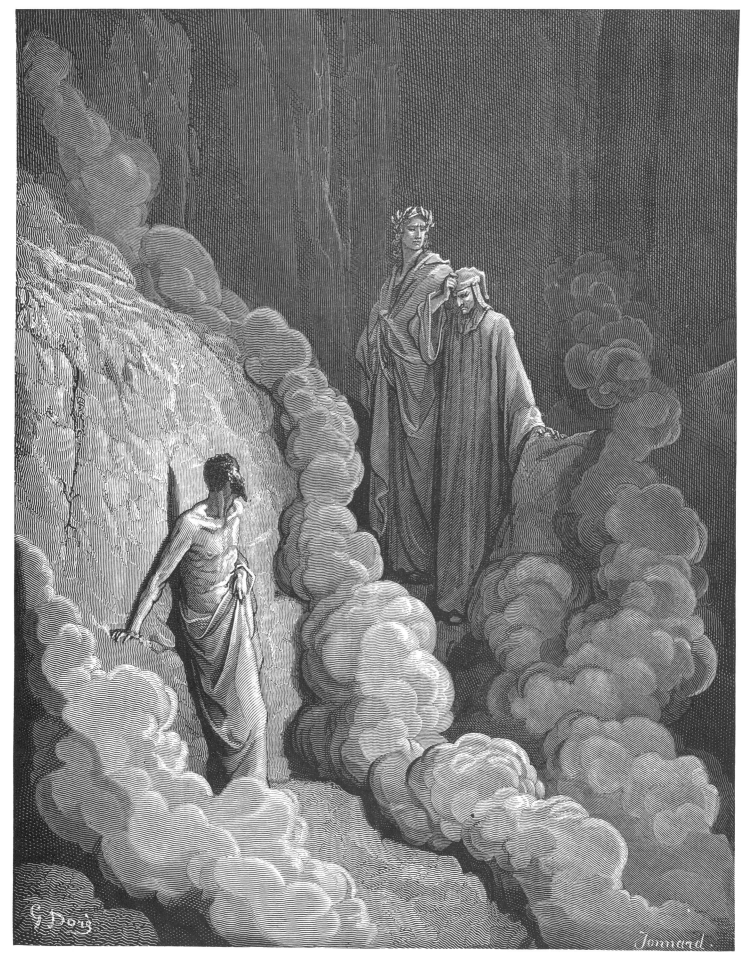

MARCO THE LOMBARD

"Now who art thou, that cleavest through our smoke, / And art discoursing of us
even as though / Thou didst by calends still divide the time?" (*Purg.* XVI, 25–27).

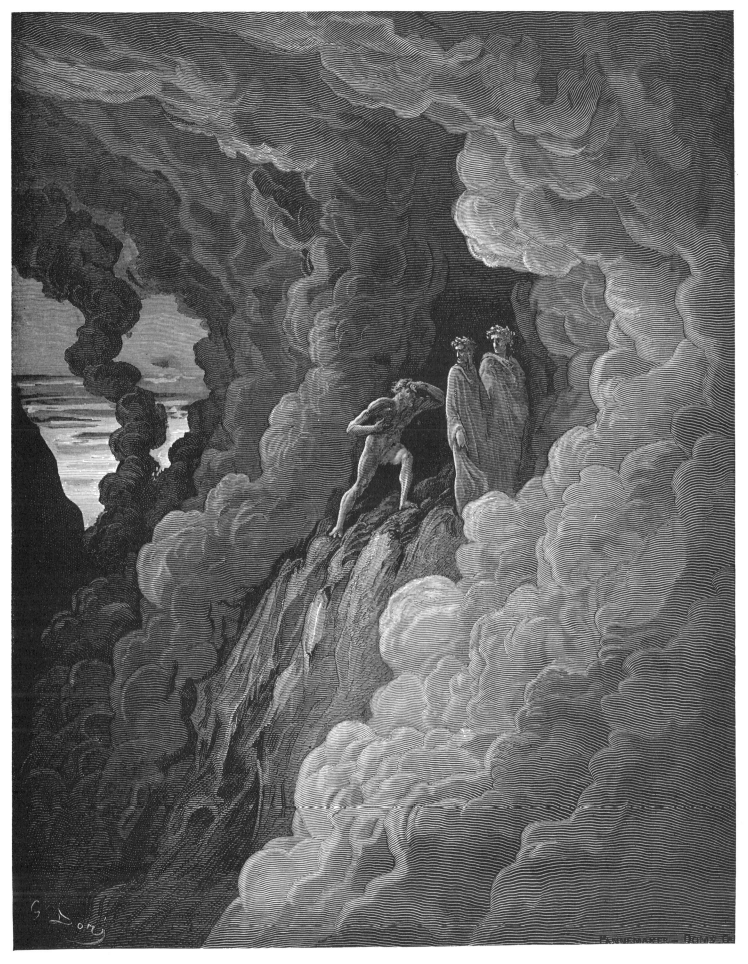

MARCO THE LOMBARD

"Thee will I follow far as is allowed me," / He answered; "and if smoke prevent our
seeing, / Hearing shall keep us joined instead thereof" (*Purg.* XVI, 34–36).

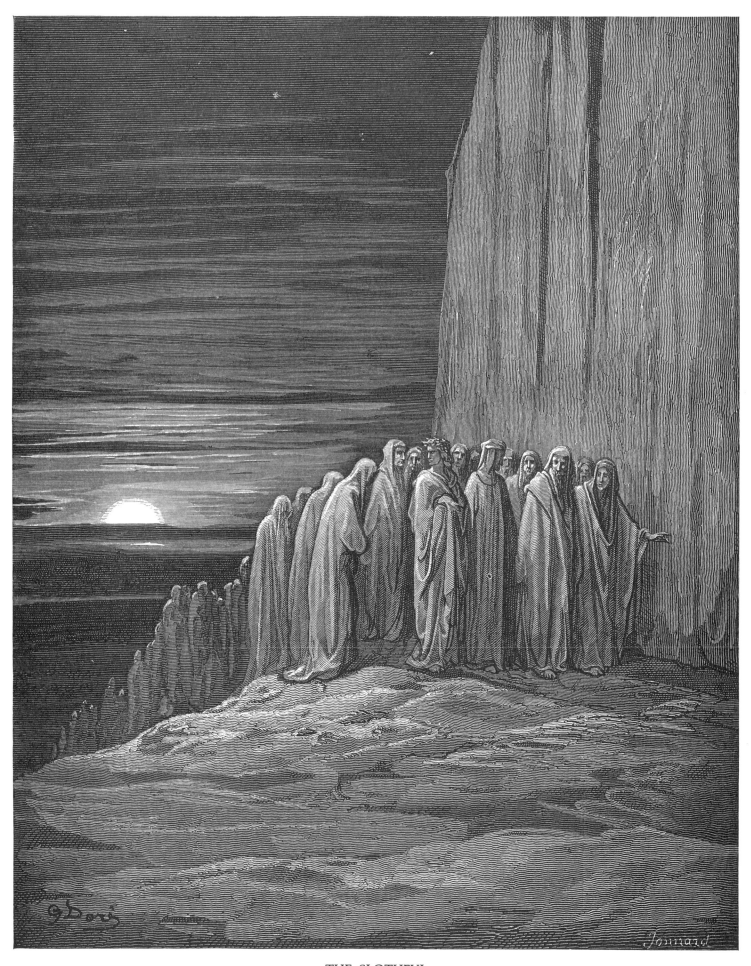

THE SLOTHFUL

But taken from me was this drowsiness / Suddenly by a people, that behind / Our
backs already had come round to us (*Purg.* XVIII, 88–90).

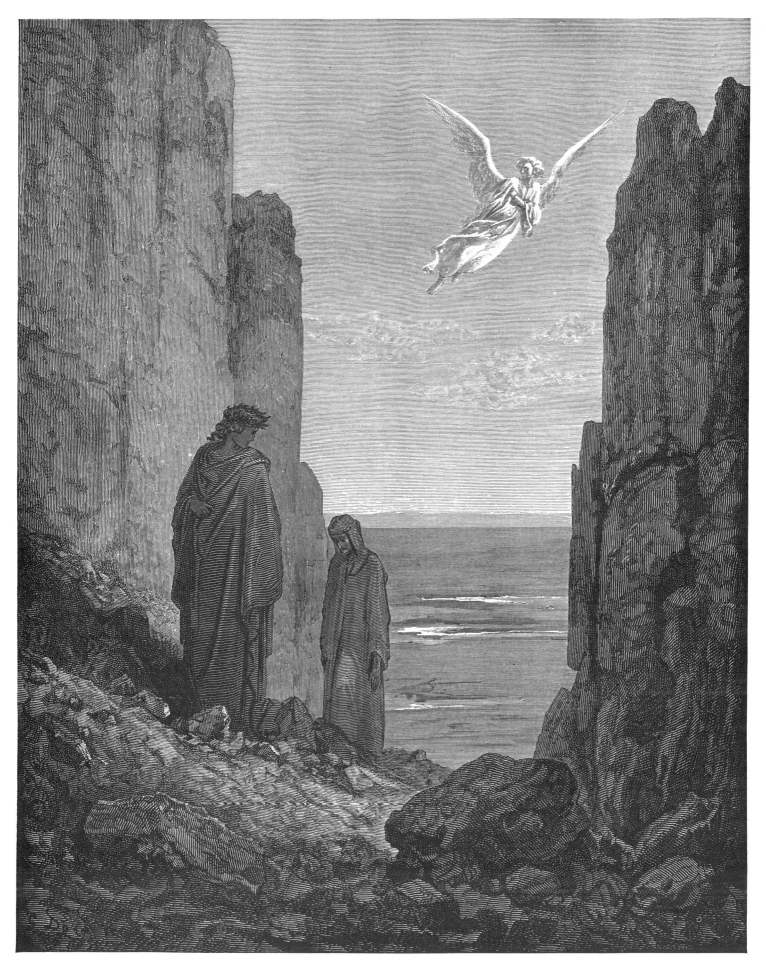

ASCENT TO THE FIFTH CIRCLE
"What aileth thee, that aye to earth thou gazest?" / To me my Guide began to say,
we both / Somewhat beyond the Angel having mounted (*Purg.* XIX, 52–54).

101

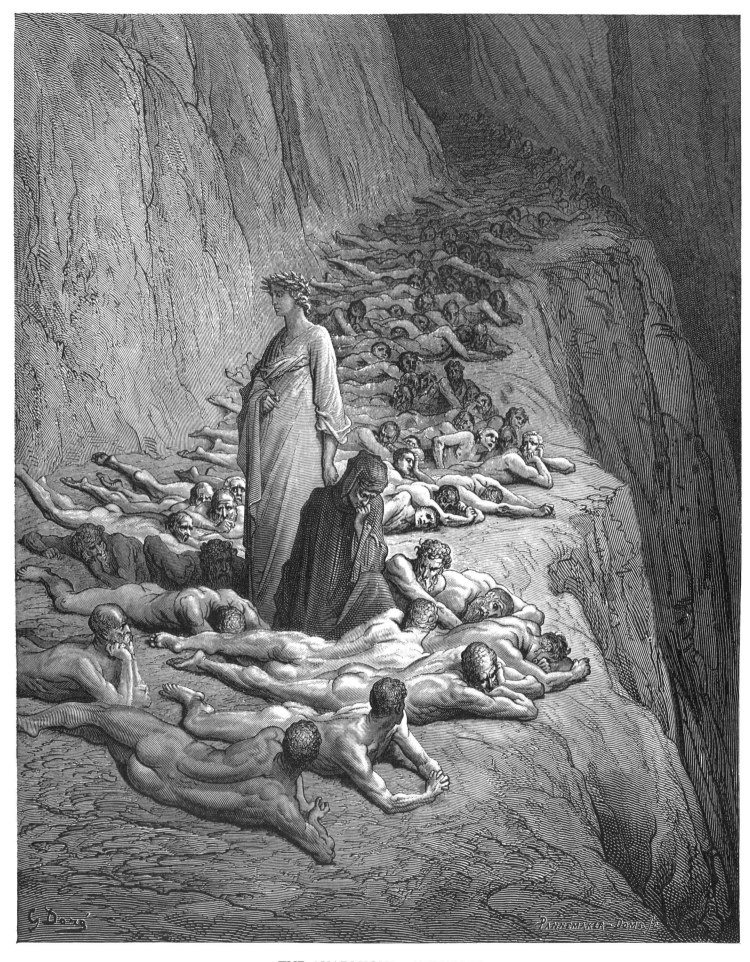

THE AVARICIOUS—ADRIAN V
"What cause," he said, "has downward bent thee thus?" / And I to him: "For your
own dignity, / Standing, my conscience stung me with remorse" (*Purg.* XIX, 130–132).

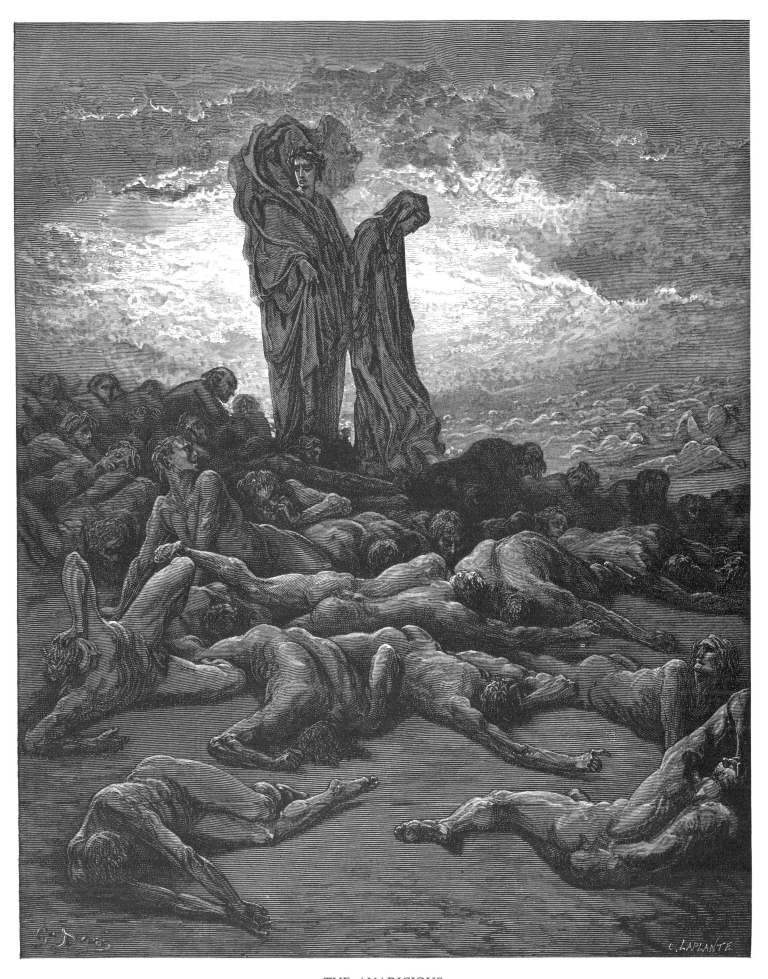

THE AVARICIOUS
Onward we went with footsteps slow and scarce, / And I attentive to the shades I
heard / Piteously weeping and bemoaning them (*Purg.* XX, 16–18).

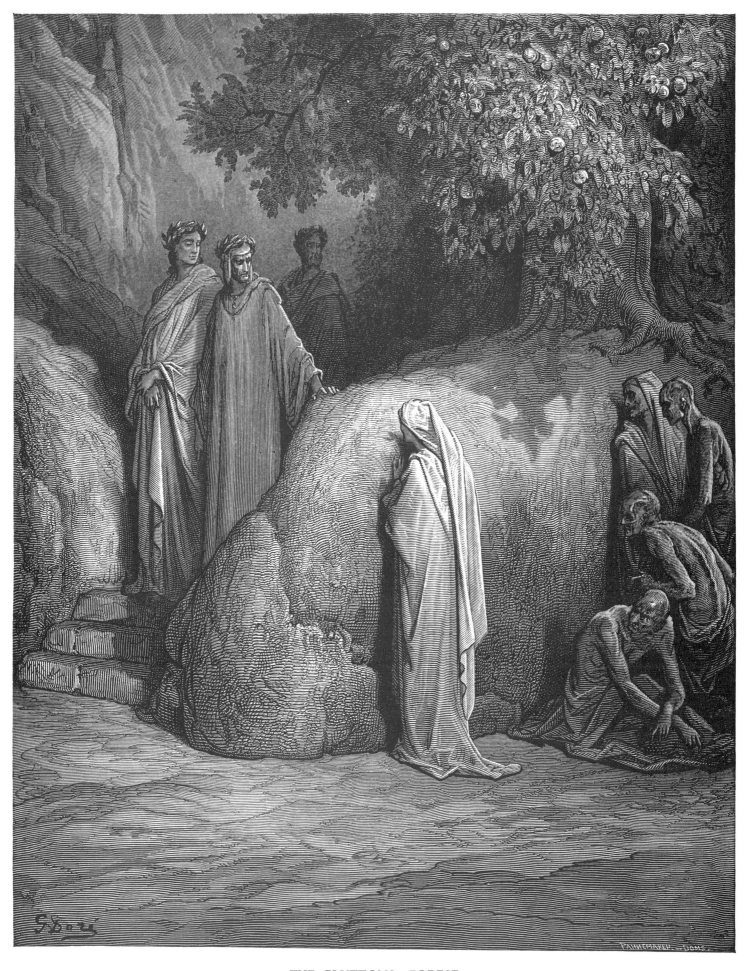

THE GLUTTONS—FORESE

"Ah, do not look at this dry leprosy," / Entreated he, "which doth my skin discolor, / Nor at default of flesh that I may have" (*Purg.* XXIII, 49–51).

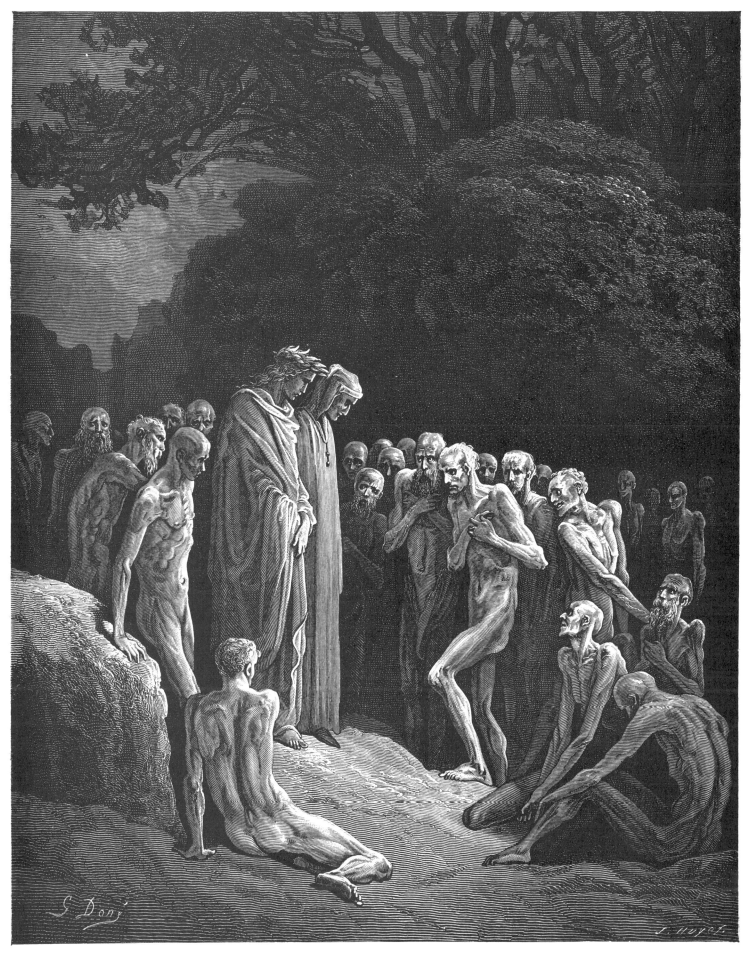

THE GLUTTONS
And shadows, that appeared things doubly dead, / From out the sepulchres of their
eyes betrayed / Wonder at me, aware that I was living (*Purg.* XXIV, 4–6).

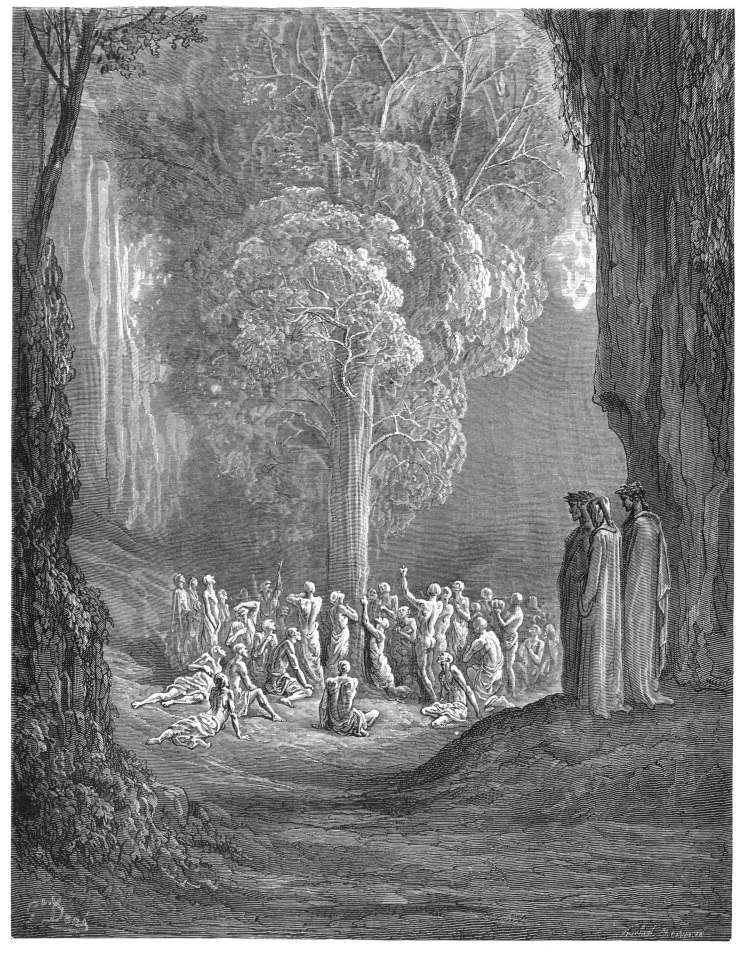

THE TREE
People I saw beneath it lift their hands, / And cry I know not what towards the
leaves (*Purg.* XXIV, 106, 107).

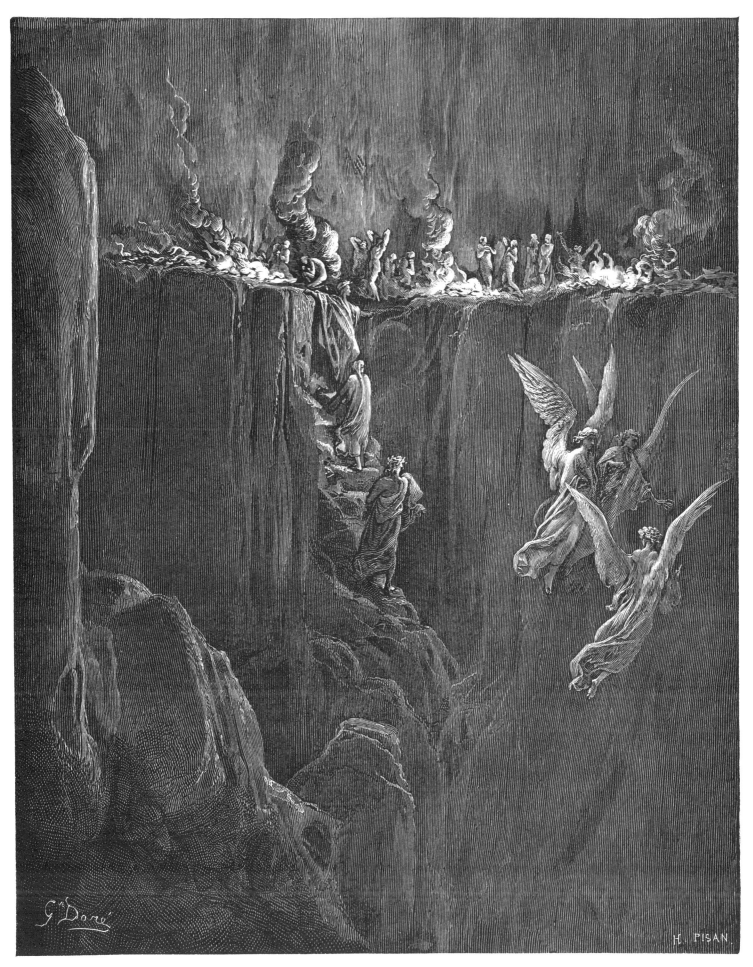

THE SEVENTH CIRCLE
There the enbankment shoots forth flames of fire, / And upward doth the cornice
breathe a blast / That drives them back, and from itself sequesters (*Purg.* XXV,
112–114).

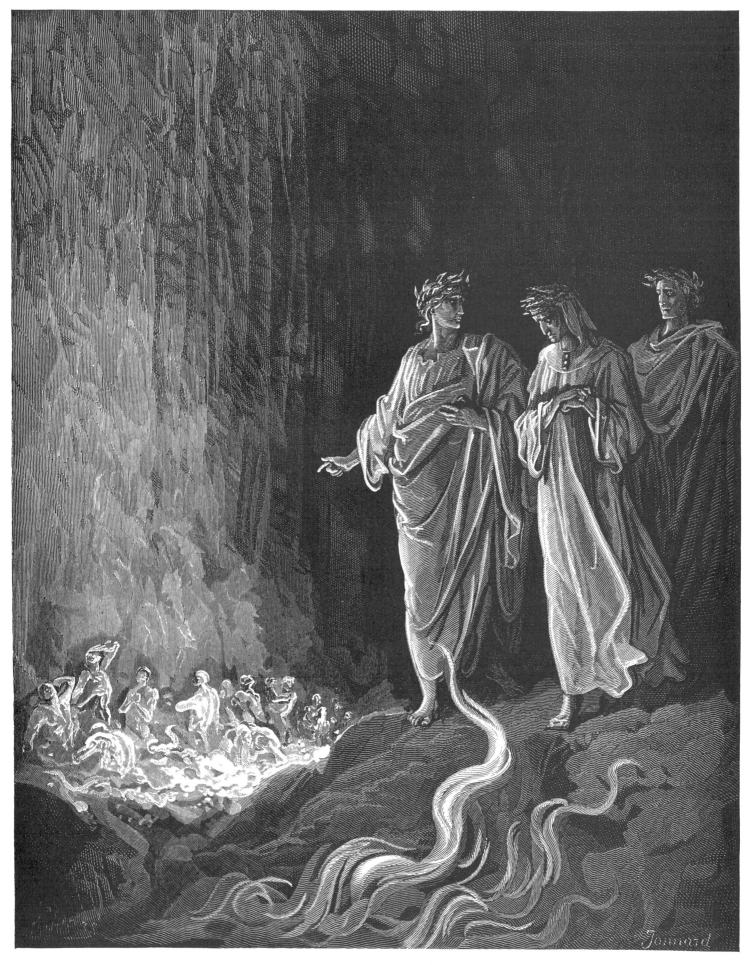

THE SEVENTH CIRCLE
"Summae Deus clementiae," in the bosom / Of the great burning chanted then I
heard, / Which made me no less eager to turn round (*Purg.* XXV, 121–123).

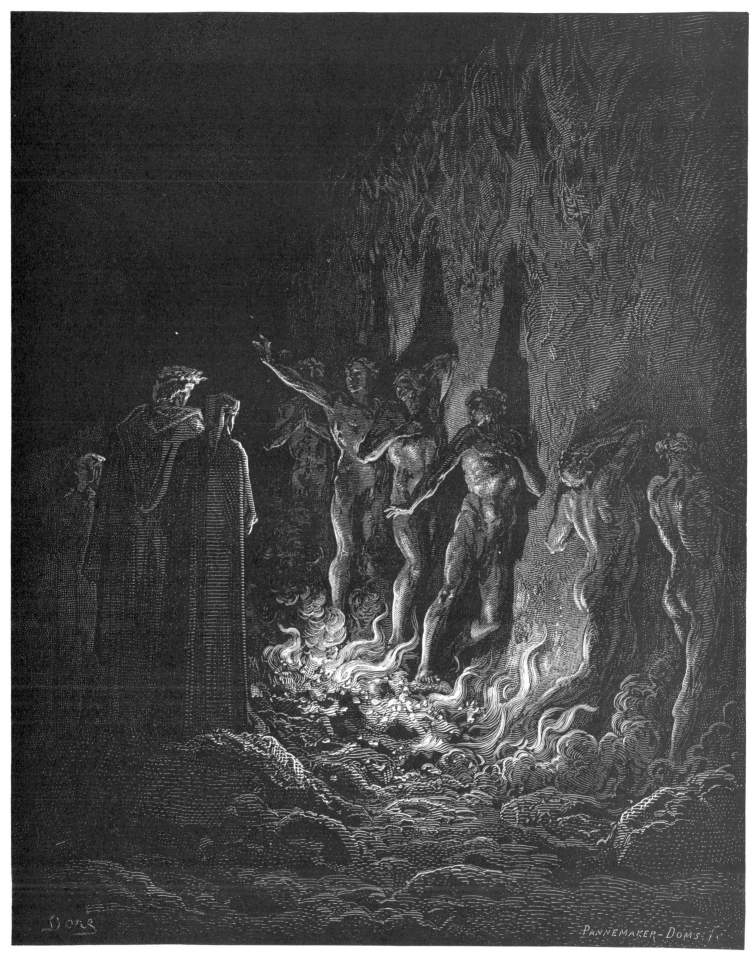

THE SEVENTH CIRCLE—THE LUSTFUL
And spirits saw I walking through the flame; / Wherefore I looked, to my own
steps and theirs / Apportioning my sight from time to time (*Purg.* XXV, 124–126).

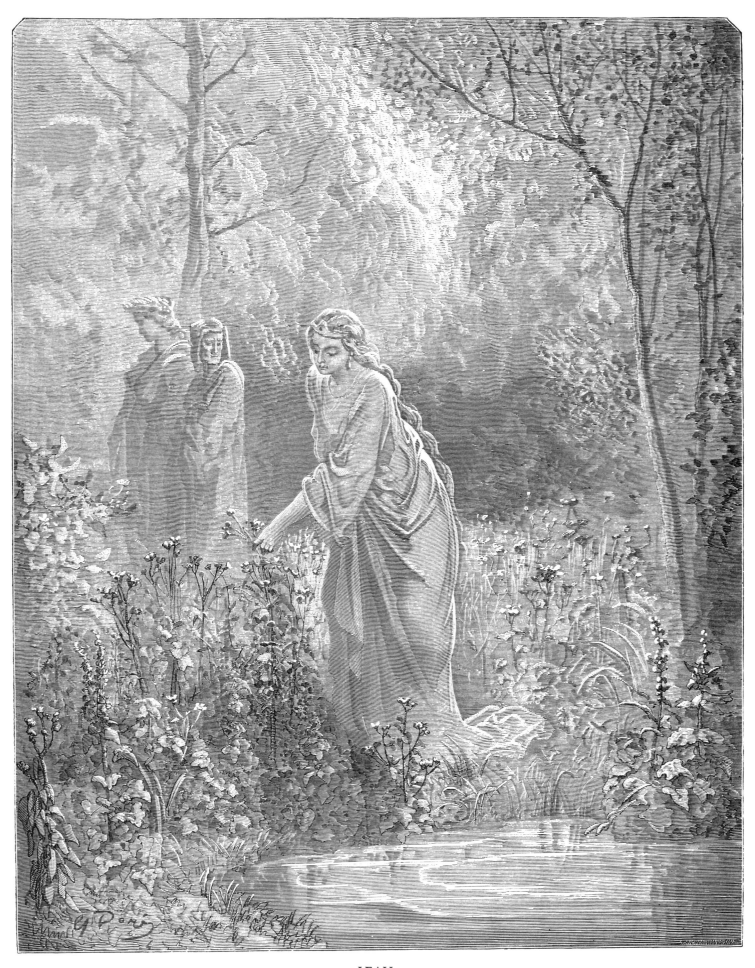

LEAH
Youthful and beautiful in dreams methought / I saw a lady walking in a meadow,
/ Gathering flowers (*Purg.* XXVII, 97–99).

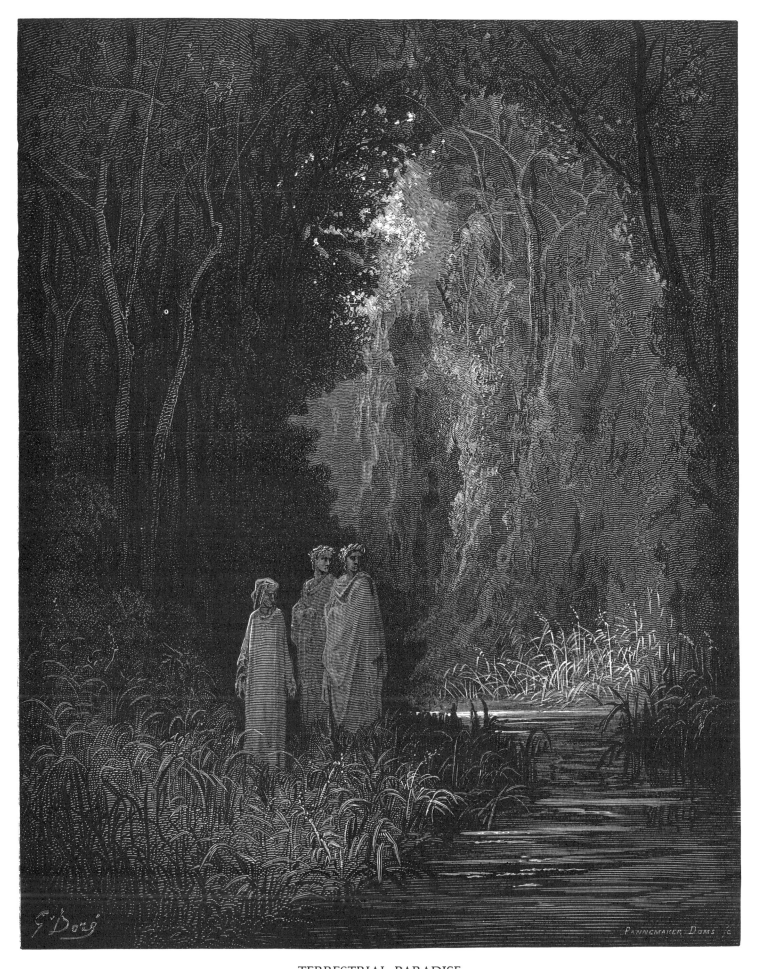

TERRESTRIAL PARADISE

Already my slow steps had carried me / Into the ancient wood so far, that I / Could
not perceive where I had entered it (*Purg.* XXVIII, 22–24).

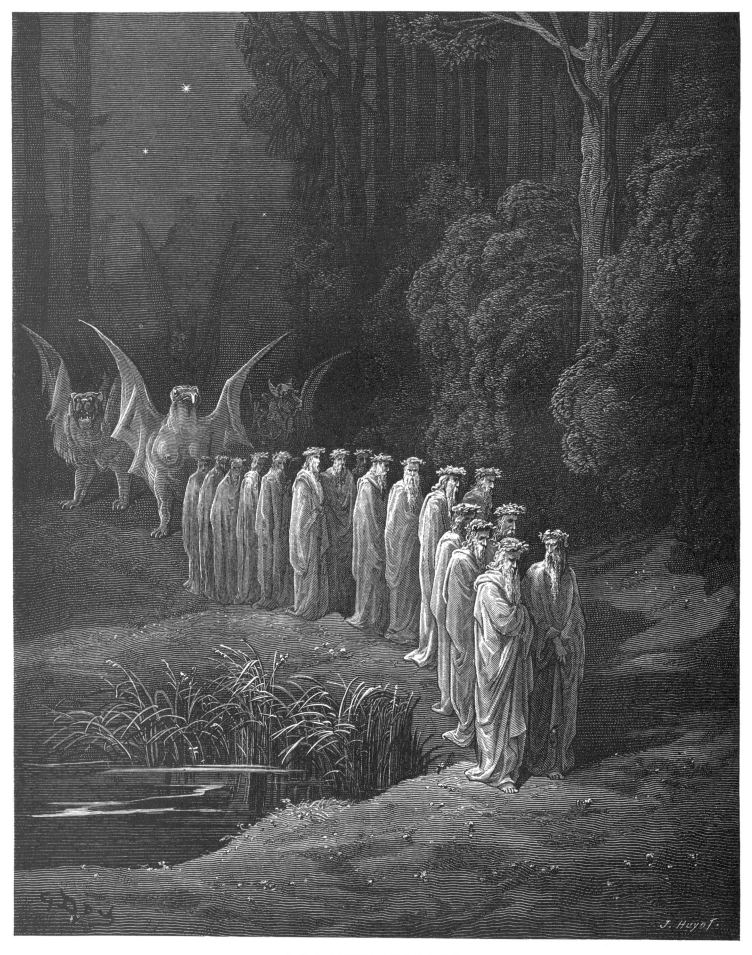

APOCALYPTIC PROCESSION

The four and twenty Elders, two by two, / Came on incoronate with flower-de-luce
(*Purg.* XXIX, 83, 84).

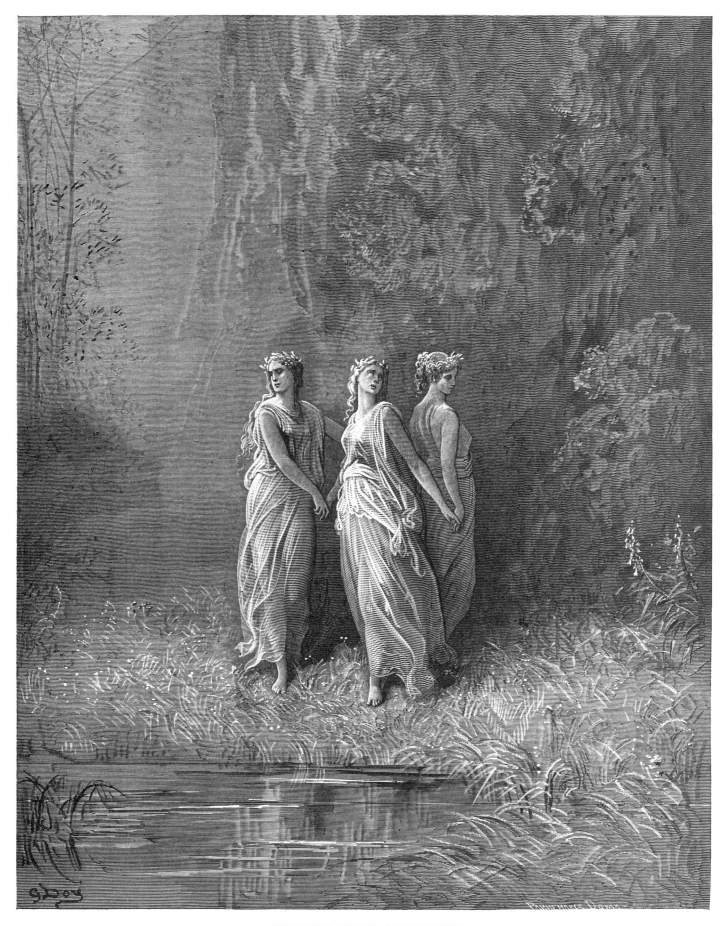

CHARITY, HOPE AND FAITH

One so very red / That in the fire she hardly had been noted. / The second was as
if her flesh and bones / Had all been fashioned out of emerald; / The third appeared
as snow but newly fallen (*Purg.* XXIX, 122–126).

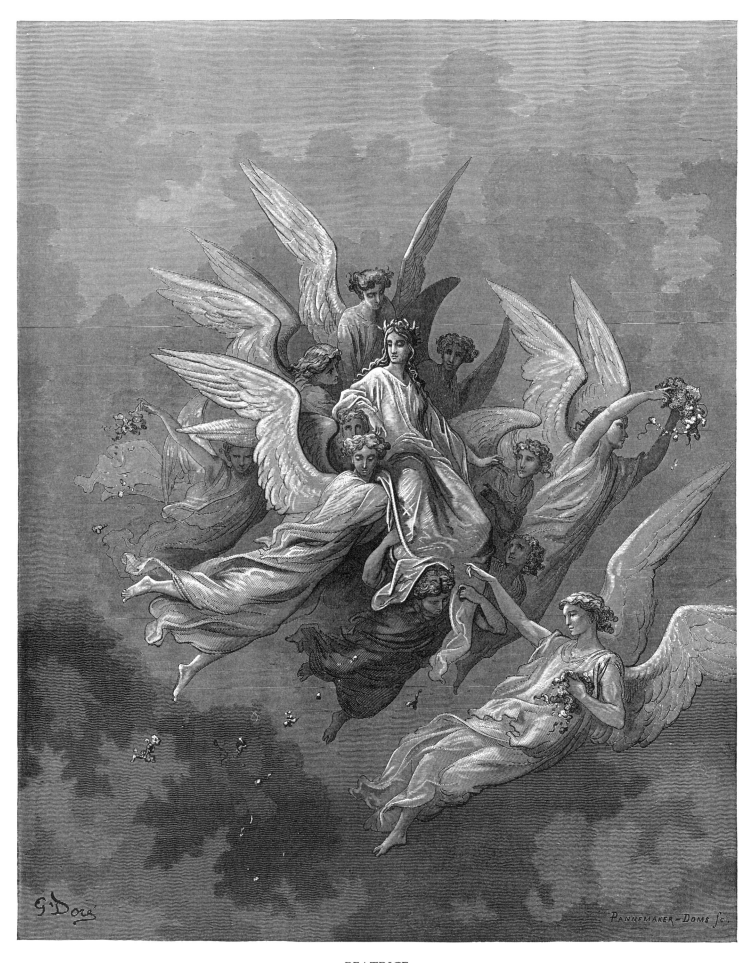

BEATRICE

Appeared a lady under a green mantle, / Vested in color of the living flame (*Purg.*
XXX, 32, 33).

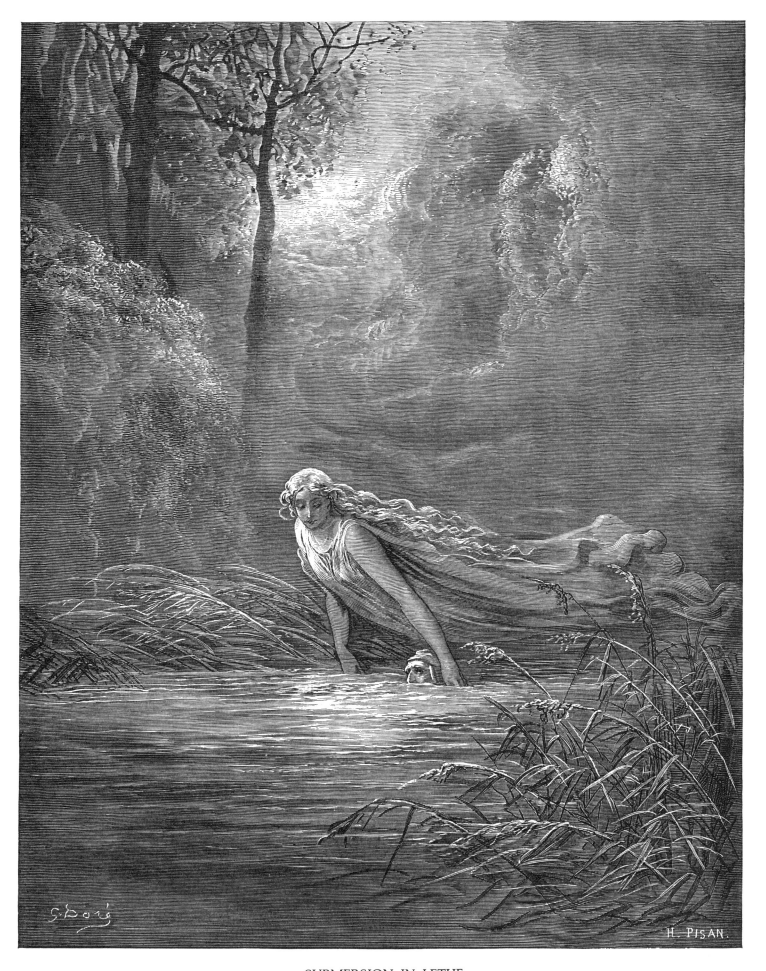

SUBMERSION IN LETHE

The beautiful lady opened wide her arms, / Embraced my head, and plunged me underneath, / Where I was forced to swallow the water (*Purg.* XXXI, 100–102).

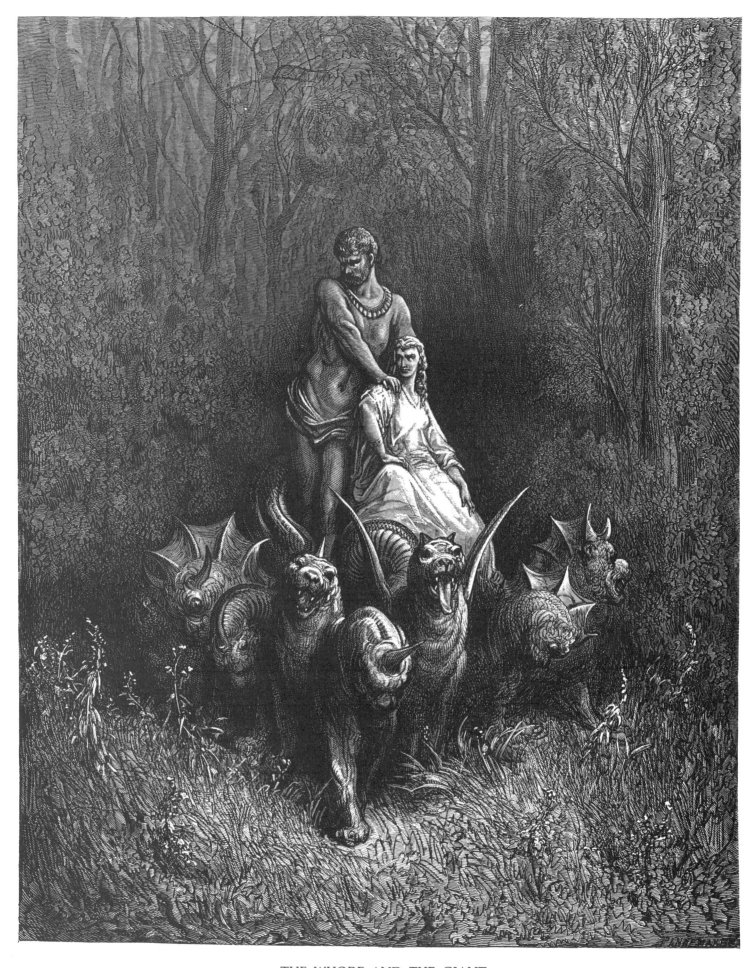

THE WHORE AND THE GIANT
Upright beside her I beheld a giant; / And ever and anon they kissed each other (*Purg.*
XXXII, 152, 153).

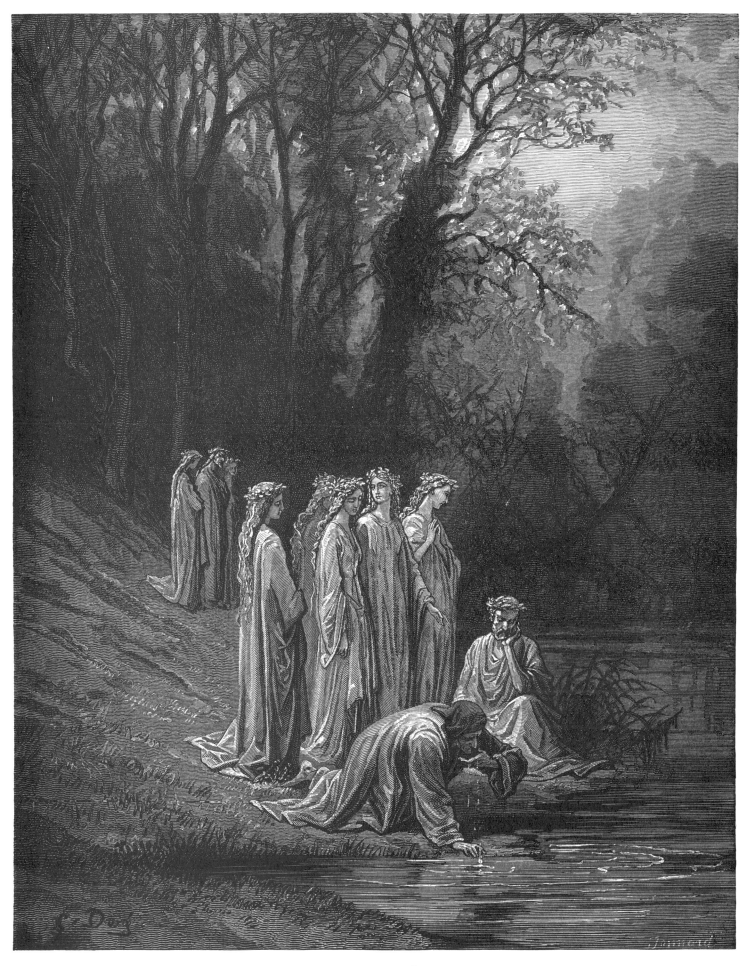

THE EUNOË

If, Reader, I possessed a longer space / For writing it, I yet would sing in part /
Of the sweet draught that ne'er would satiate me (*Purg.* XXXIII, 136–138).

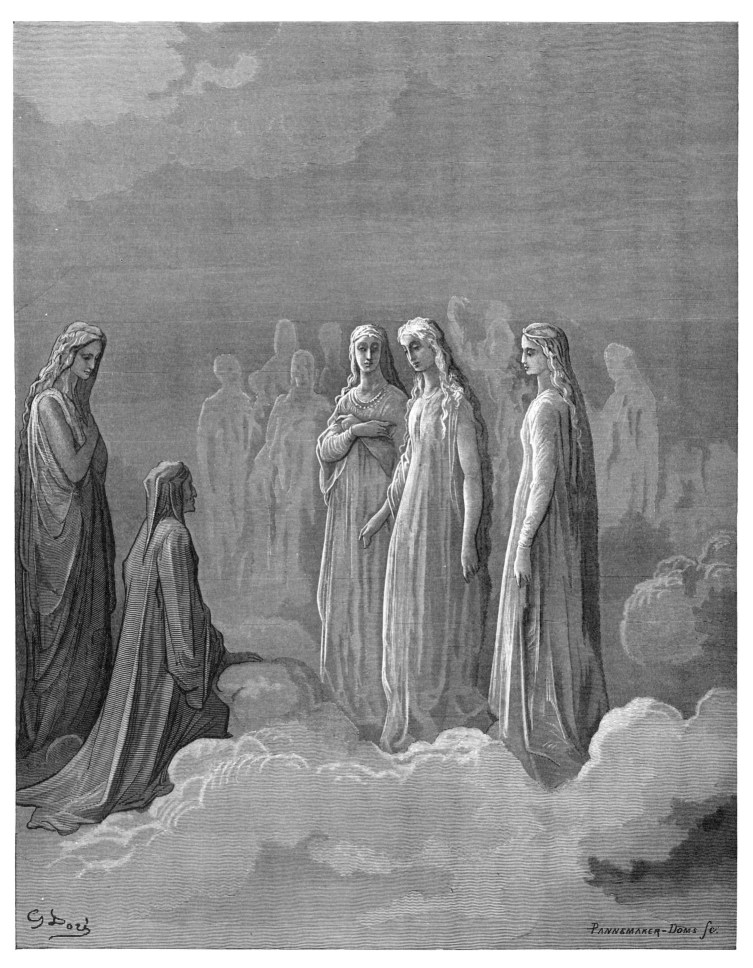

THE MOON
Saw I many faces prompt to speak (*Par.* III, 16).

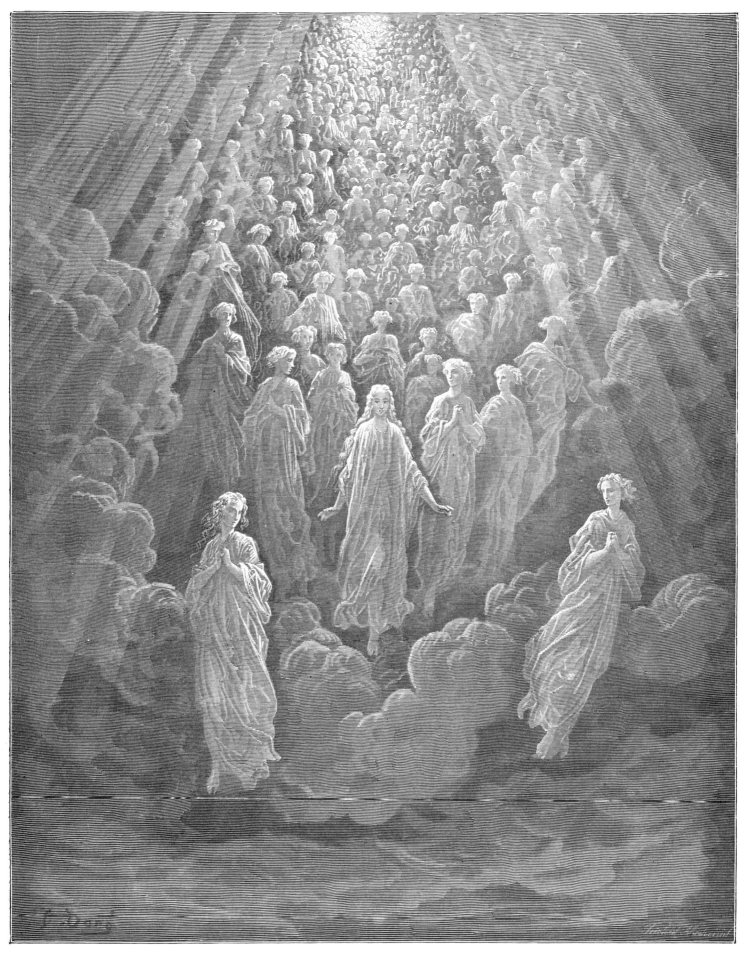

MERCURY
So I beheld more than a thousand splendors / Drawing towards us (*Par.* V, 103, 104).

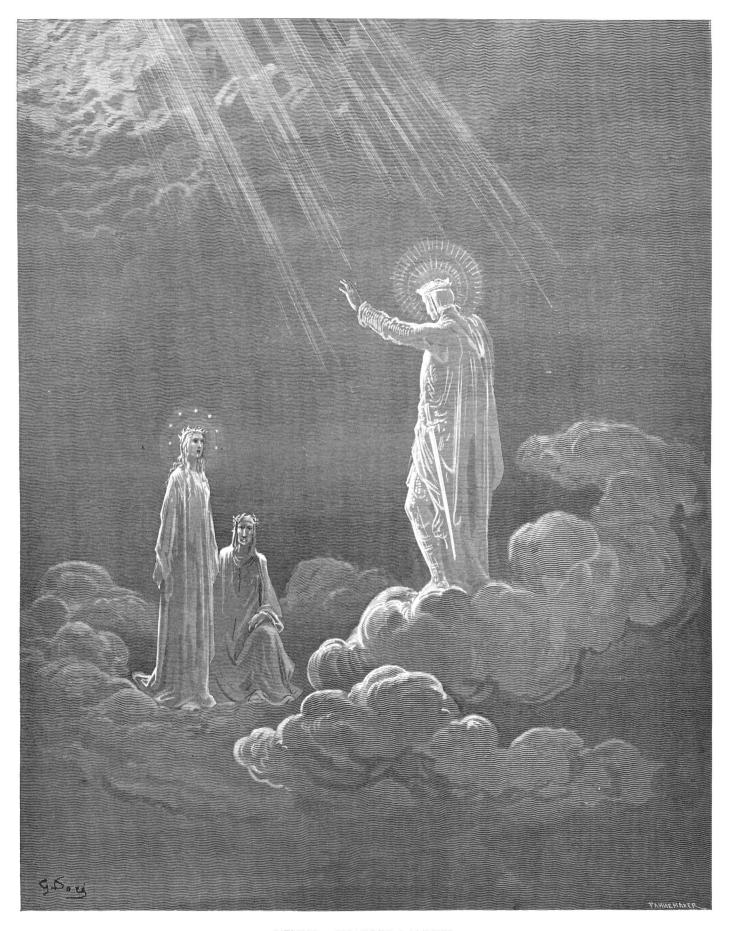

VENUS—CHARLES MARTEL
"That left-hand margin, which did bathe itself / In Rhone, when it is mingled with
the Sorgue, / Me for its lord awaited in due time" (*Par.* VIII, 58–60).

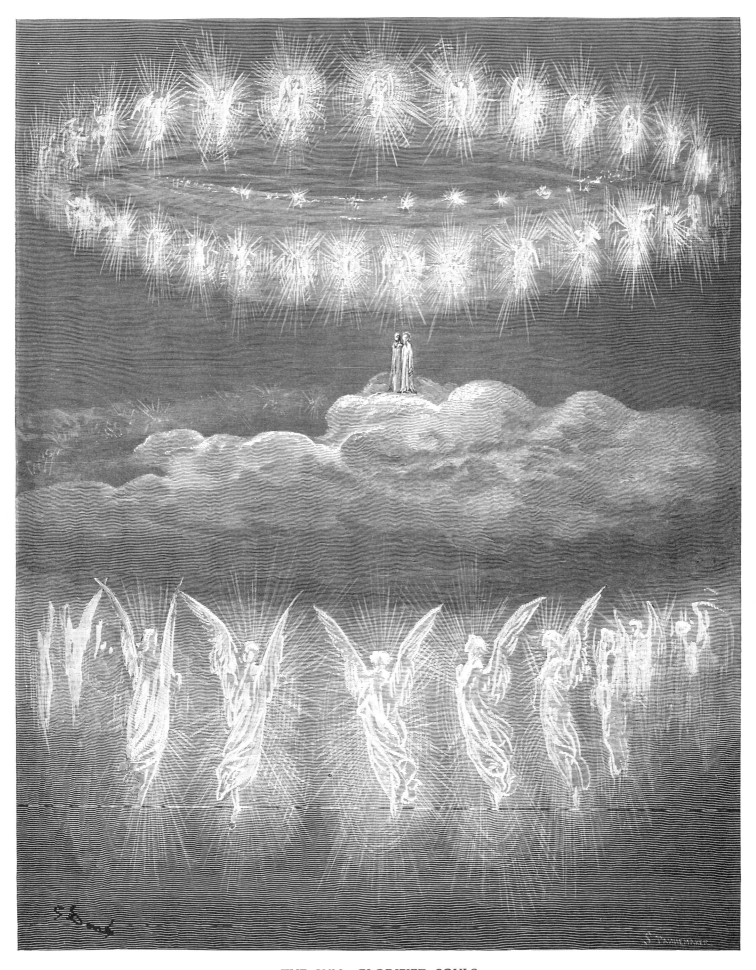

THE SUN—GLORIFIED SOULS
In such wise of those sempiternal roses / The garlands twain encompassed us about,
/ And thus the outer to the inner answered (*Par.* XII, 19–21).

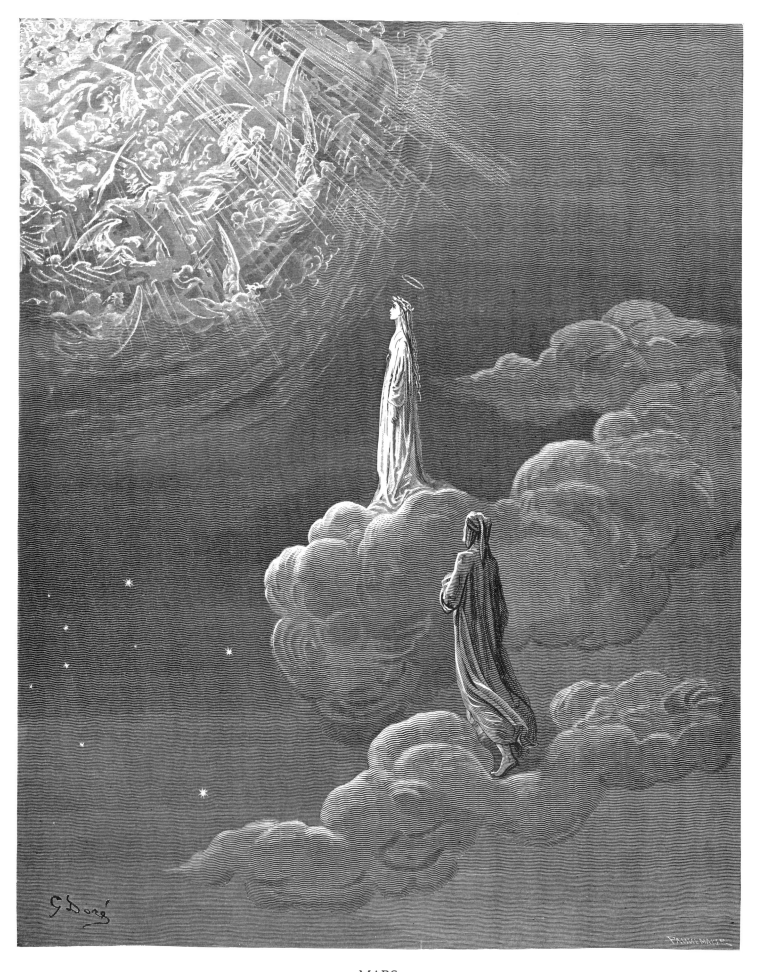

MARS

Well was I ware that I was more uplifted / By the enkindled smiling of the star,
/ That seemed to me more ruddy than its wont (*Par.* XIV, 85–87).

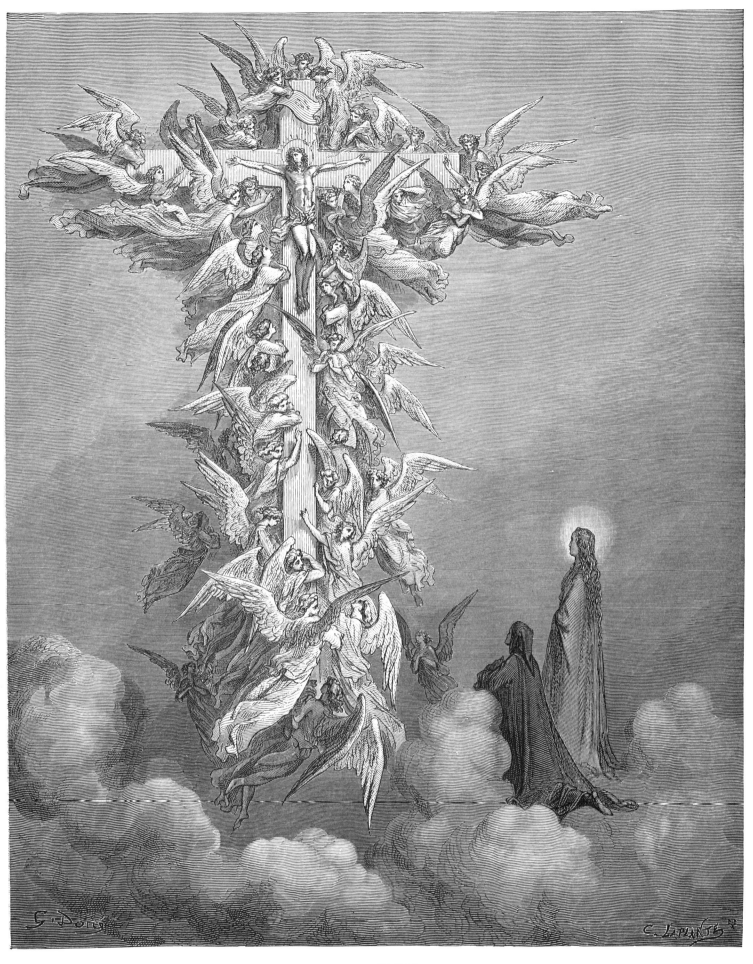

THE CROSS

Here doth my memory overcome my genius; / For on that cross as levin gleamed
forth Christ, / So that I cannot find ensample worthy (*Par.* XIV, 103–105).

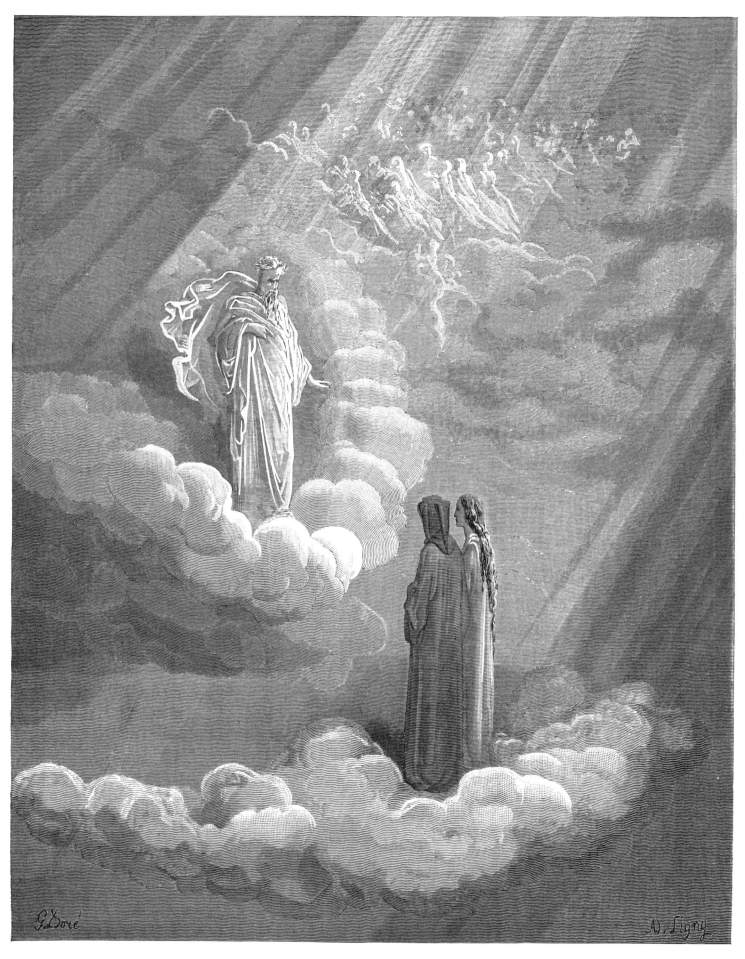

CACCIAGUIDA
"You are my ancestor, / You give to me all hardihood to speak, / You lift me so
that I am more than I" (*Par.* XVI, 16–18).

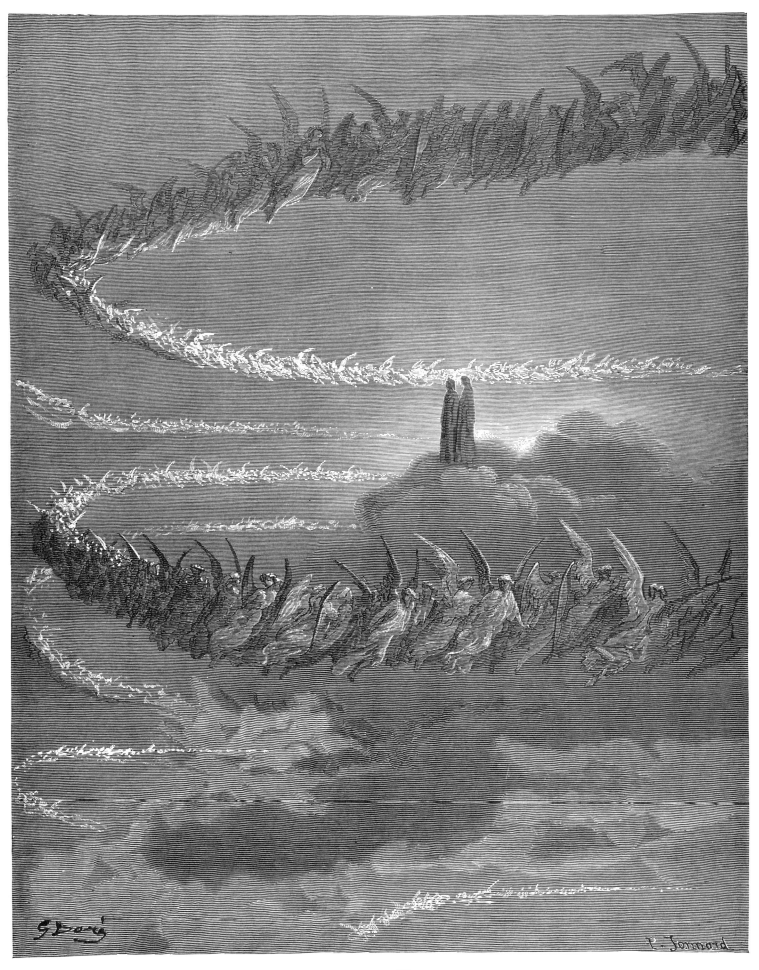

JUPITER
The holy creatures / Sang flying to and fro (*Par.* XVIII, 76, 77).

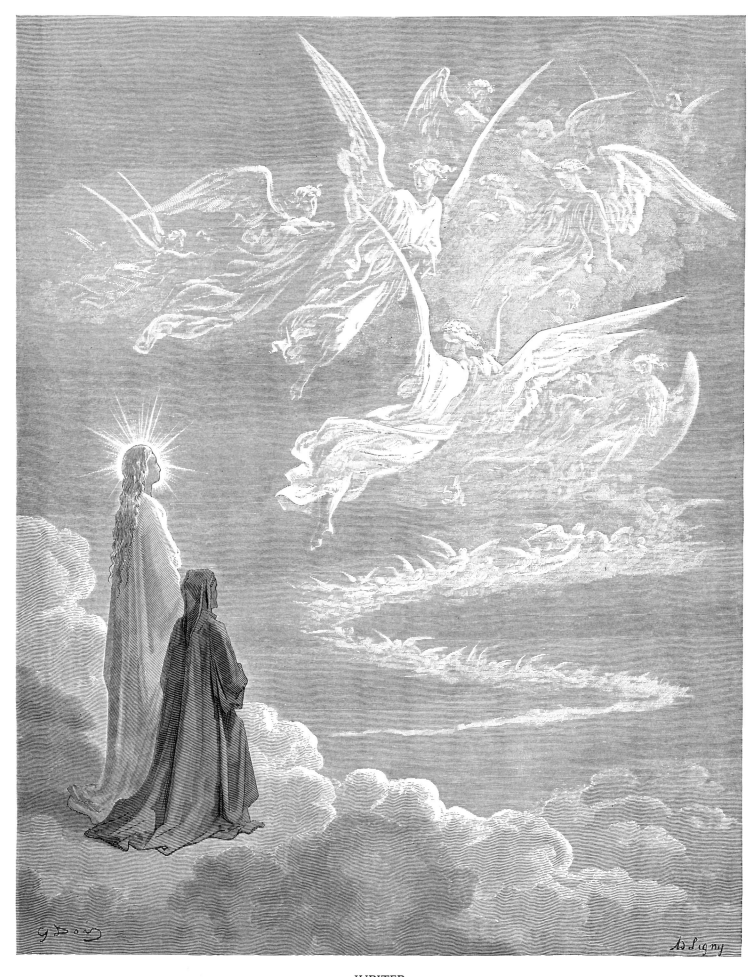

JUPITER
O soldiery of heaven, whom I contemplate, / Implore for those who are upon the
earth / All gone astray after the bad example! (*Par.* XVIII, 124–126).

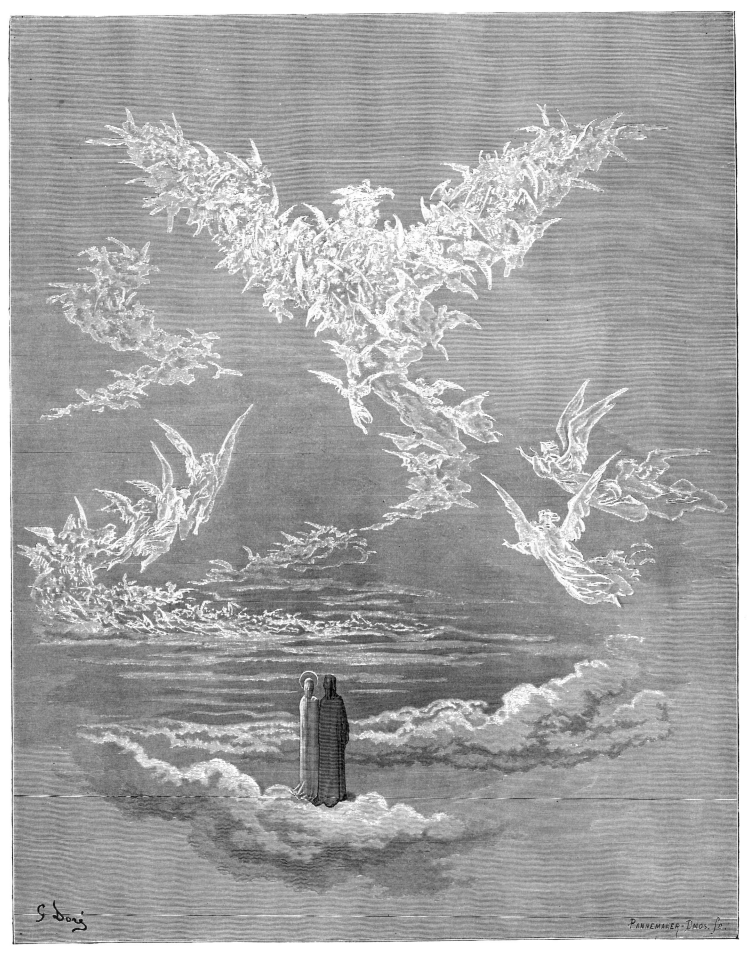

THE EAGLE

Appeared before me with its wings outspread / The beautiful image that in sweet
fruition / Made jubilant the interwoven souls (*Par.* XIX, 1–3).

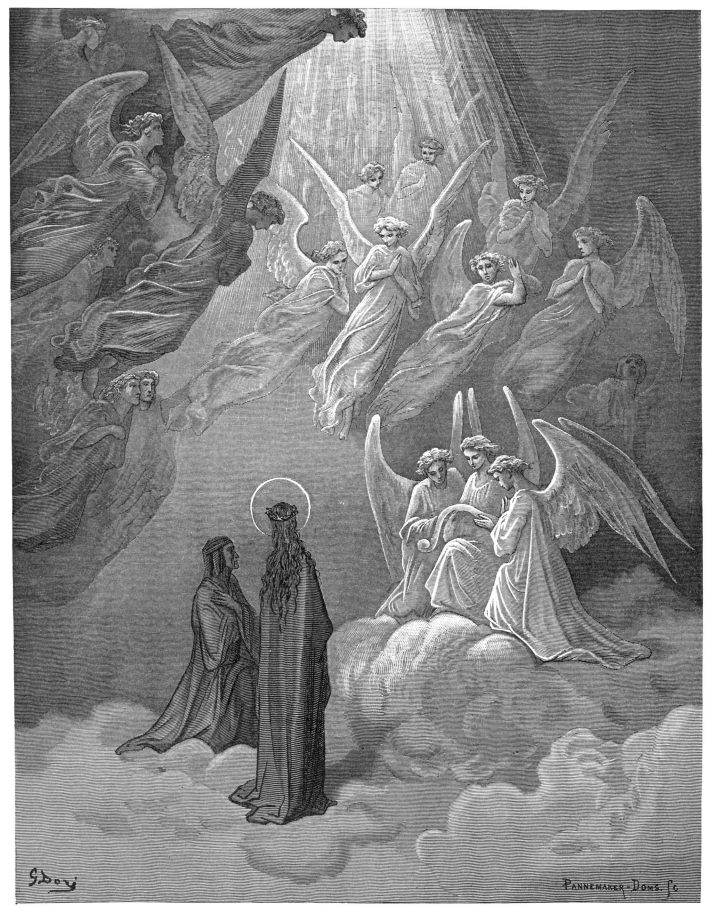

THE EAGLE

Those living luminaries all, / By far more luminous, did songs begin / Lapsing and falling from my memory (*Par.* XX, 10–12).

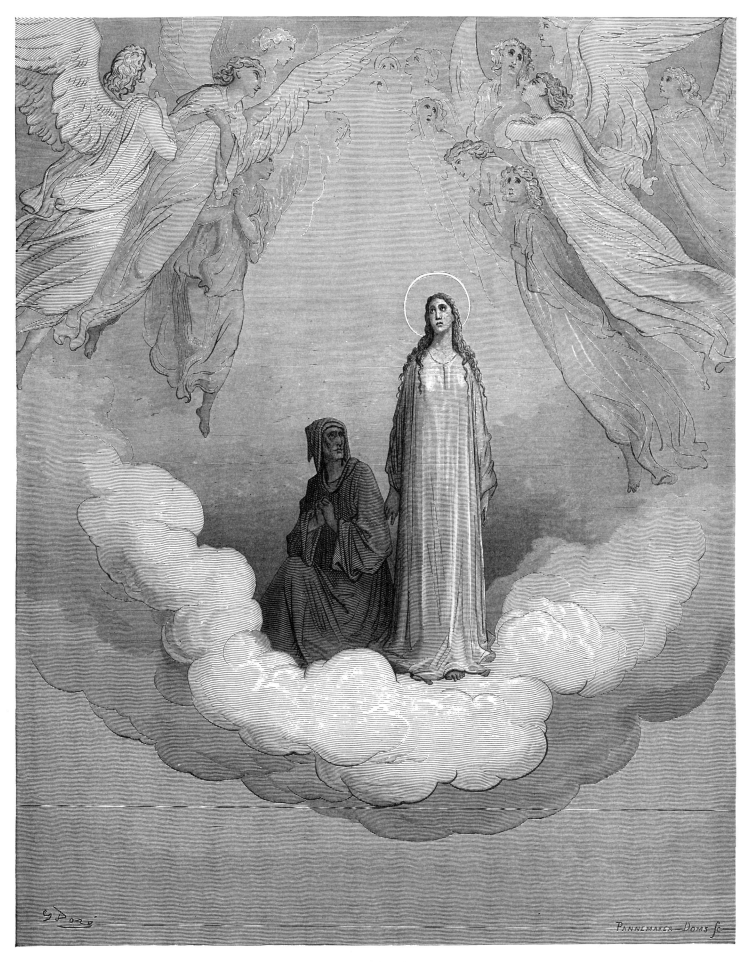

BEATRICE
Already on my Lady's face mine eyes / Again were fastened (*Par.* XXI, 1, 2).

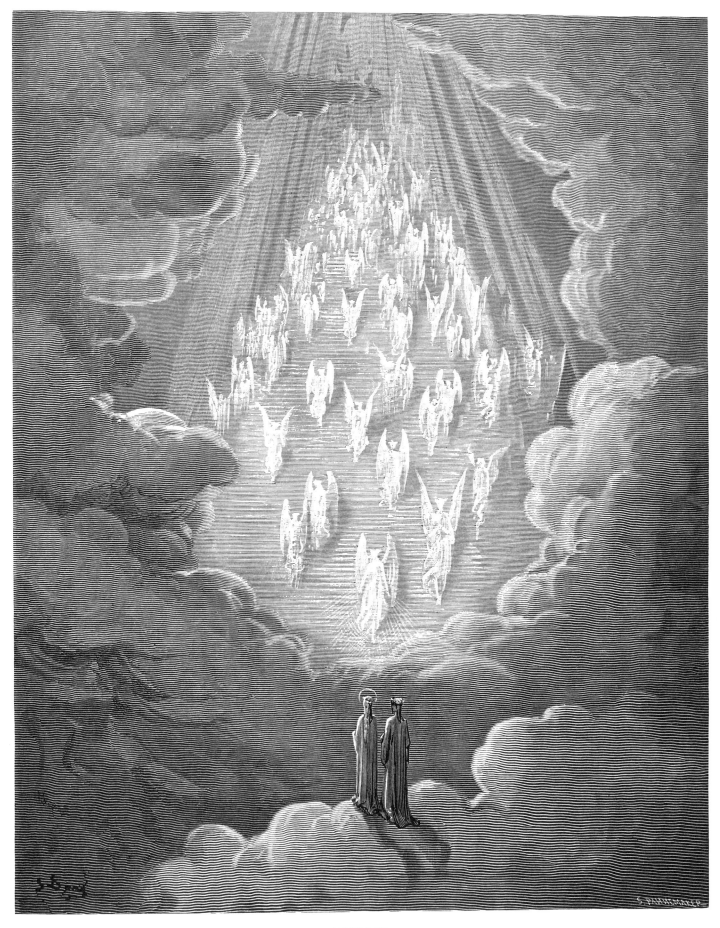

SATURN
A stairway I beheld to such height / Uplifted, that mine eye pursued it not (*Par.* XXI, 29, 30).

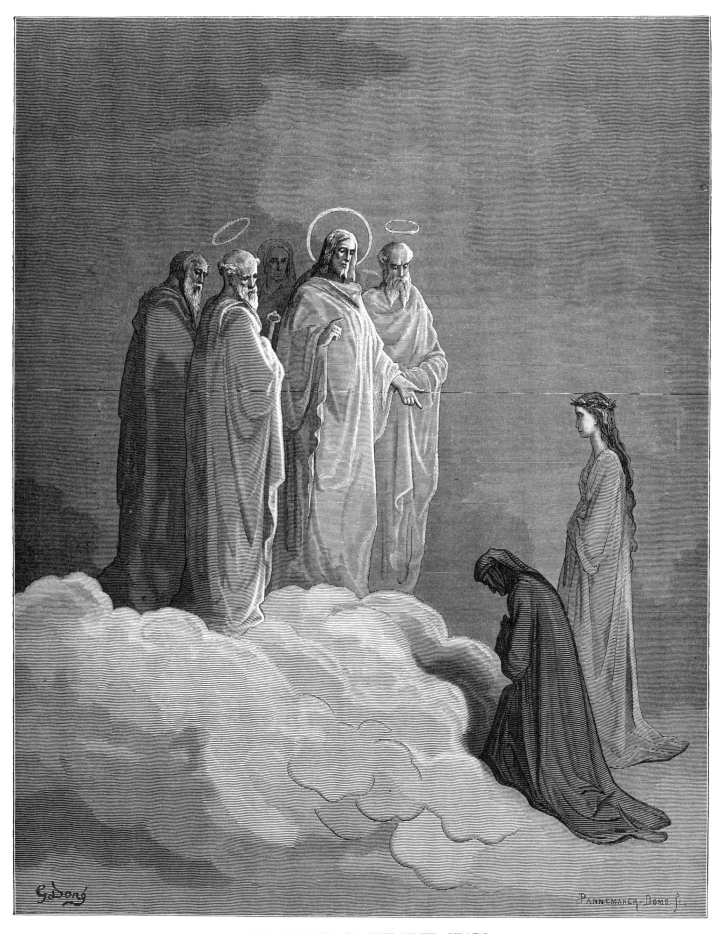

THE HEAVEN OF THE FIXED STARS
"Begin then, and declare to what thy soul / Is aimed, and count it for a certainty,
/ Sight is in thee bewildered and not dead" (*Par.* XXVI, 7–9).

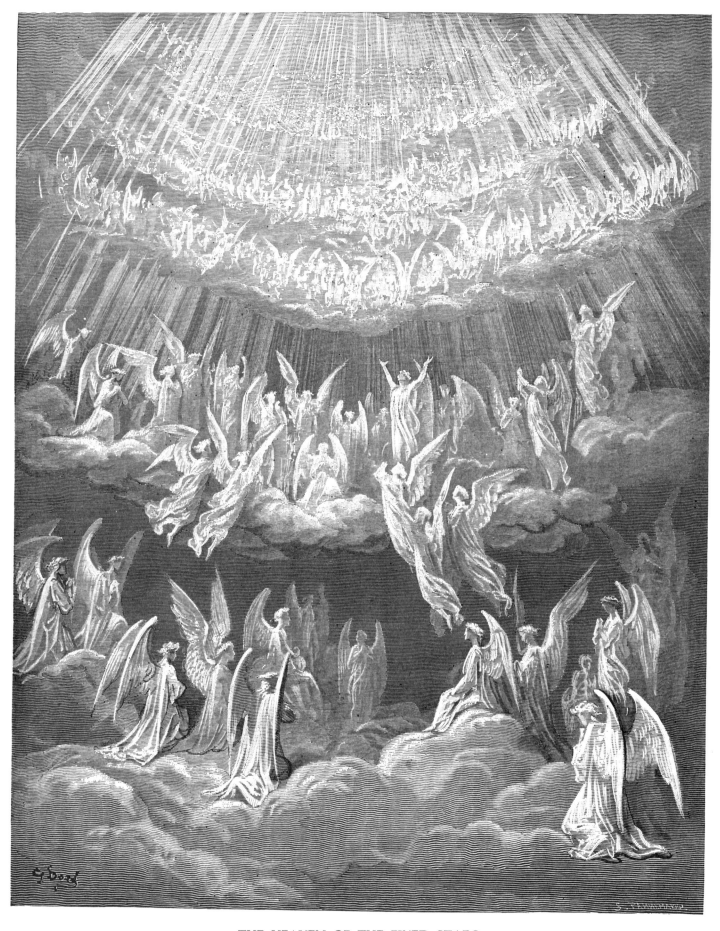

THE HEAVEN OF THE FIXED STARS
"Glory be to the Father, to the Son, / And Holy Ghost!" all Paradise began, / So that the melody inebriate made me (*Par.* XXVII, 1–3).

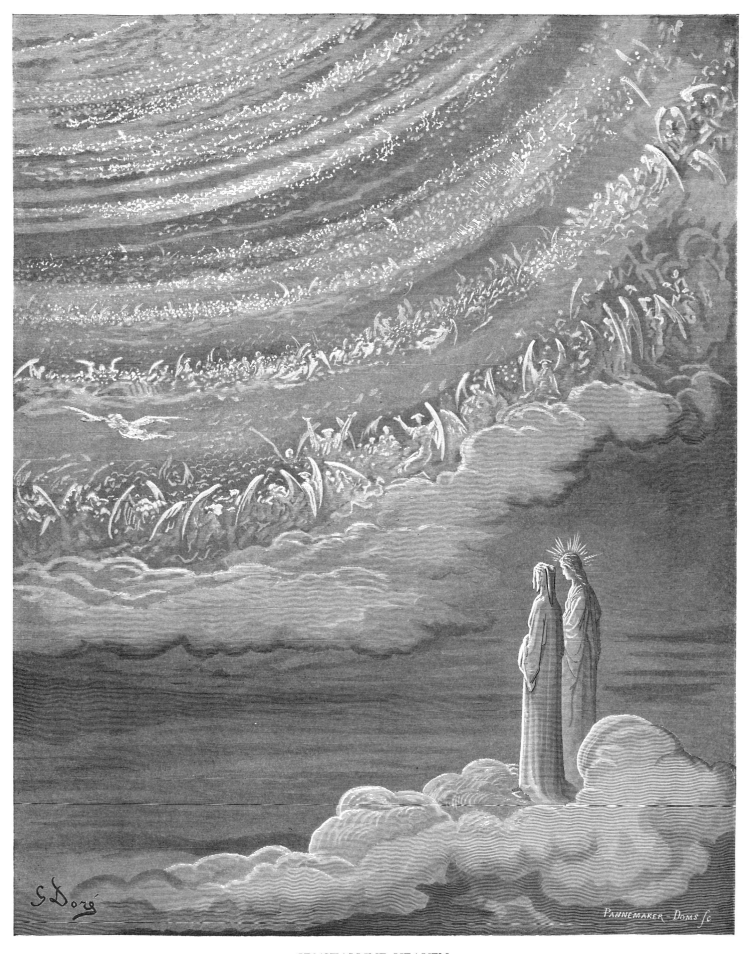

CRYSTALLINE HEAVEN
Not otherwise does iron scintillate / When molten, than those circles scintillated
(*Par.* XXVIII, 89, 90).

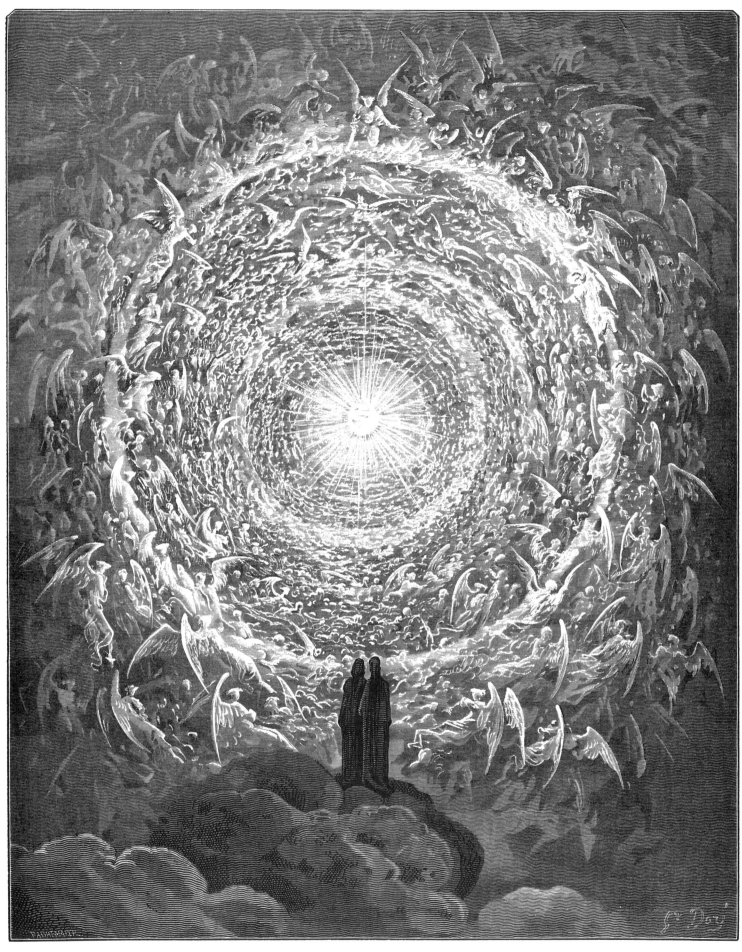

THE EMPYREAN
In fashion then as of a snow-white rose / Displayed itself to me the saintly host
(*Par.* XXXI, 1, 2).

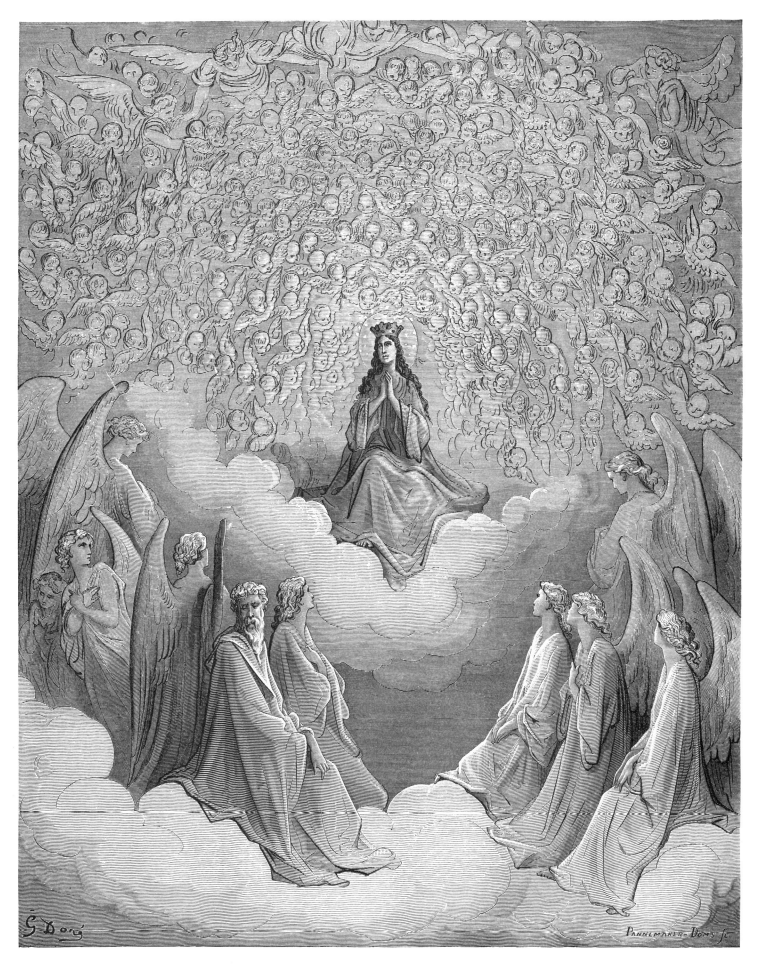

THE QUEEN OF HEAVEN
"Thou shalt behold enthroned the Queen / To whom this realm is subject and devoted"
(Par. XXXI, 116, 117).